PHOTOGRAPHY

ARTS FOR HEALTH

Series Editor: Paul Crawford, Professor of Health Humanities, University of Nottingham, UK

The *Arts for Health* series offers a ground-breaking set of books that guide the general public, carers and healthcare providers on how different arts can help people to stay healthy or improve their health and wellbeing.

Bringing together new information and resources underpinning the health humanities (that link health and social care disciplines with the arts and humanities), the books demonstrate the ways in which the arts offer people worldwide a kind of shadow health service – a non-clinical way to maintain or improve our health and wellbeing. The books are aimed at general readers along with interested arts practitioners seeking to explore the health benefits of their work, health and social care providers and clinicians wishing to learn about the application of the arts for health, educators in arts, health and social care and organisations, carers and individuals engaged in public health or generating healthier environments. These easy-to-read, engaging short books help readers to understand the evidence about the value of arts for health and offer guidelines, case studies and resources to make use of these non-clinical routes to a better life.

Other titles in the series:

Film	Steven Schlozman
Theatre	Sydney Cheek-O'Donnell
Singing	Yoon Irons and Grenville Hancox
Music	Eugene Beresin
Dancing	Sara Houston
Drawing	Curie Scott
Storytelling	Michael Wilson

PHOTOGRAPHY

SUSAN HOGAN

emerald
PUBLISHING

United Kingdom – North America – Japan – India
Malaysia – China

Emerald Publishing Limited
Howard House, Wagon Lane, Bingley BD16 1WA, UK

First edition 2022

Reprints and permissions service
Contact: permissions@emeraldinsight.com

British Library Cataloguing in Publication Data
A catalogue record for this book is available from the British Library

ISBN: 978-1-80071-538-7 (Print)
ISBN: 978-1-80071-535-6 (Online)
ISBN: 978-1-80071-537-0 (Epub)

ISOQAR certified
Management System,
awarded to Emerald
for adherence to
Environmental
standard
ISO 14001:2004.

ISOQAR
REGISTERED
Certificate Number 1985
ISO 14001

INVESTOR IN PEOPLE

CONTENTS

LIST OF ILLUSTRATIONS

SERIES PREFACE: CREATIVE PUBLIC HEALTH

The 'Arts for Health' series aims to provide key information on how different arts and humanities practices can support, or even transform, health and wellbeing. Each book introduces a particular creative activity or resource and outlines its place and value in society, the evidence for its use in advancing health and wellbeing, and cases of how this works. In addition, each book provides useful links and suggestions to readers for following-up on these quick reads. We can think of this series as a kind of shadow health service – encouraging the use of the arts and humanities alongside all the other resources on offer to keep us fit and well.

Creative practices in the arts and humanities offer a fantastic, non-medical, but medically relevant way to improve the health and wellbeing of individuals, families and communities. Intuitively, we know just how important creative activities are in maintaining or recovering our best possible lives. For example, imagine that we woke up tomorrow to find that all music, books or films had to be destroyed, learn that singing, dancing or theatre had been outlawed or that galleries, museums and theatres had to close permanently; or, indeed, that every street had posters warning citizens of severe punishment for taking photographs, drawing or writing. How would we feel? What would happen to our bodies and minds? How would we survive? Unfortunately, we have seen this kind of removal of creative activities from human society before and today many people remain terribly restricted in artistic expression and consumption.

I hope that this series adds a practical resource to the public. I hope people buy these little books as gifts for family and friends, or for hard-pressed healthcare professionals, to encourage them to revisit or to consider a creative path to living well. I hope that creative public health makes for a brighter future.

Professor Paul Crawford

1

INTRODUCTION

BACKGROUND

This book is part of a series of key texts called *Arts for Health* that explore how the arts and humanities can maintain or improve health and wellbeing. The series will guide the general public, carers and service providers as to how different arts can help people stay healthy and improve their health and wellbeing. The series poses the question, why see your doctor for issues that could be resolved without medical intervention through the arts and humanities? As a consequence, this book will explore therapeutic photography in its broadest sense, with respect to how photographic practice can aid health and wellbeing in society. As such it will be of interest to those who take photographs, or who work in the arts and health, or might be considering setting up an arts and health, or therapeutic arts service. It will also aid those who are interested in understanding photographic images more deeply, or those who are just curious to know more about photography in society. Professor Susan Hogan, cultural historian and arts in health specialist, makes links between many of the most important ideas of the nineteenth and twentieth centuries and photographic practices, from eugenics to evolution, as well as delving into the digital in our own century.

AIMS AND SCOPE

There is a need for engaging and practical short books on how particular arts can advance health and wellbeing. In this book, the social and political dimensions of photography will receive attention. Photography, unlike some other arts media, underpins our lives in immediate and complex ways. Photography supports our sense of self, reinforces social attitudes and behaviours, or can be used to subvert these. One of the consequences of modernity is a tremendously accelerated pace of change. As sociologist Anthony Giddens (1990) has pointed out, different areas of the globe are drawn into inter-connection with one another as waves of social change 'crash across virtually the whole earth's surface' (p. 6). At the heart of these waves, imagery is communicating ideas, especially photographs. As well as being at the heart of global communication, ultimately photography also underpins different types of cultural affiliation and therefore forms a central part of representational systems that constitute human society itself. To fully understand photography, and explaining concepts along the way, this text will explore how photographs work in the modern world.

Photography should appeal to scholars, clinicians, carers and self-helpers from all over the world. This book will adopt a writing style that is accessible to the well-informed general reader, as well as appealing to and informing arts, health and social-care practitioners. Though subjects such as semiotics (the study of symbols and signs and how they are understood and used) will be explored to enrich the discussion, this will be done in a way that will not exclude the non-specialist reader. Rather than dumbing-down the subject, photography will be explored in a sophisticated yet comprehensible way, so that a full understanding of the potentialities of photographic practice can be understood. This book disseminates interesting and provocative ideas from the author, as well as presenting the work of the major theorists who have had significant things to say about photography and its practice since its inception.

WHY DISCUSS PHOTOGRAPHY?

Photography is ubiquitous. The visual image is a predominant form of communication. Arguably it is a very democratic medium, since billions of people all over the planet take photographs on their phones, and digital storage means that expensive printing is not necessary and therefore the practice is not prohibitive. Photography is important to political and social movements and connects people in emotionally meaningful relationships. This book will explore the myriad ways in which photographs can be used: to document events, places or things; to consolidate personal identity; to pose a challenge to an idea or regime; to animate the inanimate (in other words, to breathe life into objects); to capture the fleeting and transitory; to create stories; to reveal what may be taken for granted, including *seeing* social practices; to enhance our perception and allow us to notice previously unnoticed details; to consolidate relationships; to represent the overlooked or marginalised; to commemorate; to authenticate; to tantalise. All these modes of photography have different possibilities, different intentions and different effects. Gómez Cruz and Lehmuskallio (2016, p. 8) assert that 'networked cameras and digital imagery play a role in how we dream, desire, think, act and connect'.

CONTENT

This book will discuss the background and development of photographic practice. A short monograph cannot be definitive and as this text is part of the *Arts for Health Series*, the focus is on the broadly *healthful and socially beneficial* uses of photography. Chapter 2, 'A Brief Summary of the History and Development of Photography', provides an overview, but alas only a snapshot of this vast and fascinating subject. It is necessarily impressionistic. It touches on documentary photography; photojournalism; photographs of the natural world; architectural and landscape photography; photography in anthropology; photography as art; photographic portraiture, in short introductory sections. It

concludes with a brief investigation of digital imaging technology and its repercussions. The chapter begins to develop themes that are expanded further, about ways of seeing and the fundamental truth of photographs. These topics run as on-going philosophical conundrums throughout the manuscript. Ideas surrounding the production of photographs are privileged over detailed exploration of the works of individual photographers, or personal biographies. Chapter 2, with necessity, must overlook some genres: fashion photography is an unfortunate casualty and pornography eschewed because of the book's length and overall emphasis on the beneficial social uses of photography, of which there is already too much to discuss – however, the erotic is not overlooked, but picked-up in the discussion of arts practice.

The book moves on to explore what is distinctive about photography, including a discussion of how images work in semiotic terms. Chapter 3, 'How Are Photographs Distinctive?', introduces photographic theory and explores the contribution of the major photographic theorists. It explains how photographs make meanings.

The text then moves on to talk about photography and health practices, including photography for pleasure. Chapter 4, 'Photographic Practice for Health and Wellbeing', discusses portraiture and self-portraiture, photography in health promotion and social care, photography to empower communities and photography in activism and as art.

Photography is a social science tool which can explore subjects that improve health and wellbeing. The value of this is articulated in Chapter 5, 'Photography in Research (Summary of Photographic Research Methods: Photo-documentation, Photo-elicitation, Semiotic Analysis and Content Analysis)'. This chapter also includes a useful overview of how images can be used in research. The chapter expands some of the theoretical discussion introduced in Chapter 3.

Explicitly therapeutic ways of using photography then receive detailed attention in the final chapters. Chapter 6, 'An Introduction to Re-enactment Phototherapy', explores a technique that uses role-play, dramatic enactment and reformulation of personal stories

via photographic sequences. This penultimate section explores the background and development of re-enactment phototherapy and then elucidates the techniques used in detail.

Chapter 7, 'Therapeutic Photography', investigates different elements of therapeutic photography in practice. It explores key dimensions: photographs in a psychotherapeutic model; therapeutic self-portraiture; metaphor in therapeutic photography and finishes off by exploring the use of family albums in personal and family therapy. The book ends with suggestions for further reading.

Some of the photographs mentioned, but not reproduced, are easy to find on the Internet, so if you have a laptop, ipad or other devise handy, please do look at the images mentioned as you read this text to enrich your overall experience of the book. Concepts build throughout the text, so the reader may find it fruitful to read it sequentially.

2

A BRIEF SUMMARY OF THE HISTORY AND DEVELOPMENT OF PHOTOGRAPHY

From mistaken attempts at recording physiognomy (the recognition of character from facial characteristics) to Eadweard Muybridge's illuminating high-speed photographic sequences in the late nineteenth century, which showed animal and human movement in an unprecedented way, photography has shown an interest in exploring the human condition and culture. This chapter will give a brief outline sketch of the main ways photography has been used for human benefit. It will develop themes that are explored in more depth later. Each section is a very brief snapshot of a particular topic, arranged chronologically.

* * *

PHOTOGRAPHY OF THE NATURAL WORLD

Photographs have been used to explore the *natural world*. A botanist, Anna Atkins, employed the first photographic illustrations in a book in 1843. She used a blueprinting method to reproduce plant specimens. She is often also cited as the first female photographer (1899–1871).

**Fig. 1. Photographs of British Algae: Cyanotype Impressions.
Anna Atkins. c. 1850.**

Human specimens were also important. This section will intro-
duce important concepts that underpinned how humans were *seen*
in popular culture, in psychiatric discourse and evolutionary theo-
ry. It will also touch upon how

> photographs published in the medical and, to some extent,
> the popular press helped readers to interpret expressions
> and gestures as signs of emotional states, morbid con-
> ditions and physiological and psychological processes.
> (Pichel, 2019, p. 52)

**Fig. 2. Leonine Specimens: Illustration in Giambattista Della Porta's
De Humana Physiognomia (Naples, 1602). The Getty Research Institute,
2934-552.**

In the early seventeenth century, Italian scholar Giambattista della Porta had compared human heads to those of various animals, attributing animal traits to those depicted. Physiognomy has developed in antiquity, and was well established across and beyond Europe by the time photography developed, from the ancient Greek physis (nature) and gnomon (one who knows or examines).[1]

Physiognomy is the practice of assessing a person's character or personality from their outer appearance – especially the head and face; the face was thought to be an index of the mind. The Swiss poet and theologian Johann Kasper Lavater's (1866) work was quite explicit in describing physiognomy as 'reading the handwriting of nature upon the human countenance'. [2] Lavater's work was widely translated and reprinted posthumously and is credited with stimulating public interest in paying attention to facial characteristics as indicators of character (Gilman, 2014). Different shapes of various bits of the face and skull, Lavater believed, incontrovertibly indicated different personality traits, or the result of 'mental deformity'. Indeed, there was often a moral judgement involved in the physiognomic perception of appearance, as physical characteristics were thought to predetermine character. Cultural and literary historian Sander L. Gilman (1988) suggests that Lavater's *Physiognomic Fragments,*[3]

> postulated a strict relationship between physical and spiritual traits His illustrations of this relationship are rooted in the simplistic visual analogies found in the Renaissance. His influence, however, was intense and immediate. (p. 26)

The works of Lavater interpreted the body in explicit ways. For example, the shape of a person's lips indicated certain forms of personality, a 'mild overhanding upper lip generally signifies goodness'; fulsome lips could indicate 'sensuality and indolence', whereas thin lips denoted something quite different:

> A lipless mouth, resembling a single line, denotes coldness, industry, a love of order, precision, housewifery; and, if it be drawn upwards at the ends, affectation, pretension, vanity, and, which may ever be the production of cool vanity, malice. (Lavater, 1866, p. 61)

Like astrologists, who sought to link the movement of the stars to human behaviour and make predictions and pronouncements, physiognomists used drawings and then photographs as a reference for acts of interpretation. Photography was employed by physiognomists to help decipher the character of those depicted and to illustrate the different types of physical characteristic and what they were supposed to denote. Some physiognomists offered a postal interpretation service and it was possible to send a photograph (of a fiancé, or potential business partner) for personality analysis! Our visage was thought to show the consequences of indulgence of passion, or of vice, which were believed to be heritable through a process of intergenerational degeneration (and in an age of hereditary syphilis, perhaps this was not so outlandish).

In 1852, Hugh Welch Diamond (1809–1886), who was medical superintendent of the female department of Surrey County Lunatic Asylum (1848–1858), and a keen photographer, started to produce photographs of his inmates to record their appearance, with a physiognomic theoretical underpinning. Indeed, Diamond expanded the meaning of the word physiognomy to include characteristics such as clothing and hairstyle (Pearl, 2009), but he was still interested in producing physiognomic categorisations – for example, a set of photographs exhibited as, *The Types of Insanity* in 1852 at the London Society of Arts. Secondly, and innovatively, he used the camera to create accurate self-images of his psychiatric patients, which he then shared with the woman concerned, sometimes with salutary results. Thirdly, he took photographs to keep as a record to help with processes of identification and readmission, if required. He also found that the photographs helped him personally to remember the cases. This could be argued to constitute the origins of therapeutic photography, and it certainly contributed to its emergence (Gilman, 2014, pp. 7–8).

In a paper of 1856, Diamond elaborated the advantages to be obtained from keeping a photographic record,

> as faithfully representing the features of the disease in its different forms, or its successive phases in the same patient, and as affording unerring records for the study and comparison by the physician and psychologist.[4]

In this paper, he also gives an example of a purported cure via photography:

> I may refer with pleasure to a case in which Photography unquestionably led to the cure. A.D. aged 20 was admitted under my care in August 1854, having been recently discharged uncured from Bethlem Hospital after a year's residence there. Her delusions consisted in the supposed possession of great wealth, and of an exalted station as a queen. Any occupation was therefore looked upon by her as beneath her dignity. I wished to possess portraits of the several patients who imagined themselves to be Queens and Royal personages, and one of these in a dominant attitude and with a band or 'diadem' round the head, stands first in the frame. It was however not without much persuasion that I induced the Queen, A.D., to give me the honour of a sitting. I told her that it was my wish to take portraits of all the Queens under my care, and I will remember the contempt with which she observed 'Queens indeed! I How did they obtain their titles?'. I replied, as she did: *They imagined them*. 'No!' she said sharply, 'I never imagine such foolish delusions, they are to be pitied, but *I* was born a Queen'. Her subsequent amusement in seeing the portraits and her frequent conversation about them was the first decided step in her gradual improvement, and about four months ago she was discharged perfectly cured, and laughed heartily at her former imaginations.[5]

Diamond's work was inventive in using photographs to give feedback to patients in this way. Pearl (2009) summarises his approach,

> therapy was not in the production of art as a leisure activity (as in moral management), nor was it an exercise in subconscious personal exposure (as in the art therapy movement pioneered in the 1940s), but [it was crucial] in the training of personal judgement. (p. 293)

Diamond was also credited with harnessing the power of photography to capture the pathos of insanity and in this way he moved

beyond mere, misguided, physiognomic classification. Furthermore, the works were used to underpin John Connolly's asylum reforms, and in 1858 Diamond's photographs were used in a series of essays to illustrate and underpin the value of moral management in asylums, which eschewed the use of physical restraints (Gilman, 2014, p. 11).

Later in the century, Francis Galton, polymath, physiognomist and eugenicist, used photographs in an endeavour to categorise.[6] Galton devised a composite photographic method whereby multiple exposures were made on the same photographic plate. He created alleged definitive 'types' by overlapping many images, to create the definitive image of 'criminality', for example. The method visually identifies the 'traits in common' (Galton, 1883, p. 10).[7] He advocated that mental characteristics are hereditary, so he looked for signs of this in the body. He espoused the idea that there was a 'central physiognomic type of any race or group' and that composite portraiture could *reveal* this (Galton, 1883, p. 15). Alas, for modern policing, not all criminals do look alike![8] Galton (1869) regarded the 'ablest race' to have been that of ancient Greece (p. 340). An ancient Greek physical aesthetic was therefore deemed desirable and noble.[9] What these early photographic projects tell us is a lot about the values and prejudices of the day in the way classifications were made.[10] This is a cultural legacy that has informed ideas of how we view people today and what is deemed attractive. For example, the 'attractiveness halo' is a phenomenon whereby good-looking individuals are likely to have better lifetime earnings than those who are less attractive.[11]

In 1872, Charles Darwin (1809–1882), biologist, naturalist and geologist, founder of modern evolutionary studies, used photographs as illustrations in his book *The Expression of Emotions in Man and Animals* to show human expressions from joy, to disgust, to grief. Here photographs are being used to underpin evolutionary theory. Though some theorists, he suggests, see facial muscles as purely instrumental in expression, Darwin (1872) sees them as pointing to our evolutionary development:

> With Mankind some expressions, such as the bristling
> of the hair under the influence of extreme terror, or the

uncovering of the teeth under that of furious rage, can hardly be understood, except that man once existed in a much lower and animal-like condition. (p. 239)

The book contains many fascinating photographs of different variants of emotions as evidence of this evolutionary theory.

In 1880, Muybridge developed the lantern slide projector, which could show a series of images of movement and project this on a screen. Speeded up, a series of images of a moving subject became the first *motion-picture* demonstration. Muybridge's high-speed photographic sequences changed the perception of how people and animals move through space – it was revelatory. Walter Benjamin was to reflect later in 1935:

> It is indeed a different nature that speaks to the camera from one which addresses the eye Photography with its various aids (lenses, enlargement) can reveal this movement. Photography makes aware for the first time the optical unconscious, just as psychoanalysis discloses the instinctual unconscious. (cited Wells, 2004, p. 19)

Microscopes also reveal aspects of the natural world normally invisible to us. Although there is specialist photographic equipment available, it is possible to use a good quality mobile-phone camera to photograph directly from a microscope eyepiece. The microscope can be adjusted to maximise the image clarity and then the camera's autofocus should then self-adjust to give a clear image. Photographs thus obtained can be transmitted to a specialist at another location with obvious health benefits, especially where timely intervention is crucial (Maude, Koh, & Silamut, 2008).

Finally, though electron microscopes are not cameras, their operation is sometimes described as analogous. They can produce highly magnified visual images called 'electron micrographs'. For example, the distinctive Covid-19 virus spike was produced as a 3D image and model, as the basis of the first US vaccine. In order to 'see' the structure of a protein molecule, which is smaller than the wave-length of visible light, beams of high-energy electrons are used. They have much smaller wave-lengths than visible light, enabling tiny details (for instance, the spikes of a Covid-19

particle) to be imaged, then this 2D material was formulated into a 3D model. Even though only this tiny detail was used for the vaccine, it was found to be effective.[12] Photographic imaging and animation has also been very helpful in explaining how the vaccine, which gives protection from Covid-19, was formulated and how it works.

ARCHITECTURAL AND LANDSCAPE PHOTOGRAPHY

Architectural and landscape photography allowed places and monuments to be viewed in new ways. The accuracy of photography in making records was valued. Total scenes could be captured. Buildings facing demolition or erosion could be recorded for posterity, Eugène Atget's (1857–1927) capture of 'old Paris', for example. Photography supported development proposals, accompanying surveys. Large building projects such as dams, bridges and railways began to be routinely photographically documented. Philip Henry Delamotte recorded the construction of the Crystal Palace in London in photos between 1851 and 1854, for example.

The expansion of photography largely took place in the second half of the nineteenth century, enabled by technical developments in photographic process. Elizabeth Eastlake (1857) notes in an article (p. 1) that a Mr Beard established four different daguerreotype establishments in different parts of London as early as 1842 and 'alone' supplied the metropolis until 1847. Thereafter was an exponential growth of interest.[13] Eastlake (1857) describes 'petty dabblers' selling photographs in trays along every large thoroughfare of London at a price ordinary people could afford. Photography had 'become a household word and a household want' (p. 1).

In the United States, in 1871, W. H. Jackson's Yellowstone photographs were given to congressmen. These photographs were important in the campaign to establish the area as a national park. Not only has photography been significant with respect to land conservation, anthropologist Poignant (1992) argues 'this containment of nature's spectacles and wildernesses can be seen as part of a consolidation of an American Nation after the Indian and Civil Wars' (p. 55).

The glamour and excitement of monumental modernist architecture were also captured by photography, such as Lewis Hine's (1874–1940) now famous set of vertigo-inducing photographs documenting the construction of New York's Empire State Building. Hine also produced works, which were more stylised using selected and carefully posed models. The Brooklyn Museum catalogue notes that Hine was concerned about the stature of industrial workers, who were 'increasingly diminished by the massive machinery they operated'. Man and machine might almost seem merged in this image, which could also viewed as a celebration of manliness, as demonstrating a taut muscularity, in the context of industry. It has become an iconic image of masculinity. Furthermore, it has been suggested that Hine's later, more formulated, work helped to cement the pictorial formulas used by burgeoning corporate public relations departments.[14]

As well as photographs highlighting inequality, Edith Tudor Hart (1908–1973) also produced some stunning modernist, almost abstract, architectural images, such as that of the Pater Ferris Wheel in Vienna.

Ansel Adams (1902–1984) may be the most famous twentieth century landscape photographer from the United States, especially remembered for his work of Yosemite National Park. President Jimmy Carter said of him that he was 'a visionary in his efforts to preserve this country's wild and scenic areas, both on film and on Earth' (1980).[15] Interestingly, in contrast his documentation of the incarceration of Japanese–American citizens in WWII (taken 1943–1944) was actively censored.

Photographers of architecture experimented with different ways of seeing. Hilla Becher (1934–2015), for example, influenced by the *Neue Sachlichkeit*, a 1920s German art movement, photographed disappearing industrial buildings, often in sets of prints shown together as 'typologies' – presenting softly lit small architectural variations of one particular structure, a cooling tower or a blast furnace, for example. Hilla said of the work:

> By placing several cooling towers side by side something happened, something like tonal music; you don't see what makes the objects different until you bring them together, so subtle are their differences. (cited Collins, 2015, p. 1)

Fig. 3. Lewis Wickes Hine (USA 1874–1940) Power House Mechanic 1921. Part of the Men at Work 1920–1940 Dignity of Labour Series. Brooklyn Museum, Gelatin Silver Photograph.

Her collaborative work with her husband Bernd (she taught him large-format plate photography) influenced the Düsseldorf School, considered to be widely influential today and associated with conceptualism and minimalism and a style sometimes called 'deadpan' – a neutral and unemotional style comprising a disposition of detached

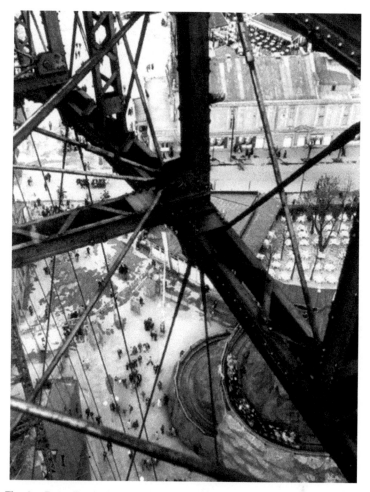

**Fig. 4. Pater Ferris Wheel in Vienna by Edith Tudor Hart c. 1930
National Galleries Scotland, © Held Jointly by Peter Suschitzky, Julia
Donat and Misha Donat. Reproduced with kind permission from the
Tudor Hart Estate.**

observation and fine detail. Working together, the Bechers demon-
strated uniformity of presentation, with the object of interest iso-
lated in the frame.

Influenced by the Bechers, the photographic works of Andreas
Gursky (b. 1955) and Michel Wolf (b. 1954) are less a record of
modern architecture (though it is that too) than an aesthetically

Fig. 5. Typologies, Water Towers. 1972–2009. Hilla and Bernd Becher. Nine Photographs, Gelatin Silver Print on Paper.

pleasing set of abstract shapes and colours: the repetitions of hundreds of windows and balconies developing a visual plane of light and colour and shape; some of the photographs evoke minimalist art and are both panoramic and disorientating.

* * *

PHOTOGRAPHIC PORTRAITURE AND *CARTE DE VISITES*

Julia Margaret Cameron's (1815–1879) portraiture is a strong example of early photographic work. Through her social

connections, she was able to gain access to many notable Victorians, including the evolutionary theorist and naturalist Charles Darwin. She is noteworthy for her attempts to portray 'interiority': she said of her aim,

> my whole soul has endeavoured to do its duty toward them in recording *faithfully the greatness of the inner man* as well as the features of the outer man. The photograph thus obtained has almost been the embodiment of a prayer. (cited Vallencourt, 2015, p. 43, my italics)

Cameron's work divided opinion at the time, but did achieve some critical acclaim and the works were regarded as thoughtful studies, their soft focus was praised and the bold chiaroscuro (strong contrasts between light and dark) seen as evoking old master oil paintings.

Fig. 6. Iago, Julia Margaret Cameron, 1867. © Creative Commons.

Internationally, many people began to commission portrait photographs of themselves, especially for commemorative purposes. Royal and wealthy households across the globe began to employ photographers. Lewis Carroll (1832–1898 of Alice in Wonderland fame) was also a notable portrait photographer of his day.

An aspect of the nineteenth century was that of post-mortem portraiture. The likeness of someone who had died, particularly children in that age of high mortality, was captured, often in a 'life-like' pose. Photography was rapidly adopted. To modern sensibilities this might seem distasteful, but it was a common practice and formed part of elaborate mourning rituals. Indeed, some hospitals are now reintroducing the possibility for next-of-kin to stay with the dead body and giving opportunities to take photographs, especially in the case of the death of children and newborn babies. Literary historian Terry Castle (1995) noted photography has 'a way of possessing material objects in a strangely decorporealized yet also supernaturally vivid form' (p. 137).

Portraiture is discussed in much more depth later in this text. However, there is a rich cultural heritage of street photography portraiture which is not formal portrait, nor quite documentary, nor anthropology, but which captured the life of people in cities. The work of Cartier Bresson (1908–2004), for whom the camera was 'an instrument of intuition and spontaneity', and the less well-known eccentric and characterful studies of Austrian-American Lisette Model (1901–1983), or the later street portraits of Helen Levitt (1913–2009) and Vivian Maier (1926–2009) are early examples of this still thriving genre. Some contemporary portraiture evolved out of the Düsseldorf School's influence (mentioned above). Thomas Struth (b. 1954) manages the 'deadpan' photograph engagement in his portraits effectively.

Portraiture is still thriving, especially with regard to therapeutic portraiture and communities of interest, an area to be discussed further: Sunil Gupta's (b. 1953) work on gay men and hijras in India is an outstanding example.[16] There is also a very interesting body of work, encompassing portraiture, exploring pregnancy and motherhood, of which Eti Wade's (b. 1968) work is a notable example in her exploration of maternal anxiety and desire.

Fig. 7. Eti Wade. Bathwomb 2005. © Eti Wade.

The Carte de Visite evolved out of the earlier tradition of 'calling cards', which bore the bearer's name and emblem, and were presented to the host during a social visit, or in advance of a social visit. These in turn had evolved out of a tradition of visitors leaving hand-written notes at the homes of friends if they called when the host was not in. Some houses had a tray near the door for the gathering of these small cards. From 1857, they began to feature a photograph of the visitor. This was an albumen print pasted onto the card.[17] They could be simple or complex in design, some were even edged in gold.

People began to collect *Cartes de Visites*. They were arranged in albums, or displayed, or posted to friends and relatives, or a loved one, as a remembrance. Newspaper advertisements for marriage partners advocated exchanging Cartes. Soon *Carte de Visite* of celebrities could be bought in stationers' shops. Around the 1860s, *Cartes de Visites* became immensely popular, following a set of Carte portraits produced of Queen Victoria, her husband

and her children. Indeed, these images are noted to have permeated from Britain into the Colonies, and having them became *de rigueur* (Lamb, 2019, p. 19). In an age of mass media, it is easy to forget the popular excitement felt in being able to see what royalty and celebrities actually looked like. The media historian John Plunckett (2010, p. 72) suggested that there was 'a voyeuristic schadenfreude at being able to see the authentic countenances of kings and queens for the first time' which helped to make these *Cartes* very compelling. He explains the fascination for *Cartes* in further detail, in contrast to the National Portrait Gallery (founded in 1858 and regarded by some as pompous), 'the carte was both contemporary and egalitarian' and very accessible (p. 69). The *Carte* was often accompanied by a message written on the front or back of the card, which might explicate the image in further detail. *Cartes* also began to feature 'types' and were also used for more supposedly systematic surveys: 'a fishwife from Newhaven near Edinburgh' (1878), or 'A group of Miners taken at Dalcoath tin mine a half mile from Cambourne, Cornwall' (1878) are a couple examples of local natives photographed in an attempt to explore and classify regional differences (Poignant, 1992, p. 59).[18] *Cartes de Visites* remained popular up to around 1910, and are the precursor of the postcard, or greetings card, the two forms existing simultaneously for a time. Historian Warner Marien (1997, p. 79) sums up the importance of the genre:

> Cards or cartes not only increased the number of personal portraits available to the public, they also greatly increased public assess to views and to celebrities [They] potentially verified everything from natural disasters to the playthings of royal children. Framed in the language of democracy ... this vast capacity seemed like a political entitlement. However, voyeuristic, the right to look – and the necessity to make the world visible – were aspects of the mid-nineteenth-century understanding of modernity. Allied with the interdependent concepts of natural and neutral vision that suffused photographic discourse, looking became a prerequisite of modern life.

In the 1890s, picture postcards began to circulate. It was customary to buy a card as a souvenir when on holiday, or to post to friends and family with written news when travelling. Indeed, this might be seen as an easier way of discharging the obligation of writing a letter, and finding and negotiating with local post offices to purchase stamps and send mail, was an essential part of the foreign travel experience. Postcards often depicted the image of a place, a landscape or a historic monument, or they might portray a local 'type' rather than a place, labelled as a 'native Senegalese man with his guitar', for example. The individual depicted may be seen posed in front of a painted canvas background of a landscape, or village with props. Such artificial theatrical mise-en-scène was not intended to be realistic, but rather romantic. Often these background painted sets were exotic and stylised. Though the individual is objectified, these images can retain a sense of personal dignity of the subject. The same technique was used to depict native subjects in Britain – a farm worker in the field and so forth. It was rather contrived, but, to give a sense of the collective enthusiasm for this genre, between 1909 and 1910 an estimated 866 million postcards were sent in the United Kingdom (Street, 1992, p. 122). Some historical commentators have suggested that this proliferation of images should be understood as part of a mass movement towards literacy – photography being to art what the printing press was for literature and linked to campaigns such as 'pictures for the poor' and 'museums without walls' (Warner Marien, 1997, p. 116).

It was customary practice in places of popular entertainment (such as fun fairs), for contortionists, freaks and 'marvels' of many sorts – bearded ladies, so-called 'Siamese twins' and so forth, to be exhibited as a form of spectacle. A rather different type of sensational portrait was taken of these exhibited people. To take one highly distasteful example, a showman called R. A. Cunningham toured a group of Australian aboriginal persons in 1884 describing them as, 'Ranting man eaters', 'blood-thirsty beasts' and 'ferocious, treacherous, uncivilised savages'. Publicity material emphasises their 'deep scars', 'bones and huge rings thrust through nose and ears as ornaments'. Photographs show the group posed with boomerangs and the act included dances, throwing of spears and

'whirling' of the boomerang, 'worth journeying a hundred miles to see these specimens of the lowest order of man' ran the publicity.[19] Poignant (1992) notes that this sort of language was not unusual in the description of other toured groups of colonial people (p. 53).[20]

Picture postcards remained tremendously popular up to around the end of the twentieth century and into the beginning of the twenty-first century. Though they can still be found in abundance, mobile-phone text and image messaging has largely replaced the post card as a form of communication, though they are still bought as souvenirs, or sent for fun. Sending them as an obligatory courtesy is no longer current.

In the twenty-first century, contemporary digital photography has revisited the genre of the staged studio portrait photograph of the 'exotic' other. Dow Wasiksiri, for example, in this work entitled *It's Plastic But Trust Me* uses digital editing to insert himself into a postcard from a portrait series depicting Javanese customs, produced by a local commercial photographic studio at the turn of the nineteenth century. A young Indonesian street vendor wearing traditional batik attire is depicted kneeling on the floor selling local fruits. She looks puzzled and uncertain as Wasiksiri proffers his credit card in a supercilious gesture. The contrast between the past and present is accentuated by the black and white of the original post card contrasted with the colour of Wasiksiri in a light blue suit flourishing a golden visa card (really it relies on colour for its effect). Although on one level this is a playful image, reminding us of cultural changes which are now a norm and unquestioned – the notion of plastic credit – it has many underlying uncomfortable resonances, not least that poor native women may be bought for sex by rich tourists in Thailand today, especially young girls and boys. It also connotes a history of profound inequality between so-called 'developed' and more traditional societies.

PHOTOJOURNALISM

Newspapers and magazines began to feature photographic illustrations and *Photojournalism* was born. Roger Fenton gained an appointment as official photographer of the Crimean War in 1855.

Fig. 8. Dow Wasiksiri. *It's Plastic But Trust Me* 2013 (Conversation with the Past Series) 2209 Gallery Singapore. Colour Print. © Dow Wasiksiri.

Wood engravings of his most notable photographs were printed in the *Illustrated London News*. This work might be seen as early photographic propaganda, since the photographs were intended to counter some of the swingeing criticism of the war's poor management and the lack of care given to the wounded (which famously prompted Florence Nightingale's arrival at the Scutari barracks to offer her administrative expertise and nursing regime).[21]

The political significance of photography was soon recognised. Historian Edward English notes that opponents of the Third French Republic (1870–1914) were quick to draw upon photography.[22] He argues that right-wing groups were prolific users of photography and that the widespread use of political photographs alarmed the government. These images with their 'elementary symbolic messages' represent an early form of *photographic propaganda*. In particular, English suggests that the Paris Commune of 1871

led to photography playing a particularly important role in French politics, both in documenting change and destruction, but also in recording Communard activity. These images were to be used later for political purposes by both pro-Communard and conservative sympathisers. Sometimes they were made freely available.[23] Several photographers recorded events on the barricades. Jean Claude Gautrand wrote:

> A new population takes possession of Paris, a new ideology inundates the city, whose bourgeois districts are deserted by political emigrants to the interior. Exceptional events unfold in Paris. *Photography takes on its new, primordial role as living witness.* (1871, cited English, 1981, p. 17, my italics)

Imagery was thought to be particularly powerful with respect to the behaviour of crowds. The prominent psychologist Gustave Le Bon thought that being in a crowd could undermine individual rationality, bringing lower instincts to the fore: 'Crowds think only though images …. Only these images can terrorise, seduce, and mobilise them into action' (Le Bon, 1895 cited English, 1981, p. 8).

A form of photo-montage was developed by Ernest Eugène Appert, using a mixture of hand composition and photography, in which historical events were re-enacted (not always accurately) by actors, with the faces of the actors then replaced with the faces of the relevant historical figures. These composite photographs showed the Communards in the worst possible light and distorted historical events in interesting ways. For example, the execution of Generals Clement-Thomas and Lecomte was hasty and spontaneous, conducted by a group of enraged National Guards and Parisian citizens – the two generals were taken from confinement and hastily shot separately. The photo-montage by Appert shows an orchestrated, rather than spontaneous scene, with the two men being shot together.

English (1981) astutely notes that propaganda

> is often narrowly associated with large, blatant, and systematic campaigns directed by elaborate political organisations in order to control the thoughts and actions of

individuals. It is also frequently viewed as the dissemination of false or misleading information. In reality few pieces of communication, written or visual, are totally devoid of propaganda content or intention. (pp. 1–2)

Another way of thinking about this is the philosopher Louis Althusser's notion of ideology, which is imbued in day-to-day activities and social relations and acts upon people 'by a process that escapes them'. Ideology is 'a system (with its own logic and rigour) of representations (images, myths, ideas or concepts, depending on the case) endowed with historical existence and role within a given society' (Althusser, 1969, p. 231).

Photojournalism often links to underlying ideals. For example, in January 2021 a broad coalition of right-leaning President Trump supporters stormed the United States Capitol building (where elected officials debate and vote on laws). The photographs of the event, especially of the protesters inside the building, were widely propagated by the mass media and social media to show the unfolding of events as a chronology, as a visual story of a mob attack upon the seat of democracy and representative processes which were disrupted, and as a symbolic warning of democracy under threat.[24]

DOCUMENTARY PHOTOGRAPHY

In the mid-nineteenth century, photography began to be used as a means to reveal the circumstances in which different people lived. For example, Henry Mayhew used photographs to inform the illustrations used in his *1851 London Labour and London Poor*, which combined observation with interviews and political and social analysis. Following rapid urbanisation which put the infrastructure of cities under stress, Glasgow City Council commissioned a photographer to document the poor housing conditions of its old town, especially its closes and wynds following the 1866 Glasgow City Improvement Act. The photos taken of old Glasgow by Thomas Annan (1829–1887) between 1868 and 1871 helped to justify the demolition of parts of the city, which were being bought up by The City Improvement Trust. Some nineteenth century reports suggest that this was the worst slum in Britain; it was certainly

very overcrowded, due to unscrupulous landlords. There were also instances of many individuals living together in houses that had been condemned as unsafe, where rent could not be levied.[25] One in ten houses were reported by census to have been spirit shops, and alcoholism was an important cause of mortality.[26] Nearly a quarter of people inhabiting the old town were recorded as dying of typhus fever, exacerbated by unsanitary conditions.[27] A great deal of housing was in dire need of 'drainage, cleansing and ventilation'.[28] Friedrich Engels (1958) summarised some of the contents of House of Commons Select Committees in his *The Conditions of the Working Class in England* (1845):

> I have seen human degradation in some of its worst phases, both in England and abroad, but I can advisedly say, that I did not believe, until I visited the wynds of Glasgow, that so large an amount of filth, crime, misery, and disease existed in one spot in any civilised country. The wynds consist of long lanes, so narrow that a cart could with difficulty pass along them; out of these open the 'closes', which are courts about fifteen or twenty feet square, round which the houses, mostly three or four storeys high, are built; the centre of the court is the dunghill, which probably is the most lucrative part of the estate to the laird in most instances, and which it would consequently be esteemed an invasion of the rights of property to remove. In the lower lodging houses, ten, twelve, or sometimes twenty persons, of both sexes and all ages, sleep promiscuously on the floor in different degrees of nakedness. These places are generally, as regards dirt, damp, and decay, such as no person of common humanity would stable his horse in. (pp. 45–46)[29]

Annan's albumen prints now constitute an important historical document of the architecture and were intended to record for posterity those areas due for demolition. Sadly, the poor, mainly Irish immigrants and Scottish highlanders, were largely just displaced, moving to other degraded conditions elsewhere in the city. Annan's photographs did not focus on the inhabitants, though sometimes they would congregate and be included. Evans (2018) confirms

Fig. 9. Close, No. 65 High Street by Thomas Annan (© Getty Open Content).

Annan's intentions were not social or political, but focussed on the commission of documenting the architecture, but in so doing he created a detailed social documentary. Annan's sons later published a set of prints entitled *Old Closes and Streets of Glasgow* in 1887.

In their book, *Street Life in London*, Adolphe Smith and John Thomson (1877) included facsimile reproductions of Thomson's photographs, in chapters exploring different groups of London's working class such as London Nomads;[30] London Cab Men; Covent Garden Flower Women; Recruiting Sergeants at Westminster; Public Disinfectors; Street Doctors; Crawlers (destitute beggars); Covent Garden labourers; Italian Street Musicians and so on, with a pseudo-sociological feel. The book gives an overview of these different inhabitants. The photographs are illustrative; in this case a picture of a caravan with a group persons sitting in front of it, and here is an example of the textual accompaniment to the Nomads section:

[...] in most civilised communities the wanderers become distributers of food and industrialised products to those who spend their days in the ceaseless toil of city life. Hence it is that in London there are a number of what may be termed, owing to their wandering, unsettled habits, nomadic tribes The wares also, in which they deal are almost as diverse as the families to which the dealers belong. They are the people who would rather not be trammelled by the usages that regulate settled labour, or by the laws that bind together communities. (Smith, 1877, p. 1)

The combination of images and text gives an interesting insight into these different subcultures.

In Ireland, Jane Shackleton (1843–1909) developed an interest in photography in the 1880s and her work captures local industry and processes of industrialisation, decrepit housing and the stark simplicity of the life, most notably that of the Aran Islands.

More self-consciously political, Jacob A. Riis (1890), a Danish born police reporter on New York's Lower East side, documented slum life and slum conditions for immigrants in New York and used drawings based on the photographs and 'half-tone' photographs in his first book, *How the Other Half Lives*.[31] The ability of photography (including flash photography to capture interior scenes) to reveal degrading and dangerous working and living conditions was powerful. Some of the images still have the capacity to shock the viewer today. Middle-class ladies were said to have fainted when Riis used photographic slides in his public lectures. The US President Theodore Roosevelt was spurred into action after having viewed the book.

Also in the United States, American Sociologist Lewis Wickes Hine is notable for having photographed child labour, including shocking scenes taken in the early 1900s of children breaking coal by hand, and working in cotton mills. From 1908, he was engaged by the National Child Labour Committee to document the working lives of children, and his work helped to spur momentum for legislation (the Fair Labour Standards Act of 1938). Human rights organisations also seized on photography to help campaign for

social reform, illustrating unhealthy and unsanitary conditions in both urban and rural locations. For example, in the United Kingdom, The National Society for the Prevention of Cruelty to Children had a formal role to bring prosecutions for neglect and cruelty under the provisions of the *Prevention of Cruelty to, and Protection of, Children Act* (1889), and produced shocking photographs of malnourished infants in its work against 'baby farms' in the latter part of the nineteenth century. These were a form of crèche in which infants were often drugged with opiates to keep them sleepy whilst the parents worked. They were also repositories of unwanted, often illegitimate children, who were allowed to perish via neglect and disease through a process of 'selective mortal neglect' (Hogan, 2020c). The photographs produced in the nineteenth and early twentieth centuries of wasted and half-starved babies and infants pricked social conscience.

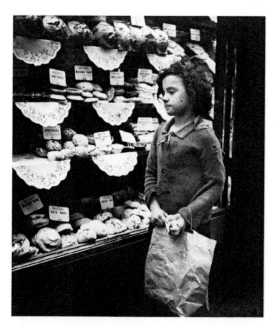

Fig. 10. Edith Tudor Hart. Child Staring into a Bakery Window, Whitechapel, 1935 (Courtesy of National Gallery of Scotland) Poverty in London Series.

The preoccupations of documentary photography in the nine-teenth century continued into the twentieth century, presenting dominant subject matter – war, colonial peoples, workers and the poor. Photographers such as Austrian Edith Tudor Hart (1908–1973) photographed the poor of South Wales, Tyneside and London's East End in the 1930s, with social reform as her aim. She had become a committed communist and used photography to reveal the desolate living conditions in which so many people lived. She supplied the Left Book Club and Picture Post with photographs. Her most popular photograph, taken in the 1930s, is of a little girl, ragged and dishevelled, looking longingly at a cake shop window – fancy cakes, the viewer presumes, she cannot afford to taste.

Amongst the most startling and disturbing photographs must surely be those made of the emaciated survivors and the dead of the Nazi concentration camps, and their haunting material remains – the plaintive stacks of suitcases, or piles of shoes – remnants of those gassed and buried in mass graves. These photographs act

Fig. 11. Fritz Klein, the Camp Doctor, Standing in a Mass Grave at *Bergen-Belsen After* the Camp's Liberation by the British *11th Armoured Division*, April 1945.

as proof and reproach, and continue to serve as a reminder of a mass catastrophe caused by the triumph of racism over humanity, underpinned by eugenic theories.[32] The images are a warning of the profound inhumanity that humans are capable of, collude with, or willing to turn a 'blind-eye' to.

Fig. 12. A View of the Ceiling at the Hall of Names at the Yad Vashem Holocaust Memorial Museum in Jerusalem. International Holocaust Remembrance Day. Photograph: © Ludovic Marin.

Some documentary photographs have become famous in their own right and we recognise these iconic images, even if we do not know the photographer's name. The most famous documentary photograph in the world has been suggested as one by Dorothea Lange (1995–1965), who is said to have humanised America's great depression, discussed below. However, Associated Press photographer Nick Ut's (1972) iconic photograph of a little girl screaming in pain following a Napalm attack must surely also be a contender for this accolade of most famous photograph. Dubbed *The Terror of War*, this and other press photographs of the civilian casualties of the Vietnam War, helped to mobilise anti-war sentiment in the 1970s. The picture shows a group of children in great distress, fleeing a burning village behind them. At the centre is nine-year-old naked Kim, screaming in agony. This little girl had third-degree burns covering 30% of her body (sometimes the

photograph is cropped so that the photographers on the periphery of the photo have been edited out of frame, so she is shown as if alone with the other children). The photographer was instrumental in getting medical treatment that saved the girl's life. Though we may not remember the photographer's name, many of us would recognise the image, which won a Pulitzer Prize and which continues to serve as an example of the personification of the horrors of war.[33]

Liz Wells (2004) suggests *Migrant Mother* might be the most reproduced photograph in history; it is certainly, she declares, one of the most famous photographs of the twentieth century. In 1918, Dorothea Lange decided to travel, earning money along the way by selling her photographs, ending up in San Francisco where she began to photograph the unemployed. Her work caught the attention of various administrative bodies, including agencies of the US Agriculture Department, which commissioned further work by her to raise awareness of the conditions of the rural poor. She is best known for her photograph of a pea picker, entitled *Migrant Mother*, which was commissioned by the Farm Security Administration (FSA). The FSA commissioned documentary photography and acted as a photo agency in supplying images for photojournalistic uses. The photographers commissioned by the FSA relinquished control of their images, and had no jurisdiction over the captioning, cropping or use of their images.

Fig. 13. Nick Ut The Terror of War 1972 © Creative Commons.

The unnamed woman was described as 'hungry and desperate'. Lange (1960) says 'they had been living on frozen vegetables from the surrounding fields, and birds the children killed' (p. 264). The original title of the image was 'Destitute pea pickers in California, a 32 year old mother of seven children, February 1936' which has gravitas, but not the singularity of the more simple title. Multiple interpretations of the image have been made. Mother and child is a powerful image (with an ancient heritage in Christian and other art). *Migrant Mother*, which became famous out of the set of photographs taken of her with her children, does not show her new baby, but her more mature children, allowing the viewer to imagine her as celibate, and non-sexual, connoting the Virgin Mary. One commentator suggested of the image that:

> She is appropriated within a symbolic framework of significance The central position of the mother, the absence of the father, the direction of the mother's 'look', all add to the emotional and sentimental register through which the image works. The woman is viewed as a symbol larger than the actuality in which she exists. (Clarke, 1997, p. 153)

That is certainly true in this case, as the image featured as a US postage stamp as illustrating the 1930s as a decade. Commentators suggest that empathy is generated by the context of the 1929 economic crisis of America and subsequent depression – she, the unnamed woman, is a victim of systematic economic, social and political failure. Indeed, the FSA is suggested to have used photography ideologically to create rhetoric of American under threat. Roberts (1998, p. 85) says of the image,

> [...] the way the image was cropped and contextualised reveals how much the image of a damaged femininity came to symbolise the crisis of community for the American public. Anxious and in obvious poverty, the woman holds on to her two children, suggesting the power of maternal values to overcome the most dire of circumstances. Here is a woman who has lost everything, yet heroically, stoically keeps her family together. Here in essence was what

the magazine editors were waiting for: an image if tragedy AND resistance.

Liz Wells (2004, p. 41) notes that she was tracked down a number of years later to her trailer home in Modesto, California and interviewed by United Press:

> One of the twentieth century's most familiar and telling images was recuperated as an ordinary, aged woman who was poor in a humdrum way no longer able to function as an icon of nobility and sadness in the face of destitution.

At the same time (1936), James Agee and Walter Evans (1941) were researching the lives of impoverished tenant farmers for an article and this led on to the publication of the book *Let Us Now Praise Famous Men* which described the lives of Alabama sharecroppers

Fig. 14. Migrant Mother by Dorothea Lange 1936. © Creative Commons.

during the depression and included Evans's stark, yet elegant and beautifully composed photographs showing the degraded conditions of the farmers. Acclaimed by Blake Morrison as one of the 'most compelling and influential books of the depression era', it is the combination of prose and images that makes this book such a powerful testament. Later in the twentieth century, in the United States, William Klein (b. 1928) used a wide-angle lens to produce compelling New York street scenes.

In Britain, in the twentieth century and running into the present day, there has been a very strong documentary photography movement capturing the lives of working people in brutal, but often empathetic, detail. Themes include the harshness of day-to-day life and unemployment, set in impoverished, industrial landscapes, often in the north of England. Repercussions of social change are explored as an overarching theme. The, mainly black-and-white, social documentary photography of John Bulmer (b. 1938), Chris Killip (1946–2020), Don McCullin (b. 1935) and Tish Murtha (1956–2013) capture, in different ways, distinctive aspects of the stunning deprivation that many experienced in Britain in the twentieth century. Killip offers a detached commentary on processes and effects of deindustrialisation. Murtha, in contrast, captures some of the intimate details of working-class life in Newcastle in a social-realist style, seemingly as an insider.

Some extremely distinctive work by Tony Ray Jones (1941–1972) captured quirky aspects of British life, highlighting the bizarre of the everyday. His work sought to capture the 'aura' of the commonplace, but his portrayal of the 1960s renders it peculiar. He said of his work:

> I have tried to show the sadness and the humour in a gentle madness that prevails in a people. The situations are sometimes ambiguous and unreal, and the juxtaposition of elements seemingly unrelated This, I hope helps to create a feeling of fantasy. Photography can be a mirror and reflect life as it is, but I also think that perhaps it is possible to walk, like Alice, though a Looking-Glass, and find another kind of world with the camera. (1965, n.p.)[34]

Influenced by this work, highlighting the more strange aspects of the everyday of the working class at play, Martin Parr (b. 1956) uses close-ups and intense colour, using a ring-flash placed directly in front of the lens in order to saturate the subject with intense shadowless light. Although his work is sometimes rightly described as satirical, it might also be argued in some ways to reaffirm a working-class identity deracinated by neo-liberal values. Odd aspects of British culture and behaviours are underlined in many of his works and for this reason the photography is said to have an 'anthropological' quality. He manages to de-familiarise social norms and customs in ways that render them curious. Similarly, the work of Neil Bailey (b. 1963) captures aspects of the 'normal' as bizarre, but often with a more deadpan lens, sometimes contributing a disturbing quality to the work.

Fig. 15. Holiday Makers. Neil Bailey 2019. (Original in Colour.) © Neil Bailey.

Documentary photography can capture important historical moments, such as this photograph of Iranian women protesting on the last day before it became illegal to leave the house without wearing a hijib (head covering) on 8 March 1979.

* * *

Fig. 16. Hengameh Golestan b. 1952. Untitled from the *Witness 1979* Series, March, Tehran © Hengameh Golestan, Courtesy of Archaeology of the Final Decade (Original in Colour).

PHOTOGRAPHY IN ANTHROPOLOGY

The latter part of the nineteenth century saw major consolidation of global European power, bringing Europeans (and those of European heritage) into contact with people from different cultures in unprecedented ways. From around the 1860s, these cultural differences began to be recorded photographically, both informally and deliberately. Anthropology remains 'a highly visualised practice' which 'has resulted in a rich photographic legacy, both intentional and incidental' (Morton & Edwards, 2009, p. 1). Indeed, 'photographic practices *were* central to anthropological endeavour' in producing useful anthropological data (Banks & Vokes, 2010, p. 1). Early anthropologists were also of this view; in 1876 Tylor (who went on to hold the first ever academic appointment in anthropology, at Oxford) wrote 'the science of anthropology owes not a little to the art of photography' (p. 184). Crucially, 'photography was viewed largely as a simple recording truth-revealing mechanism' (Edwards, 1992, p. 4).

Early anthropological photography emerged into a period in which our understanding of evolution was just emerging as the dominant paradigm, but the mechanisms by which inherited traits

are shared were utterly unknown. The idea that racial 'types' are immutable was popular.[35] Disturbing to the modern eye are some of the early photographs concerned with measuring and recording racial variations, in which native people are photographed and recorded in much the same way as specimens of flora and fauna. Anthropology 'adopted much of its method from the biological sciences, the stress being on observation, recording and classification' (Edwards, 1992, p. 6). Photographs were also taken of exhibited living people, who were brought over to create ethnographic shows for the great exhibitions, which became popular, not just as amusement, but that were regarded as having educational value in informing the British public about 'others' on Earth. These living exhibits became very popular as post cards, often in the form of portraits, or depicting small groups. Street (1992) suggests there was a drift away from the educational emphasis throughout the nineteenth century:

> At first the exotic peoples were asked simply to carry on their daily routines for the viewing public, but later the financial necessity of drawing large crowds led sponsors to emphasise the unusual or bizarre in response to the public's wish to be entertained. (p. 122)

Street notes that in the early twentieth century, official bodies began to take exhibitions out of the hands of commercial impresarios, but none the less an emphasis on the 'bizarre' continued to run through trade fairs, such as the Japan–British Exhibition of 1910. However, as well as creating and perpetuating myths and stereotypes with an unhelpful emphasis on exotica, photography was also seen as having the power to combat reductive oversimplifications about race. For example, Tylor (1876) asserted that photographic evidence could 'check rash generalisations as to race ... by impressing on the minds of students the real intricate blending of mankind from variety to variety' (p. 184).

Much anthropology was ethnographic in focus. Ethnography is a branch of anthropology concerned with research based on direct observation and documentation of different peoples' ways of living. Its focus is on understanding the meaning of culture. Ashcroft, Griffiths, & Tiffin (2007) provide a clear description of ethnography:

It is the basic methodology employed by cultural anthro-
pologists and consists of two stages: fieldwork, which is the
term used for the process of observing and recording data;
and reportage, the production of a written description and
analysis of the subject under study. Historically, ethnogra-
phy concerned itself principally with recording the life and
habits of peoples from societies not the observer's own –
usually distant locales, distant, that is, geographically or
culturally from the West, and seen as different from the
normative European cultures. Anthropology began as a
kind of natural history, a study of the peoples encountered
along the frontiers of European expansion. (p. 79)

Bronislaw Malinowski used photography in his ethnographic
fieldwork in the Trobriand Islands, Southeast Papua New Guinea,
from 1914 to 1918 as part of his participant observation method.
The photographs depicted housing, dress, customs and other
aspects of daily life. Elizabeth Edwards (2015) notes an increas-
ing concern of anthropology with the explanation of whole cul-
tural systems and understanding all facets of the culture. Edwards
(2013) sums up of the relationship between early anthropology
and photography:

Anthropology's relationship with photography was part
of a broader practice of visualization within an emerg-
ing modern science Photography in anthropology was
premised on the idea of the camera as a mechanical eye.
However, this practice emphasized increasingly the direct
observation of not just bodies but cultural practices. With
the professionalization of anthropology from about 1900,
new methods demanded new visualizing practices that
could deliver the desired data in certain ways. There were
different national emphases within these practices, such as
the tradition of individual fieldwork established in Britain
by the second decade of the 20th century, notably in the
work of Bronislaw Malinowski (1884–1942), while the
'expedition' model was longer lived in France ... these
approaches were premised on the immediacy of observa-
tion by the trained eye. In effect the camera became an

extension of the experience of the fieldworker and an ancillary activity of anthropological observation.

Early photographic work by Evans Prichard she notes as moving close to the centre of action of cultural activity, and thus photographs

> become privileged sites for communicating a feeling of cultural immersion. They mark the personal experience of fieldwork, giving authority and credence to an account of what could have been seen. (Edwards, 2015, p. 242)

Edwards (2015) also points out that photographs are important sites of interaction in the field: 'They oil the wheels of fieldwork in acts of friendship, exchange and diplomacy, and they stand for a communication in shared time, even in the contexts of political asymmetries' (p. 243). So, in other words, as well as providing interactive opportunities during the actual production of images, in early anthropology the photographs themselves became important, and were given as gifts as tokens of friendship and thanks. Edwards (2015) uses the term 'exchange objects': photographs 'facilitated social relationships across space and time' (p. 243). Edwards (2013) notes the changing role of photographs as the emphasis of anthropology shifted,

> [...] the major anthropological emphasis shifted to understanding cultural rather than racial difference, and the study of how human societies negotiated their physical and spiritual worlds. Photographs 'of culture' no longer constituted a serendipitous collection of visual facts, such as wearing masks, making hand axes, or climbing trees – all recurrent tropes of early anthropological photography. Rather, photography became integrated into the practices of field anthropology, recording images of rituals, everyday practices, and people, as in the photographs of British anthropologist E. Evans Pritchard (1902–73) in southern Sudan However, little analytical weight was given to photographs themselves. They were effectively recording tools that could authenticate observation and legitimate

analysis. There were notable exceptions, in particular the 1936–8 work of Margaret Mead and Gregory Bateson on socialization and child development in Bali. In the course of this work they produced over 25,000 photographs in addition to film. Central to their project was the idea that carefully managed, yet apparently unmediated photographic recording could be used to both formulate and answer anthropological questions.

* * *

PHOTOGRAPHY AS ART

The photograph as art took many different forms, sometimes involving themes and elements taken from the tradition of oil painting. Liz Wells (2004, p. 17) emphasises the representational importance of photographs:

> Photographic aesthetics commonly accord with the dominant modes and traditions of Western two-dimensional art, including perspective and the idea of a vanishing point. Indeed, as a number of critics have suggested, photography not only echoes post-renaissance painterly conventions, but also achieves visual renderings of scenes and situations with what seems to be a higher degree of accuracy than was possible in painting. Photography can, in this respect, be seen as effectively substituting for the representational task previously accorded to painting.

From the 1850s, 'pictorial photography' experimented with photographs that resembled paintings in their composition or technique for picturesque results. For example, an image might be,

> out of focus, slightly blurred and fuzzy; 'they made pictures of allegorical subjects, including religious scenes; and those who worked with the gum bichromate process scratched and marked their prints in an effort to imitate something of the appearance of a canvas. (Wells, 2004, p. 14)

Not everyone liked these developments. The famous critic Baudelaire, for example, thought that photography should confine itself to aiding professional activities that could benefit from accurate recording, as did Ruskin. Others, such as Eugene Delacroix, used photographs as an aide-memoire in his painting process, thought photography soulless. Baudelaire (1859) argued that art 'diminishes its self-respect' by attempting realism, suggesting that painters should paint what they dream, rather than reproduce what they see (p. 154). Warner Marien's (1997) cultural history of photography suggests that many nineteenth century artists regarded photography as prescribing 'a dogged and enervated imitation of the real' (p. 70). But more than this, photography was seen as in contradiction to faith; she posits that, 'Baudelaire and Ruskin understood photography as a multivalent metaphor. To champion photography was not simply to stand for realist representation, but to embrace positivism' – science rather than religion (Warner Marien, 1997, pp. 64–65).

A 'high-art' photography was attempted by some, with an emphasis on purifying and instructing through didactic homilies for spiritual edification. Warner Marien (1997) argues that high-art photography can be viewed as another of the nineteenth century's 'social betterment schemes' – whilst not evincing superior creativity, such photography might try to improve society by influencing the viewing public (p. 87). In an age in which sensationalist novels were very popular, some photographers attempted to produce narrative images, images that suggested an unfolding drama. These might be staged shots, or might employ combination printing, which was a montage-like technique in which several images were combined into one whole, often producing a slightly stilted effect.

In a different vein, Lady Elizabeth Eastlake (1857), an author, critic and photographer, saw it as a 'new medium *creating a space between other mediums*' (p. 93, my italics). The studies of photography are 'facts' but 'facts which are neither the province of art nor of description, but that new form of communication ... neither letter, message, nor picture – which now happily fills the space between them'.

So as we can see, during the nineteenth century photography became important. Eastlake (1857), again, summarises thus,

it is used alike by art and science, by love, business and justice; is found in the most sumptuous saloon and the dingiest attic – in the solitude of the Highland Cottage, and the glare of the London gin palace – in the pocket of the detective, in the cell of the convict, in the folio of the painter and architect, among the papers and patterns of the mill owner and manufacturer and on the cold breast of the battle field.

In the twentieth century, the writer Andre Breton tried to develop a technique based on free association in psychoanalysis where the mind is put in a receptive state and writing occurs spontaneously. He called this 'automatic writing'. When experimenting with this technique he noted, 'But the most serious obstacle to surmount... is the continual irruption of purely visual, and therefore incommunicable, elements in the verbal flow' (Breton, 1924 cited Hogan, 2001, p. 95). Drawing on the idea that the unconscious mind – that is thought freed from logic and reason – could be depicted pictorially without a preoccupation with aesthetic or pictorial norms, revealing 'the real process of thought', the Surrealist art movement used photographs in collages, which scandalised and shocked perception at the time. The work produced had odd juxtapositions, impossible differences of scale of objects that create a weird or disconcerting jumble, or were simply bizarre (Andre Breton, 1924 cited Hogan, 2001, p. 94). For example, a woman stands in Trafalgar Square, surrounded by pigeons, but in place of a head she has a flower. Today, in the age of digital editing, such works seem less surprising, even trite, but were certainly astonishing at the time first produced. At around the same moment, photo-montage for political purposes took off (though a form of photo-montage, or composite photo, had been used previously as early as the 1880s). A pioneer and exemplar of photo-montage, John Heartfield worked for the German communist press producing visual anti-Nazi propaganda in the form of posters. Berger (1967, p. 23) notes that between 1927 and 1937 Heartfield became internationally renowned for the wit and potency of his photo-montage posters and cartoons.

THE RISE OF THE FAMILY ALBUM

The twentieth century saw the growth of the popularity *of the family album*. This compilation of photographic prints represented the self-identity, and even the ideals and aspirations, of families across the United Kingdom and beyond. Family albums would form a talking point within families and served as something to show visiting friends and relatives to stimulate conversation and reverie. Getting out the album was a cultural norm. As a cultural practice, it was very important and fashionable throughout the twentieth century. Some families might have their latest album on permanent display on a stand or sideboard, so that visiting guests might peruse it at their leisure, rather than waiting for the host to share it, though more commonly the book would be brought out by the host. The album was often regarded as a very precious object; it imbued the essence of the humans involved. It might be one of the objects hastily snatched up in a fire and the deliberate destruction of a family album would be regarded a heinous act. Such an act would be regarded as a form of assault. Susan Sontag (1979) notes that photography became a family rite.

> As that claustrophobic unit, the nuclear family, was carved out of a much larger family aggregate, photography came along to memorialise, to restate symbolically, the imperilled continuity and vanishing extendedness of family life. These ghostly traces, photographs, supply the token presence of the dispersed relations. A family's photographic album is generally about the extended family – and, often, is all that remains of it. (p. 91)

Rather eloquently, Sontag (1979) goes on to suggest that all photographs are *momento mori*:

> To take a photograph is to participate in another person's (or thing's) mortality, vulnerability, mutability. Precisely by slicing out this moment and freezing it, all photographs testify to time's relentless melt. (p. 15)

Whilst it is true that old albums might depict the lost extended family as part of their role, the most recent family album was very

much a statement about the here and now: the family's self-representation and current activities, especially non-routine events, such as holidays, or rites of passage (births, birthdays, graduations, etc.). Indeed, the way guests were unable to avoid being shown the family albums became a bit of a cliché, especially when it became a show-and-tell performance with a slide projector.

In some families, just one person (a parent) would take the photos and children might not be allowed to touch the camera, let alone express themselves by taking pictures (though 'disposable' cameras which briefly emerged in the 1970s changed this, and allowed children to have a go; these were a roll of film in a fairly flimsy plastic camera for one-time use). Ideals and aspirations underpin the family album. It is a document, which may conceal more than it reveals, in terms of family dynamics and may be quite orchestrated. What or who is left out may be very significant. As Anne Higgonet (1998, p. 90) notes regarding the depictions of children 'no tantrums, tears, or bruises, no mess, no pleading, no failures, no conflicts, no resistance, few if any expressions except smile'.

Martin (2009, p. 40) elaborates, stating that that traditional family album is an ideological construct:

> Editorial control is held by the archivist, usually the mother, whose preferences are shaped by an unconscious desire to provide evidence of her own good mothering. The conflicts and power struggles inherent within family life are repressed. Like a public relations document, the family album mediates between the members of the family, providing a united front to the world, in an affirmation of successes, celebrations, high days and holidays, domestic harmony and togetherness. It is bound within established codes of commemorative convention, so ubiquitous that they are taken for granted, even minutely reconstructed and sold back to us in advertising campaigns.

However, many families did not possess a camera, so made pilgrimage to a local photographic studio for a family photograph, to update images of the children's growth or to depict a new baby. These studio photographs might become an important link with

family members abroad, particularly for migrant families, who might still have grandparents in the Caribbean, for example.

For those families who possessed a camera, producing photos in the predigital area meant posting the role of film, or dropping it into a local chemist, to be developed and then waiting for the return of the prints. Then a process of selection would take place, as not all images would find their acceptance into the album (many prints were thrown away, as blurry, unflattering or otherwise unsatisfactory – note Martin's remarks). Sontag (1979) points out that one of the functions of the album was to authenticate family holidays, as they became more of a social norm, but also that the *task* of documentation began to function as a form of labour to assuage guilt for having leisure: in cultures with an unrelenting work ethic it becomes a job to be undertaken, that of recording the event:

> It seems positively unnatural to travel for pleasure without taking a camera along. Photographs will offer indisputable evidence that the trip was made, that the program was carried out, that fun was had. Photographs document sequences of consumption carried on outside the view of family, friends, neighbours. (p. 9)

Gillian Rose (2011) notes the way the family album, as a physical thing, has become a defunct concept in the twenty-first century, with family photographs becoming mobile and more public, being displayed in multiple domains from coasters to T-shirts:

> It is necessary to acknowledge the complexity of family photographs both as images and as visual objects with which a range of things are done, if we are to understand their current mutations. Family photography is going digital, which is enabling some new things, while much is staying the same. Family photography is also going public in ways it has not been before. Increasingly, family snaps are leaving the domestic realm and entering other spaces of circulation and display… Now, family photographs have always travelled between family members. And, of course, some family snaps have long been visible in more public places. Framed photographs sit on many an office desk;

in several Europe countries, it is taken for granted that a family photograph will embellish a gravestone. In the UK, such practices have been less popular until recently. However, in the past few years it seems that ... family snaps are entering public spaces of display more and more often. Once mostly restricted to being looked at only by the family and friends of the people pictured, family snaps are now visible more and more often to the gaze of strangers. Increasingly they are appearing on gravestones; they are uploaded onto social networking websites; they are printed onto shopping bags and t-shirts; they are published frequently in the mass media. In this sense, family snaps have gone public. (pp. 5–6)

As well as the importance of the family albums, photographs began to adorn people's homes; indeed, to enter a family home and not find a photograph on display would still be somewhat unusual, even today. Hurdley (2006, p. 721) notes the mantle piece as the main focus of the room and the place where photographs are most likely to be displayed.

The mantelshelf provides a formal structure for this display, a highly traditionalized and normalized form of revelation, which, like the 'once upon a time' narrative motif, can be conceptualized as a formal structuring devise. These devises are not necessary for narrative or aesthetic accomplishment. In reading the poetics of living rooms, however, mantelpieces do predicate and delineate display space at the room's central point, in a way that perhaps no other architectural convention has done.

So, with the caveat that modern homes do not always have a mantelpiece, it has been the case that the photograph has assumed a dominant position in most homes, especially during the twentieth century.

Before moving on to the digital, the environmental consequences of film-based photography should be noted. Photography has always involved the use of heavy metals. Kodak Park (the industry giant, founded in the 1880s) had on-going problems with toxic

chemicals being found in groundwater under local residences around their 2,200-acre industrial complex in Rochester, New York (McKinley, 1994). On another occasion, carcinogens leaked into the local environment near a school and was reported in the *New York Times*,

> at the southern border of Kodak Park, an industrial tableau of grey smokestacks and thick white plumes. A pipe ruptured there in late December, spewing out about 30,000 gallons of methylene chloride – a solvent used to make film and a suspected carcinogen – and raising questions about possible health risks at the school. (Foderaro, 1989, p. 1)

<p align="center">* * *</p>

DIGITAL PHOTOGRAPHY AND THE RISE OF SOCIAL MEDIA PLATFORMS

From the start twenty-first century, mobile-phone technology incorporating *digital cameras* made photography both pervasive globally and democratic. Digitisation also changed the way we take photographs, concentrating less on just special events, with any scene potentially documented by more than one of its participants. As Gómez Cruz and Lehmuskallio (2016, p. xix) note, 'Cameras are being called upon to see and "capture" more of the world, of everyday life, than ever before'. They also note that even before digitalisation, picture taking per household had been on the rise, but that digitalisation meant that photography became less compartmentalised, no longer with one person assigned to the role of 'family photographer' (p. xviii). Digital photography is not a unified phenomenon but a plurality of practices. Nevertheless, photography remains a predominant mode of commemoration, especially of significant events, such as a graduation or a wedding. Indeed, the ritualistic aspects of the wedding photography may have become a central focus of the day for many couples.

Ubiquitous mobile-phone technology has changed the way we take photos, allowing us to make instantaneous decisions about

which photos to keep and which to lose. Most mobile-phone cameras now enable us to take several photographs very quickly in a burst, producing a choice of several almost identical shots and a potentially ideal selfie. We can choose the 'best'. Digital photography has also changed the social relations around taking pictures. As Lister (2016, p. 271) points out:

> Where the viewfinder once conferred a privileged separation on the photographer, the digital screen is likely to prompt a fair degree of social exchange between photographer and photographed, which takes place around the very act of photography. Moreover, on the same screen, the photographer, and those photographed, can view an almost instantaneous 'play back' of whichever Image is chosen. In short, the choosing or conception, the exposure, the storing, and the display, all take place within [or in relation to] the digital camera. With Internet connectivity and the downloading of photographic 'apps' ... the distribution and, to a degree, the processing of the photographic image can be added to this list.

Uimonen (2016, p. 21) suggests that the rise of smartphone has stimulated 'relational' practices centred on 'expression and dialogue', rather than 'collection and recording'. Mobile photography in Tanzania, she suggests, is

> exemplified by the preferences for the pictures of the self taken by others, rather than selfies. Similarly, the performativity of photography continues to be a striking characteristic, building on cultural preferences for ideal selves rather than everyday shapshots.

The physical photo album has been displaced as a primary mode of exchange by social media platforms. *Facebook*, launched in 2004, has 2.8 billion monthly active users. Profile and cover pictures have become an important aspect of self-presentation, even self-interrogation. These 'front' images can be used in different ways, with some individuals maintaining a clearly recognisable unchanging identity – a 'brand' identity, and others frequently

changing their profile and cover shots to reflect changing moods and circumstances and to stimulate further interactions with friends. Objects or fantasy images can also be used as self-representations. Posts appear on a timeline. Facebook permits sharing of images on one's timeline with 'friends' (with optional accompanying explanatory commentary), allowing friends to respond in a variety of ways, with remarks, images, 'likes', – a form of acknowledgement rather than literally 'I like this' per se (or, more recently, with other automatic suggested responses including sad and angry faces – as the 'like' response was counter-intuitive when applied to images of hardship, or horror). Getting almost instant responses to photographs from friends is gratifying, whilst a lack of response can prove unsettling, or to sensitive teenagers, even devastating. Sadly, there have been instances of young people sending a cry for help out on Facebook and upon getting no responses, proceeding to self-harm or to commit suicide. Settings can be altered, but most users allow themselves to be 'tagged' in others' photos, and these images of themselves in social settings are automatically shared to their own timeline and friends, with potentially embarrassing consequences.

Photo sharing is a central aspect of Facebook and images can also be congregated in 'albums'. Facebook is more than a real time photo album because of the interactive dimension, the increased use of text, the fact that debate can take between several friends around an image, and the fact that posts can be edited or deleted with ease, without this being evident on the timeline (unlike a traditional album where a gap would be obvious, even noteworthy). Indeed, the wall can be curated and re-curated with ease. Furthermore, posts can be shared beyond ones friendship group (depending on the account settings in place) which means that millions of people might end up appreciating a particular photo. Indeed, digital photography can be seen as a mobile medium. Anthropologist Sarah Pink (2016, p. 189) urges us to think about movement:

> As images move through the world, they become interwoven in new stories, and those people who engage with them, take them up and journey with them some way, and they become part of new 'stories' ….

Unfortunately, photographs can deceive. Facebook has been used for the online cultivation of friendships with children by paedophiles, who assume a false identity and otherwise deceive, or 'groom' vulnerable children and teens. Bullying has also taken place on the platform. Although it is too strong a statement to say that Facebook has a societal policing function, it is certainly the case that public behaviour and public actions are likely to be reported to Facebook by friends with unavoidable consequences. There are also cross-cultural difficulties with Facebook. Different societies have different norms about what is acceptable and unacceptable. For example, Dubai has laws, which make it a criminal offence to post insulting or defamatory words on social media, which has led to British nationals being arrested for seemingly innocuous Facebook posts, whilst abroad. On the other hand, Facebook is able to share coverage of events overlooked by mainstream media, captured in photographs and film, and it may be argued that it serves a very useful social purpose in this way, beyond the individual's account in providing evidence for actions and behaviours of political regimes, which are denied or covered up. Police brutality towards people of colour in the United States, and violence against Palestinian people by the Israeli military are examples where video footage and photographs promulgated on Facebook have produced and brought irrefutable evidence of illegal and immoral behaviours to public attention. Sousveillance (watching from below) has been coined as a term for this activity, whereby events are recorded by small portable personal technologies. Sousveillance has been described as

> the monitoring of authorities ... by informal networks of regular people, equipped with little more than cellphone cameras, video blogs and the desire to remain vigilant against the excesses of the powers that be. (Hoffman, 2006, n.p.)

It is the collective nature of Facebook testimonies, and sousveillance in general, that can make it difficult to refute, so it is a powerful platform for potential good.

On the other hand, faked photos are also increasingly prevalent. Indeed, now that images can be faultlessly altered, a loss of

confidence might be anticipated in photography as a medium, but viewer awareness of the importance of context (some contexts being more reliable than others, with 'fact checkers') or the collective nature of several testimonies together, combine to preserve the overarching confidence in the medium as a conveyor of truths. Furthermore, fake images are often exposed and publicised as fake when discovered and denounced.

Another major platform, Twitter, enables users to post messages (called tweets) of up to 140 characters, with uploaded pictures and video links. Twitter operates on the basis of non-reciprocal 'following'. There are many social networking sites active now. Flickr hosts images, and allows users to follow one another and comment on the images creating 'communities of practice' (Wenger, 1998). Private messages can also be sent. Flickr has a more relaxed censorship policy than Facebook, allowing a wider range of imagery to be reproduced (Facebook tends to censor any nudity in a fairly indiscriminating manner). Images are classified as one of three categories: 'safe', 'moderate' and 'restricted' in order to separate family-friendly and pornographic, or otherwise disconcerting content. WhatsApp (2009), Instagram (2010) and Snapchat (2012) are simpler ways of communicating images to others, incorporating the opportunity to send an image and comment instantaneously and are favoured by younger people, being faster to use than Facebook. Instagram, an online mobile photo and video-sharing social media platform, also offers the capacity to follow others, comment and like their content, so shares some similar features with Facebook; it has a younger user group than Facebook. TicTok is an important newcomer specialising in short videos.

Through these media platforms, digital photography now performs a role of mediating between public and private spheres (Becker, 2016). Spontaneity comes with the 'Oops!' drawback – people may regret images they posted. 'Sexting' is the exchange of erotic or explicitly pornographic imagery, primarily between couples in intimate relationships, and is a practice that has been encouraged by magazines such as *Cosmopolitan* to improve and spice-up relationships; however, these allegedly private images can become public. One survey suggested that over 20% of such imagery is routinely distributed by individuals who enjoy sharing 'private' sex photos

(Kinsey Institute, 2016). 'Revenge porn' (intimate images of an ex-lovers posted as an act of psychological violence and retribution) is another regrettable feature of these sites.

SELFIES AND DIGITAL REALISM

Mobile-phone technology comes replete with a palate of editing tools to remove imperfections, filters to smooth skin or even make us look thinner. A generation of people has grown up with this as a norm and would not consider posting unedited images of themselves. Indeed, there is great sensitivity around what images can be seen on many people's sites and younger women, in particular, have internalised the glamorous images from television and photographic advertising, duplicating pouting looks ('duck face') and fashionable poses. To post 'raw' photographs is becoming unthinkable. Conversely, no-make-up 'selfies' have become a special event, such as a campaign raising money for Cancer Research, United Kingdom, for example (#nomakeupselfies, 2014). Grogan and Wainwright (1996) argued that girls as young as eight recognise and internalise prevailing cultural pressures to be thin. They are bombarded with highly sexual and digitally manipulated images of idealised women, leading to astonishing levels of body dissatisfaction amongst women and girls and to epidemics of self-mutilation or self-starvation (Grogan, 1999). The proliferation of the 'selfie' as a dominant mode of self-presentation for young people has contributed to body dissatisfaction and cyber-bullying. Louis Theroux's (2017) documentary film *Talking to Anorexia* noted the pervasiveness of perceived feelings of 'powerlessness and lack of self-worth' amongst those young women he spoke to. The 'selfie' often has a predominant style, as well as characteristic make up. The 'selfie' is also a mode of authentication and the 'selfie stick' allow the camera to be held at a distance so more background information can be included, so that is clear that one is standing in St Mark's Square in Venice, for example, or in the presence of a famous individual. Cameras are being embedded into other devises, such as computers, drones and glasses, each yielding particular and new opportunities for connecting and interacting via images.

The equation of ugliness with sinfulness is woven into the fabric of our language: for example, she was 'ugly as sin' or he 'looks like the Devil'. Stigma (στίγμα) is a common Greek noun meaning 'a mark, dot, or puncture', or generally 'a sign'. Stigma (plural, stigmata) referred to a tattoo or mark that was cut or burned into the skin of traitors, criminals and slaves, in order to visibly identify them as a slave or as morally polluted. These individuals were to be avoided or shunned, particularly in public. Erving Goffman talks interestingly about this topic. He points to the Greek concept of stigma indicating an entrenched link between ideas about interiority and bodily signs. A blemished person shows a corrupted morality. Even in the early twentieth century, the idea that outward signs showed evidence of internal unnatural passions or moral corruption was to the fore. Given this entrenched aspect of our culture, it is hardly surprising that there is an on-going quest for unblemished depictions of self.[36]

Within the health humanities, art therapy (incorporating the use of photography), therapeutic photography and photography as part of visual research methods are used to explore health topics, are all noteworthy developments, but before discussion of these domains, the next chapter will explore in further detail how images work in order to inform the discussion and introduces photographic theory.

3

HOW ARE PHOTOGRAPHS DISTINCTIVE?

Victor Burgin (1982) elaborates on the nature of photographic practice:

> Photography is a practice of signification, of meaning making ... practice here is meant work on specific materials, within a specific social and historical context, and for specific purposes. The emphasis on 'signification' derives from the fact that the primary feature of photography, considered as an omnipresence in everyday social life, is its contribution to the production and dissemination of *meaning*. (p. 2)

Photography also contributes to the constitution of social practices and subjectivity as the previous chapter explored. Furthermore, the processes of photography are not static, have involved a large number of different types of photographic methods, the technicalities of which have not been elaborated as this is done well elsewhere; however, as Kelly (2014, n.p.) notes:

> As photography has spread by wider use and across various metal, glass, paper, and emulsion surfaces, through successions of cameras, optics, chemistries, and kinds of manual control, various aesthetics have emerged, including the pictorial, straight, pre-visualised, snapshot,

high-fashion, press, monochrome, colour, and so forth. With steady development of photo-related technologies, including moving pictures, and sped by modern marketing, few processes or kinds of photography – including their reproductive processes – have long remain[ed] standard.

WAYS OF SEEING

As Berger (1972) puts it:

> It is seeing which establishes our place in the world, we explain that world with words, but words can never undo the fact that we are surrounded by it. The relationship between what we see and what we know is never settled. (p. 7)

When we view a picture we don't all see it in exactly the same way; our eyes scan around an image and may focus on details that are of specific interest to us because of our own particular biographies and acquired interests. What we notice in terms of content differs from individual to individual, so how we interpret the image may vary. Roland Barthes in his famous essay *Death of the Author* made the suggestion that what the viewer brings to the work is of crucial importance as to how it is *seen* and understood. This essay contradicted received wisdom that the artist's intention is of paramount importance and that the viewer's duty is to try to understand what the maker of the image is trying to convey – the *meaning* imparted to the object by the artist or photographer – the intention – the anguish – his soul ..., *his* as it was mainly a masculine preserve. Perhaps the artist's biography could be scrutinised to give further clues as to the correct interpretation of the image. Burgin (1982, pp. 10–11) put it like this, that before Cubism drew attention to the surface of paintings, within Romanticism, which stressed the primacy of the author:

> The painted surface – or that of the newly emerged photograph – *was conceived of as a projection, a communication from a singular founding presence 'behind' the picture,* either that of the author or that of the world.

The image was thus held, paradoxically, to give presence to an absence to a very great extent our ways of conceiving of photography have not yet succeeded in breaking free of the gravitational field of nineteenth-century thinking: thinking dominated by a metaphor of *depth,* in which the surface of the photograph is viewed as the projection of something which lies 'behind' or 'beyond' the surface; in which the frame of the photograph is seen as marking the place of entry to something more *profound* – 'reality' itself, the 'expression' of the artist, or both (a reality refracted through a sensibility).

Instead Burgin suggests that the photograph can be viewed as 'a place of work' in which the viewer of the image *makes sense* of the image with the resources she possesses. It is a structuring and structured space. With such a perspective the photograph cannot be reduced to 'pure form' or 'a window on the world', nor is it a path to the presence of an author (Burgin, 1982, p. 153).

John Berger, in his TV series and book *Ways of Seeing,* shows a series of details of an image. He suggests that the film-maker can zoom in on a series of details, leading the spectator through an image, from detail to detail, to the film-maker's own conclusions. The temporality of film is more like that of spoken language in which one word follows another. The viewer's own constructions of meaning can become overwhelmed. Berger (1967) suggests that 'In a film one image follows another, their succession, constructs an argument which becomes irreversible' (p. 26); if not irreversible, it is at least compelling (sets of advertising images can be used in this way, as will be explored). However, in contrast, when we look at a photograph, or any other image, we can to an extent construct our own narrative and part of the fun of looking at images is precisely this act of constructing meanings and interpretations and narratives.

Some artists and photographers produce work that is ambiguous, quite deliberately so. Others toy with their viewer's perception of reality. René Magritte's 1929 image of a smoking pipe with the accompanying text 'This is not a Pipe' is one of the most well-known examples of such visual teasing. Its title *Treachery of Images* is a warning! Surrealist artists used photographic images in

collages to produce fantastical scenarios, which in the era before digital photography (and editing tools such as Photoshop) must have scandalised viewer's perceptions. The photographer still has power; to understand the artist's intentions may be enriching and may deepen our appreciation of an image, so might knowing more about the origins of the work and the work's original location, social context, details as to why it was commissioned and so forth, but following Barthes' thesis, it is the viewer of the images who becomes 'author' of the work though their own beliefs and interpretations, through a distinct vision. We in some senses 'construct' the image.

A critique of semiotics (discussed in Chapter 5) is provided by Liz Wells (2004, p. 30) who also emphasises the importance of the viewer of the image:

> The key limitation of semiotics as first proposed, with its focus upon systems of signification, was that it failed to address how particular *readers* of signs interpreted communications, made them meaningful to themselves within their specific context of experience.

Various theorists have thought about what it is that captivates us about photography. Wells, extrapolating the work of Barthes, distinguishes between the shock or revelatory nature of a photograph which can arrest attention, with *punctum* – a shock or sting.[1] The former a shock value can be the result of startling content, whereas the *punctum* of recognition 'transcends mere surprise, or rarity value, to inflict a poignancy of recognition for the particular spectator' [is linked to] 'the particular spectator's history and interests'. She expands to explain that,

> [...] even a relatively insignificant detail might offer a key point of focus for a person. In other words, the poignancy or joy of recognition is founded in the act of engagement, the act of looking at a particular image, the relation between the spectator and the photograph. (Wells, 2004, p. 32)

Indeed, on a fundamental level, the animation of photographs takes place *during the act of looking*. Victor Burgin (1982) suggests that what the viewer brings to the image is of crucial importance:

Photographs are sensorially restrained objects: mute and motionless variegated rectangles. Looking at photographs can nevertheless occasion great interest, fascination, emotion, reverie – or all of these things. Clearly, the photograph here acts as a *catalyst* – exciting mental activity which exceeds that which the photograph itself provides. (p. 9)

OBJECTIFICATION

It is important to acknowledge that many of the conventions codes schemas of modern photographic and filmic practices are indebted to our tradition of fine art. We also inhabit these norms and embody them. Berger in *Ways of Seeing* suggests that in the tradition of European oil painting the presumed spectator was male. It was men, primarily, who commissioned art works of sumptuous interiors or landscapes, often to illustrate their ownership of the property depicted, to enhance their status and to further decorate their already burgeoning interior spaces. He writes, 'In the average European oil painting the principal protagonist is never painted. He is the spectator in front of the picture and he is presumed to be a man' (Berger, 1967, p. 54).

Berger (1967) also expands on the profound hypocrisy of the European tradition as it related to the depiction of women:

When the tradition of painting became more secular, other themes offered the opportunity of painting nudes. But in them all there remains the implication that the subject (a woman) is aware of being seen by a spectator Often – as with the favourite subject of *Susannah and the Elders* – this is the actual theme of the picture. We join the Elders to spy on Susannah taking her bath. She looks at us looking at her The mirror was often used as a symbol of the vanity of woman. The moralizing, however, was mostly hypocritical.

You painted a naked woman because you enjoyed looking at her, you put a mirror in her hand and then you called the paining *Vanity*, thus morally condemning the woman whose nakedness you had depicted for your own pleasure The real function of the mirror was otherwise.

> It was to make women connive in treating herself as, first
> and foremost, a sight *The Judgement of Paris* was
> another theme with the same in written idea of man or
> men looking at naked women. (Berger, 1967, pp. 49–51)

The signs and symbolism of the past are alive in the present.
Indeed, in further versions of *The Judgement of Paris* women are
judged against each other for their beauty and Paris awards the
apple to the most beautiful. Beauty now has become competitive,
prize winning: the beauty contest is born.

The US art historian Linda Nochlin (1989) suggests that ideo-
logical ideas about the differences between men and women are
contained in the pictorial surface of images. She does not suggest
attempting to look *behind* the surface of the images (at the author's
personality or unconscious motervations), rather it is the surface
itself which may reveal operational discourses about the nature of
gender through narrative and iconography – it's all there, through
concentrated looking:

> 'Assumptions about women's weakness and passivity; her
> sexual availability for men's needs; her defining domestic
> and nurturing function; her identity with the real of nature;
> her existence as object rather than creator of art', and the
> pictorial reinforcement of strength and weakness 'as natu-
> ral corollaries of gender difference'. (Berger, 1967, pp. 2–3)

Though it may not be thus in all cultures, Berger suggest that
women's social presence is different to that of man. The male figure
suggests that what a man is capable of doing for you, or to you,
is to the fore. Women's presence expresses her attitude towards
herself, her aura:

> To be born a woman has been to be born, within an allot-
> ted and confined space, into the keeping of men. The social
> presence of women has developed as a result of their inge-
> nuity in living under such tutelage within such a limited
> space. But this has been at the cost of women's self being
> split in two. A woman must continually watch herself.
> She is almost continually accompanied by her own image

of herself. Whilst she is walking across a room or whilst she is weeping at the death of her father, she can scarcely avoid envisaging herself walking or weeping. From earliest childhood she has been taught and persuaded to survey herself continually Her own sense of being herself is supplanted by a sense of being appreciated by another. (Berger, 1967, p. 46)

Berger is persuasive. Nevertheless, women do enjoy moments of unselfconsciousness, and because of the rise of selfie culture, it may now be the case now that many men too are becoming more self-conscious. Whilst, in other non-Western contexts, women may be depicted as sexually powerful or sexually active, in the European tradition there is an overwhelming passivity in most of the female poses that are not formal portraits. These ways of seeing continue in the more recent medium of photography. Linda Nochlin (1989) agreed with this point, and suggests further that women's entrenched position as 'object' rather than subject has made it harder for women to be artists and accepted as artists. One of the ways that Nochlin makes her argument is to photograph men in traditionally female poses, with comic effects. Other photographers have done the same, to question the gendered nature of pictorial depictions, to toy with these or to highlight the power of gender in shaping the way we inhabit our bodies. Indeed, the tendency of men to take up more room pictorially and in real space has recently acquired the term 'manspreading' and has been revealed as prevalent social norm through photography, which shows men spreading out and taking up room in contrast to women taking up as little public space as possible.

Nochlin (1989) suggests that 'the White Western male viewpoint, unconsciously accepted as *the* viewpoint' is becoming more questioned, and that artistic disciplines are becoming more self-conscious of the nature of their presuppositions (p. 146). Images are also being used to question or 'queer' the nature of binary gender and photographs play with such ideas in their work. The reality is that women and men are heterogeneous. Even though certain discursive practices are powerful, photography, arguably, can provide an opportunity for a pluralistic perspective to emerge (Mohanty,

Russo, & Torres, 1991). Burgin (1982) notes that feminism has been useful in pointing out that it is *through* representations that women's subjectivity is shaped, noting 'Representations therefore cannot be simply tested against the real, as this real is *constituted* through the agency of representation' (p. 9). A key point is that photographic practices are both constituted and constituting. Photography, as a signifying system, 'produces the ideological subject in the same movement in which they "communicate" their ostensible "contents"' (Burgin, 1982, p. 158).

Ethnographic and anthropological imagery has also been the subject of intense debate, as to whether it is objectifying and how. Edwards (1992, p. 6) points out that early anthropological photography must be acknowledged to be part of colonial power structures, 'a controlling knowledge which appropriated the "reality" of other cultures'. Photography was, she suggests, part of the interest in 'delineation and control of the physical world, whether it be boundary surveys, engineering schemes to exploit natural resources, or the description and classification of the population' (p. 6). Ethnographers were interested in using photography to capture customs and habits, but also cultural differences. On the Isle of Wight at Osbourne House, Queen Victoria, then Empress of India, constructed a corridor of photographs of her native colonial subjects leading to a grand Indian-style dining room (the Durbar room). Some of the photographs show people in interesting head dressings, jewellery and attire. Are they dignified or objectified? Many of the photographs are powerful portraits, which seem to indicate a depth of personality of the subjects depicted. It is certainly a rich photographic legacy. Yet, in the context of the Queen's former home we *do* see these people as exotic others.

The term 'othering' is attributed to Gayatri Spivak. 'Othering' refers the various ways that colonial discourses produce their subjects: 'In Spivak's explanation, othering is a dialectical process because the colonizing *Other* is established at the same time as its colonized *others* are produced as subjects' (Ashcroft et al., 2007, p. 156). Othering, it is asserted, creates a 'binary separation of the colonizer and colonized and asserts the naturalness and primacy of the colonizing culture and world view' (Ashcroft et al., 2007, p. 155). Some theorists argue that anthropological subjects 'were

rendered as powerless, objectified and passive under the colonial gaze' (Barkan, 1994, p. 181). Photography, it is suggested, was instrumental in the development of ideologically determined discourses of both race and culture, and in some circumstances this must surely be true – the exotic and subjugated other can be petrified in the form of a photograph. However, as Wright (2003, p. 148) points out, ethnographic images are often complex, reflecting 'an overlapping series of desires involved with looking, collecting and classifying that were central to processes of colonial appropriation'. Early texts such as Victor and Dammann's *Anthropologisch-Ethnologisches* (published between 1873 and 1876) show photographs of tremendous cultural diversity, which might put pause to over-generalisations about 'race', whilst at the very same time a hierarchy of race is implied the way it was laid out. Poignant (1992, p. 55) notes that:

> The arrangement of the sheets implied a hierarchy of race beginning with 'Germanic & Teutonic type', of which David Livingstone provided the British example, and ending with the Australian Aborigines. The captions, which gave verbal expression to this hierarchy, began with named individuals (who were often either persons of rank, e.g. Bismarck, or iconic poses, e.g. an Italian Madnonna); gradually they changed to denoting types such as 'Arab' or 'Kaffir', or used tribal group names such as 'Watschandi' (Australian). This gradation is paralleled visually by a transition from dressed to undressed; a line of descent from manufactured clothing via traditional or ceremonial costumes to natural native garb of fibre and skin.

Edwards (1992) suggests that the postcards of 'native visitors' which became popular in the nineteenth and twentieth centuries can be viewed as part of a romantic tradition in which contradictory feelings towards 'others' are distanced through rendering them into aesthetically pleasing de-contextualised formulations. Another impetus was of a documentary nature in salvaging remnants of culture subject to change – the preservation of otherness in some senses. Also compelling it its 'status of a pure trace, an indexical fragment' that Edwards notes may refute its character

as a constructed image (Richon, 1985 cited Edwards, 1992, p. 123). Others seek to challenge a reductive reading of ethnographic photography suggesting (Tagg, 1988, p. 63) that photography has no 'identity' per se, but is imbued with different power relations. Elizabeth Edwards (2013, my italics) explains:

> Beginning in the 1970s, post-colonial and post-structural analyses positioned anthropology and its visual and textual practices as a site of forceful cultural critique Photographs, as tangible traces of colonial practices and asymmetrical power relations, assumed the quality of both symptom and metaphor in a vigorous politics of representation. The anthropological response to these criticisms was to take a detailed and critical look at its visual practices, historical and contemporary. This study revealed sets of photographic encounters that were profoundly disturbing *and yet complicated the more reductionist accounts of those encounters.* This critical process opened a space in which the multivocality of photographs of cultural encounter might be addressed.

Morton and Edwards (2009) strongly caution against a too reductive a view of anthropological photographic practices, suggesting that it may be productive and interesting to think about photographs 'as contested sites of encounter and cultural exchange even within asymmetrical power relations' (p. 4). They also worry that 'political dispositions have been given a naïve and direct causality that needs to be problematized' (p. 3). Morton and Edwards (2009) also emphasise that this overdetermination of the dynamics of power in relation to visual rhetoric is 'analytically paralyzing in their trade in absolutes' and ironically 'silencing' of indigenous voices (p. 3). Clifford (1988) too thinks that whilst it is difficult in ethnography to 'entirely escape the reductionist use of dichotomies and essences, it can at least struggle self-consciously to avoid portraying ahistorical others' (p. 23). Rather than photography being seen as a part of ethnographic surveillance, knowledge, arguably, can be co-constructed in a way which represents the local perspective in a respectful alliance (Fardon, 1990). Furthermore, Edwards has explored how ethnographic photographs are being returned to

Fig. 17. Maia Biala, the Chief of Rutland Island With This Wife. 4 May 1872. Photograph by G. E. Dobson. © Pitt Rivers Museum.

communities from which they originated and the creation of new and interesting scholarly endeavours which focus on the photographs themselves.

> This has enabled the emergence of critical, reflexive and collaborative micro-histories of visual, cross-cultural encounters and photography's relation with the material and sensory. These studies reveal not only complex orders of photography but, more significantly, they use photography as a prism through which to think through other areas of anthropological endeavour such as identity, exchange or globalization. (Edwards, 2015, p. 245)

These debates themselves have stimulated photographic practices. For example, the work of Roshini Kempadoo challenges

Fig. 18. Roshini Kempadoo. Sweetness and Light, 1996. © Roshini Kempadoo.

historical stereotypes. Her work employs digital manipulation and text to reveal a clash of discourses inherent in colonialism.

Jorma Puranen, a Finnish photographer working in Lapland, is best known for his experimental images of nature, incorporates ethnographic photographs of the native Sámi people into his work, which he discovered in the archives of the musée de l'homme in Paris.[2] In particular, he returns the peoples captured in these antique photographs to their traditional landscape in various ways with poetic results.

WORD AND TEXT

Sometimes images are used in a tautological manner, with the image merely repeating what is said in the words. Marcus Banks (2009) has talked about the value of using images in research projects to create 'a parallel argument' or a 'parallel discourse' to that of the written text. Here word and text can offer slightly complementary or even contradictory accounts, which create a helpful dissonance and reflective space, disrupting the usual linear continuity of the prose. Photographs are more than mere illustration in this case.

Images are influenced by their context. Images are also changed when they are accompanied by words. Photographs also influence

each other, so the other images that surround a photograph, create a sort of pictorial conversation with it, which might influence the way it is perceived. Try this experiment, if you are not already familiar with the work: find and look at the picture Wheatfield with Crows by Van Gough. The text with the image is 'This is a landscape of a cornfield with birds flying out of it'. Look at the image for a few moments before reading further. Don't read on at this point. Okay, now the text accompanying the image is different, it is 'This is the last picture that Van Gough painted before he killed himself' – does this change the way you experience the work? Does 'the image now illustrate the sentence' in some way? Berger (1967) suggests that knowledge of the suicide irrevocably changes the way we see the work (p. 28).

Text is often used in photographic marketing, within the photographic frame, or accompanying it. Berger pointed out that the images in advertising are seldom a celebration of a thing in itself. Drawing on the tradition of oil painting, advertising too assumes a spectator-owner and many images seek to 'persuade and flatter the spectator-buyer' (Berger, 1967, p. 135). Berger also explores how advertising is associated with notions of freedom. The 'free market' is inappropriately titled, since neo-liberalism allows the domination of many people by large tax-evading corporations and is actually better described as a form of exploitative anarchy. However, as Berger (1967) points out, publicity is often justified as a

> competitive medium which ultimately benefits the public (the consumer) …. It is closely related to certain ideas about freedom: freedom of choice for the purchaser: freedom of enterprise for the manufacturer …. It proposes to each of us that we transform ourselves, or our lives, by buying something more. (pp. 130–131)

Photography in advertising has arguably helped to normalise, something that is in many ways very, very curious – excess, an excess of stuff, of goods, so extreme that it is destroying, at this moment at least, the very infrastructure of the planet on which we live and thereby countless other species. Rather than visions of a better future, we are surrounded by images – bombarded by images, of material goods that we don't need, which we are stimulated

to want, but largely that we don't need and often don't value. As Sontag (1971) notes in *On Photography*, 'The omnipresence of photography has an incalculable effect on our ethical sensibility' (p. 24). Berger (1980) in *About Looking* worries that the public use of photography leads to a form of nihilism, tied into an unscrupulous capitalism:

> The industrialised, 'developed' world, terrified of the past, blind to the future, lives within an opportunism which has emptied the principle of justice of all credibility. Such opportunism turns everything – nature, history, suffering, other people, catastrophes, sport, sex, politics – into spectacle. And the implement used to do this … is the camera. (pp. 58–59)

Captions accompanying photographs can be used to position the photograph in relation to meanings attributed to it, so can be seen as a controlling or confining mechanism; the caption may emmesh an image into a particular context. Captions can be reductive, creating 'types', or they can give voice to an individual circumstance, far removed from our own, to help the viewer develop an empathetic link which might otherwise be difficult to establish. Photographic captions can also perform a narrative role, giving us information about what happens next, amplifying the content of the photograph.

As well as the specific bits of writing that are used in relation to photographs, their textual accompaniments, Allan Sekula makes the point that the broader milieu, that of discourses, is of crucial importance in establishing the meaning of a photograph. He defines discourse as

> the set of relations governing the rhetoric of related utterances. The discourse is, in the most general sense, the context of the utterance, the conditions that constrain and support its meaning, that determine its semantic target. (p. 84)

Burgin (1982, p. 144) emphasises 'social acts' as a form of context which constitute meaning in the photographic work.

> Whatever specificity might be attributed to photography at the level of the 'image' is inextricably caught up within the specificity of the social acts which intend that image and its meanings ... they originate in determinate modes of human organisation.

This conception emphasises that the *uses* of photographs are of crucial impotence. Uses are invariably embedded in discourses, so these are not antagonistic propositions. Liz Wells (2003, p. 2) also points out the multi-faceted nature of photography:

> Photography encompasses a range of different types of social and artistic practices engaging various audiences in a wide variety of contexts ... we need to link considerations about the photograph as a particular sort of artefact with questions of uses of photography and its effects.

Wells (2004) in her critical introduction to photography produces a detailed analysis of one particular image, which has been subject to much commentary, as an example of how images can be bound up in different discussions. Her analysis shows very clearly different ways 'critical writings appropriate and 're-frame' images in relation to particular sets of concerns' (see pp. 37–48). Burgin (1982, p. 144) argues that the language of photography is never far from the determinism of language itself:

> We rarely see a photograph *in use* which does not have a caption or title, it is more usual to encounter photographs attached to long texts, or with copy superimposed over them. Even a photograph which has no actual writing on or around it is traversed by language when it is 'read' by a viewer (for example, an image which is predominately dark in tone carries all the weight of signification that darkness has been given in social use; many of its interpretants will therefore be linguistic, as when we speak metaphorically of an unhappy person being so 'gloomy').

Liz Wells (2004, p. 19) worries about a reductionist stance towards photography, which focusses on essences. She again

emphasises the pluralistic nature of photography and the uses it serves. Indeed, she debunks the idea that photography is a singular concept:

> There has never, at any one time, been a single object, practice or form that is photography; rather, it has always consisted of different kinds of work and types of image which in turn served different material and social uses. Yet discussion of the nature of the medium has often been either reductionist – looking for essence which transcends its social or aesthetic forms – or highly descriptive and not theorised.

She goes on to explore ways in which images can contain multiple meanings through different readings which may concentrate on the 'formal qualities' of the image,

> [...] for example, its arrangement within the frame, or the dispositions, stances and gestures of its subjects. Alternatively, or additionally, we may seek to locate the work within the history of image-making, noting similarities and differences from other works of the same kind. Or we may want to explore the way the image may have been examined from the standpoint of a number of disciplines or discourses (Wells, 2004, p. 46)

Two U.S. photographers who play with text and image are Laurie Anderson and Hal Fischer. Fischer's series *Gay Semiotics* de-codes 1970s gay presentation with deadpan humour. Explanatory text explains the subtle and more obvious semiotic display of the era: the earrings, handkerchiefs, leatherwear and other signs that denoted queer identity. Anderson's work is yet more sophisticated in challenging the sexual objectification of women head on. Her series *Fully Automated Nikon* (1973) consists of a series of photographs of men who harass her as she moves around New York. When she was whistled at, cat called, stalked or otherwise insulted, she asked to take a photograph of the man involved. The images are reproduced with matter of fact textual accompaniments, such as *Man With a Box*. Underneath, as one might find in educational displays, is a verbatim reproduction of the verbal exchange. Here is an example from *Two Men in a Car*:

> These two men pulled up near me in their Chevrolet on
> Huston Street 'Let's go for a ride, cutie', said the one
> in the passenger seat. When I asked to take their pictures,
> they seemed pleased. After that, they drove beside me for
> a block, kept asking me to 'go for a spin'.

A white strip over their eyes renders the men anonymous in the
black-and-white photograph. They have been stripped of the male
gaze, and are consequently oddly disempowered. Whilst the photo-
graphs are not remarkable in themselves, the overall combination
of text and image is extremely compelling. Indeed, the tables are
turned. Here is another example of a descriptive text that appears
with *Man With a Box*:

> When I walked by this man be was unloading a cardboard
> box into the trunk of his car. 'Hey cutie' he said. When
> I asked to take his picture, he began asking me a lot of
> questions – who I was, what the hell did I think I was
> doing, etc. While he was talking, the unlit cigarette, stuck
> to his lower lid, kept bobbing up and down.

POLYSEMY

Concepts can have more than one connotation or meaning – they
can be polysemous. An image may carry a preferred meaning sug-
gested through its pictorial content, but as we have already estab-
lished, it's context and the text accompanying it has an impact
upon the way an image may be perceived. Images, including photo-
graphs, are influenced by cultural practices, as Burgin (1982) notes,
although there is 'no homogeneous "language of photography" –
there is nevertheless a *plurality* of codes, most of which pre-exist
the photograph, which interact with the photograph in complex
ways' (p. 13). Context is important to creating meaning in the pho-
tograph. Before images are considered in relation to each other, it is
useful to think further about setting. As has been emphasised, there
are many ways of understanding and 'reading' images. The way
we attribute meaning to the photograph depends on contextual
clues. Such an approach, Wells argues has been particularly influ-
ential to the understanding of photography in the British context;

milieu has been emphasised, with key institutions seen as shaping the nature of photography by the way they structure the context of photographs. Such an approach acknowledges that photographs are weak at the level of imminent meaning, relying on setting. Wells (2004, pp. 60–61) spells this out:

> We rarely encounter photographs in their original state, for we normally see them on hoardings, in magazines and newspapers, as book covers, on the walls of galleries or on the side of buses. Their social meanings are already indicated to us and they are designed into a space, often accompanied by a text that gives us the preferred readings of their producers and allows us to make sense of what might otherwise be puzzling or ambiguous images. Indeed, commercial uses of photography, especially in advertising, often play on multiple possible connotations that are provoked by the image. One determinant of the way in which we understand photographs, then, is the context within which we view them.

Barthes (1980) in *Camera Lucida* complained about the misappropriation of a photographic portrait of himself:

> one day an excellent photographer took my picture; I believed I could read in his image the distress of a recent bereavement: for once the photograph had restored me to myself, but soon afterward I was to find this same photograph on the cover of a pamphlet; by the artifice of printing, I no longer had anything but a horrible disinternalized countenance, as sinister and repellent as the image the authors wanted to give (pp. 14–15)

This is an example of an important change of context, which he felt undermined the work. Lack of intended context has been highlighted as a concern. Images removed from their roles in reportage, illustration, documentation or as evidence can be reduced to objects of, fundamentally denuded, purely aesthetic concern warns Crimp (1995, p. 75). Sekula (1991) mentions groups of photographs removed from their original contexts and brought together into various archives in which

the possibility of meaning is 'liberated' from the actual contingencies of use. But this liberation is also a loss, an *abstraction* from the complexity and richness of use, a loss of context. (p. 116)

Wells (2004), rather eloquently, talks about photographs 'doomed to the visual solitude of the art object, [which] lose their plurality and their ability to traverse fields of meaning' (pp. 61–62). This is a concern that may be unfounded, but they will certainly be perceived differently in terms of meaning and as Sekula suggests, there is the possibility of a loss of complexity in their de-contextualised or re-contextualised appreciation.

The juxtaposition of images also has effects on their meanings. We see a photograph. We may see one thing in one context, but when it is placed next to another image, we may see something quite different. Somehow the presence of another photograph has changed the way we grasp the first. We may ride up an escalator and see 20 or 30 different photographs as we move through space, each creating a resonance or dissonance with the next, creating a concatenation. Arguably context can unwittingly work against, or subvert intended uses of photographs. Sekula (1982, pp. 91–92) acknowledges this potential, suggesting that images can be appropriated by other more dominant discourses:

> We are forced, finally, to acknowledge what Barthes called the 'polysemic' character of the photographic image The photograph, as it stands alone, presents merely the *possibility* of meaning. Only by its embeddedness in a concrete discourse situation can the photograph yield a clear semantic outcome. Any given photograph is conceivably open to appropriation ... each new discourse situation generating its own set of messages Furthermore, it is impossible even to conceive of an *actual* photograph in a 'free state', unattached to a system of validation and support, that is, to a discourse.

I have noted above that images that surround a photograph create a pictorial conversation with it, which can influence the way it is perceived. Different theorists use slightly different language

to describe this phenomenon. Elizabeth Cowie (1977) calls this the 'inter-textual space'; this is a space which contains multiple discourses. She suggests that the intertextual space of an image is always important to its perceived meaning. The idea of the image as cipher, as in a void that is just inscribed by the ideological, is challenged by conceptualising it within an intertextual space, in flux and contested. It is open, always open, to competing discourses and rival conceptualisations as to its meaning and is acted upon by presumed ideas, whilst simultaneously acting upon other images. Geismar (2006, p. 48) suggests that photographs should be viewed, as 'creative actors' in the development of anthropological ideas, 'not merely representations' and what I think is meant by this is that the uses of the photographs and polysemy must be acknowledged to avoid reductive readings of them. Such an approach also allows us to acknowledge photographs as the site of struggle for historical and other articulations and as such it is an active domain.

Photographs are perceived in relation to the intertextual space, which should be seen as a dynamic space containing competing discourses that reverberate in reply to each other. The ideas within the photographs interact and resonate with other ideas and images unwittingly. Or in more self-conscious ways can challenge the other, potentially engulfing and subsuming the other – they can be seen as interactive. All this – the intertextual arena – is in a state of flux and the field is dynamic, in movement, in a continual process of contestation (through metaphor, cultural practices and so forth), though this movement is not always evident. Rogoff (1998, p. 16) captures this sense of mobility of meaning:

> In the arena of visual culture the scrap of an image connects with a sequence of film and with the corner of a billboard or the window display of a shop we have passed by, to produce a new narrative formed both out of our experienced journey and our unconscious.

Burgin nods towards this with the word 'autonomous' in the following quotation. The polysemic potential of photographs is acknowledged (Burgin, 1982):

The intelligibility of the photograph is no simple thing;
photographs are *texts* inscribed in terms of what we may
call 'photographic discourse', but this discourse, like any
other, engages discourses beyond itself, the 'photographic
text', like any other, is the site of a complex 'intertextu-
ality', an overlapping series of previous texts 'taken for
granted' at any particular cultural and historical conjunc-
ture. These prior texts, those *presupposed* by the photo-
graph, are autonomous; they serve a role in the actual text
but do not appear in it, they are latent to the manifest text
and may only be read 'symptomatically'. (p. 144)

Susan Sontag (1971) proposed that photographs 'are a grammar,
even more an ethics of seeing' (p. 3); however, this is not the best
analogy, as grammar is relatively unchanging, whereas photography
does change and develop, which is why even photos taken only
20 years ago can seem strangely dated: our modes of representation
shift in line with discourses in subtle ways, despite an overarching
indebtedness to the pictorial conventions of fine art. There is a ten-
sion inherent within the photograph in that it depicts a particular
moment, yet is open to manifold interpretations, drawing on a mul-
titude of cultural and aesthetic ideas. Sontag (1971) acknowledges
that any photograph can have multiple meanings:

Indeed to see something in the form of a photograph is
to encounter a potential object of fascination. 'There is
the surface, Now think – or rather feel, intuit – what
is beyond it, what the reality must be like if it looks this
way.' Photographs, which cannot themselves explain
anything, are inexhaustible invitations to deduction,
speculation, and fantasy. (p. 28)

Burgin (1982, p. 11) challenges the idea of the author's intention as
significant in the construction of the meaning of photographs and
also the idea that photographs can contain much implicit meaning
per se:

The surface of the photograph, conceals nothing but the
fact of its own superficiality. Whatever meanings and
attributions we may construct at its instigation can know

no final closure, they cannot be held for long upon those imaginary points of convergence at which (it may comfort some to imagine) are situated the experience of an author or the truth of a reality.

VERISIMILITUDE

A photograph is persuasive because 'it appears to permit the rapid and faithful recording of visual phenomena' (Ball & Smith, 1992, p. 4). The anthropologist Malinowski's use of himself in different locales functions in a verifying manner, as 'harder evidence of his visit to the Trobriands than the stamp on his passport' (Ball & Smith, 1992, p. 3). Ball and Smith (1992, p. 9) point out that images can function to 'authenticate a research report in a way that words alone cannot', but arguably images can move beyond mere corroboration in their expressiveness and capacity to move. With respect to ethnographic fieldwork, the photograph can function, as James Clifford (1988) put it, to show 'this is what you would see had you been there with me — observing' (p. 22). This notion of the camera as 'witness' is problematic, as the above discussion of polysemy has just highlighted. However, photography does have a relation to the real, as Kozloff (1987) put it, 'The main distinction between a painting and a photograph is that the painting alludes to its content, whereas the photograph summons it, from wherever and whenever to us' (p. 236).

Unlike a painting, photographs cannot be created from memory; they are always of a moment – *a moment that was*, a moment gone – or 'flat death' as Barthes has famously called it. Similarly, Rosalind Krauss (1985, p. 31) notes that photography is 'an imprint or transfer of the real'. Anthropologist Elizabeth Edwards (1992) explains it like this,

> [...] the undeniable authority of the photograph is grounded in its temporal and physical presence The photograph confirms the presence and observation of the photographer and 'truth' of his account. As such, a photograph is an analogue of seen 'reality', for what was in front of the camera existed. (p. 7)

This concords with Barthes' position which stresses the importance of pictorial content and the importance of the physical presence of the photograph. Liz Wells (2004, p. 28, my italics) puts it like this

> [...] it is worth noting that the authority which emanates from the sense of authenticity or 'truth to actuality' conferred by photography is a fundamental element within photographic language and aesthetics. This authority, founded in realism, has come to be taken for granted in the interpretation of images made through the lens. *It is precisely this which sets lens-based imagery apart from other media of visual communication* The photographic is distinct from the autobiographic, or from the digital, in that it seems to emanate directly from the external. Inherent within the photographic is the particular requirement for the physical presence of the referent. This has led to photographs (along with film and video) being viewed as realist in ways that say, technical drawing or portrait painting are not (although they are also based upon observation). *This* is the case to be clearly acknowledged and addressed

Elizabeth Edwards (1992, p. 7) agrees that photography is therefore a unique medium in this respect:

> It preserves a fragment of the past that is transported in apparent entirety to the present – the 'there-then' becomes the 'here-now' (Bathes, 1977, p. 44). The very immediacy and realism of the photograph is grounded in its temporal and physical presence.

In a similar vein Kozloff (1987, p. 237) uses the idea of the photograph as 'witness', but notes that this runs the risks of any witness statement. Liz Wells (2003, p. 14) queries the documentary concerns of photography and explores the language employed by major theorists:

> Max Kosloff in trying to define something of the fascination of photographs suggests that photographs 'witness'

events, whilst Susan Sontag refers to photographs as 'traces' or 'stencils' imprinted from actuality, whereas John Berger suggests that photographs can best be understood as quotations from actuality ... such terminology is not only indicative of a suggested relation to the world of appearances but also of uses of images; for instance, to conceptualise the photograph as 'witness' is to suggest that photographs offer evidence, that they are testimonials, extending the analogy. Kosloff comments that images can offer false or partial witness. Furthermore such a term as 'witness', will always imply documentary concerns. By contrast, terms such as 'trace or 'stencil' or 'quotation' suggest references which become detached from their source, circulating in new contexts but with something of their origins continuing to adhere.

4

PHOTOGRAPHIC PRACTICE FOR HEALTH AND WELLBEING

PHOTOGRAPHY FOR PLEASURE

In 2008, the New Economics Foundation was commissioned by the UK Government's Foresight Project on Mental Capital and Wellbeing to review the interdisciplinary work of over 400 researchers from across the world. The aim was to identify a set of evidence-based actions to improve wellbeing, which the general public could be encouraged to build into their daily lives. This was distilled down to the *Five Ways to Wellbeing*, which is now a major driver of health policy in the United Kingdom. These are five fundamental things we need as part of our lives for wellbeing. They are:

> connect,
> be active,
> take notice,
> keep learning and
> give.

Photographic practice enables people to meet all of the five ways to wellbeing. Recently, I walked around some botanical gardens photographing the plants. Choosing specimens to photograph really made me look intently at them, and notice their detail, colour and texture. Indeed, rather than strolling around the

grounds blithely, as I often do whilst exercising, I slowed my pace and looked intently at the beauty surrounding me and at details I thought would make an interesting photograph. The task of deciding to take the photos enriched my experience of being in the here and now, and allowed me to fully experience nature connectedness, which is also associated with wellbeing. It allowed me to stop thinking about other things and concentrate on the aesthetics of the moment, allowing me to adopt a moment of mindfulness, or flow, which also has the effect of lowering blood pressure and producing endorphins. The intent to take photographs allowed my full immersion and focus on the plants, the framing of the shots, the act of intuitively searching out interesting contrasts, textures and colours. This state of flow has also been discerned during the act of drawing and painting. Time seems to become suspended and the individual experiences a state of calm absorption. Eve Forrest (2016, p. 206) suggests that 'noticing is a state awakened within the photographer; it is a form of rapture that can never be shaken off'. Ratcliffe (2019, n.p.) agrees about the benefits of being in the moment:

> You already know that when you are 'in the zone' and taking a photo (or even post-processing a photo), [when] you are completely present and mindful. When you are not worried about the future or having self-doubt about the past. This is a beautiful place for creative[s] because they can give 100% of themselves to whatever is right in front of them. There is pure acceptance here, and this is when creative people are at their best.

Photography also meets 'be active' part of the ways to wellbeing, since it stimulates movement and attention. Indeed, watching and noticing can become entrenched ways of being through photographic practice, 'As part of their skillset, photographers become accustomed to looking, in order to find interesting things to photograph, which has subsequently formed into a more solid habit' (Forrest, 2016, p. 201). We can relate this to Bourdieu's ideas of habitus, as being our habitual embodied way of being in the world; Ingold (2000, p. 162) describes habitus

as how people acquire the specific dispositions and sensibilities that lead them to orientate themselves in relation to their environment and to attend to its features in the particular ways that they do.

Forrest (2016) suggests that an attentive watching is an important part of the process and that it is this watching which 'transforms passive looking into active noticing' (p. 204). Ingold (2000, p. 25) confirms 'that perception is grounded in an act of attention'. Photographic practice may have the power to alter our very relation to the world. As Dorothea Lange put it playfully in 1978, 'The camera is an instrument that teaches people how to see without a camera' (cited Forrest, 2016, p. 205). Though very good photos can be taken using a mobile phone, the physicality of a camera is noted as important by some, 'the physical presence of the camera assists noticing, too, the weight of the machine on the body leading them though a habitual series of movements' (Forrest, 2016, p. 205). This noticing is an embodied process, 'your perception of objects is already structured by your body and its sense of its own possibilities' (Carmen, 2008, p. 106). Forrest (2016, p. 207) concludes on photographic practice:

> The more you take, the more you look, the more you notice ... it is the felt presence of the camera that makes direct experience of the world heightened for the photographer. From that point, noticing can begin and creativity can blossom every day.

Photography for pleasure can also meet 'connect' and 'give', since the images may be shared (perhaps on Facebook or Flickr) connecting the photographer with others in conversation. Indeed, there are many communities of interest around photography, which provide gratifying engagements. A site such as 'view from my window', for example, is simply that: a photograph of the view from different people's windows, but which collectively present the rich diversity of many cultures across the planet and are fascinating in themselves. Photographing places can also be a social activity and undertaken with a friend, but it also has the advantage of being a pleasing solitary endeavour. One is not lonely when concentrated.

SATISFACTION WITH CONTENT AND COMPOSITION

Two key aspects of photography are content and composition. Content is what we include in the photograph. Content can take a multitude of forms, from the shocking to the comforting or tranquil. It was the Surrealist art movement which first took shots of the everyday, but in ways that made ordinary objects seem strange, or even sinister – drops of rain falling into a pavement gutter taken at close range, or an architectural feature de-contextualised and therefore rendered peculiar.

Composition is the selection of elements in a picture including the way of framing the shot. We might do this intuitively without thinking about it. After all, we are all 'educated' or inculcated by looking at images as they surround us in many forms. Cropping is also now very easy after the event, but many people still frame their shots quite carefully at the outset and enjoy this challenge. Whether or not we have any formal education in art and design, we will have assimilated some of the pictorial ideas to which we are exposed. The format of the photograph in *portrait* format – which encourages the movement of the eye to move up and down, or *landscape* format – movement from side to side, is the first choice to make in setting up a composition. There are different styles and different ideas about composition. Taking the viewer on a journey is a popular idea. This involves having a 'leading line' of action within the shot, down which the viewer's gaze passes when encountering the image. This sense of dynamism and movement, which might be appealing in a photograph, can be captured instinctively, or perhaps at first it can be practised in a self-conscious manner. Photography enthusiast Henry Carroll (2014) puts it like this:

> One main leading line is often all you need and they're at their most powerful when they sweep in from the edge of the page ... you'll find leading lines everywhere, from the converging rails of a train track, to the branch of a tree or the cracks of a rock face – and don't be shy about making these lines very overt in your image. (p. 10)

Another technique to use is framing, which can draw attention to a particular aspect of the image. Doorways, windows and openings

can often be incorporated with strong effects. A frame within a frame is often pleasing – taking a shot through an archway, for example.

The placement of the main subject is important – the camera can zoom in on the subject leaving little space and affording no distraction, or conversely can leave lots of 'negative' (unfilled) space around the subject, which may add a tranquil simplicity – depending on the subject matter. So filling the frame in an intense way can work well as a compositional tool, as can the exact opposite. Isolating the subject by using a shallow depth of focus is one way to achieve this. Conversely, a balance of elements might be attempted. For example, the focus of the shot might have another element – a secondary subject that echoes it in shape or form – another vertical shape if the main emphasis is a vertical shape. Including another subject of lesser consequence can add balance to the photograph without taking too much focus off the main subject of the photograph.

The 'rule of thirds' suggests that three objects are more interesting in a frame than four. This is also called the 'rule of odds' – that odd numbers are more pleasing to the eye. More strictly applied, in the rule of thirds the frame of the photograph is divided up into equal rectangles, three across and three down (this grid is available on some cameras). Pictorial elements are placed to intersect with the grid lines, and this is argued to produce more pleasing compositional effects. Compositional elements consisting of diagonals and triangles are often thought to add energy to pictures and can, when applied to the angles of familiar things and buildings, afford an affront to ordinary sensibilities.

The 'rule of space' applies to moving objects; this rule suggests that there should be more space in the direction of travel in front of a moving object than behind it, so that there is room for the eye to move forward on the pictorial surface along the path in which the object is moving. The viewer's gaze can track forward in the direction of where the boat is travelling. Movement from left to right is more common because in Western cultures we tend to scan from left to right.

Other aspects to think about are the relative weight of objects in the frame: foregrounded elements of pictorial interest; how the relative scale and juxtaposition of objects can add dynamism or

curiosity; how contrasts of pattern and texture can be aesthetically pleasing and how symmetry might be used to attention-grabbing effect. Depth of field, which is the area of sharpness extending from the image's focal point, and areas out of focus for contrast, are also elements of potential visual effect. The latter is called 'bokeh', from the Japanese word blur. It is created by shallow depth of field and can be very visually pleasing. If the pleasure of making photographs includes thinking more self-consciously about composition, there are many excellent resources online which illustrate all of the ideas mentioned here. The digital native generation are already au-fait with basic editing: cropping, correcting flaws and adjusting sharpness and colour.

Ultimately, we may want to assimilate some of these ideas about composition and then dismiss them, so that they don't cramp our spontaneity too much. Another technique, encouraged by art schools, is to find painters and photographers whose work we like and then to practice emulating them. Nodding at the work of other artists and photographers is part of the tradition of photography practice; it is possible to find a photograph that appeals, analyse what it is about the work that you like and then incorporate similar elements into your own photographs.

PORTRAITURE AND SELF-PORTRAITURE

There is a profound intensity potentially at play in photographic portraiture. Richard Avedon, a portrait and fashion photographer, describes some of his photographic subjects coming to him 'to be photographed as they would go to a doctor or a fortune teller – to find out how they are' (cited Sontag, p. 187). In this interaction, the subjects come 'in the hope of feeling better through the transfigurative experience of self-exposure before a charismatic observer' (Shusterman, 2012, p. 70). Richard Avedon (cited Sontag, p. 187) expands:

> I have to engage them. Otherwise there's nothing to photograph. The concentration has to come from me and involve them. Sometimes the force of it grows so strong that sounds in the studio go unheard. Time stops. We

> share a brief, intense intimacy. But ... when the sitting is over ... there's nothing left except the photograph ... the photograph and a kind of embarrassment.

Shusterman (2012, p. 70) notes this experience as 'deeply felt and focused communicative expression structured through the Mise-en-Scène of the photographic process' with a potentially transformative intensity. This sense of time stopping is discussed in relation to photography for pleasure, above; the potential intensity of the photographic gaze is also particularly relevant to re-enactment phototherapy in which pair work is a crucial component, as will be further elucidated.

In playful mood, Barthes (1980) explored the question of authenticity in portraiture when posing for a photo:

> I don't know how to work on my skin from within. I decide to 'let drift' over my lips and eyes a faint smile which I mean to be indefinable, in which I might suggest, along with the qualities of my nature, my amused consciousness of the whole photographic ritual: I lend myself to the social game, I pose (p. 11)

We begin to get a sense of how photography is a powerful medium for explorations of selfhood. Shusterman (2012, p. 71), who is interested in the enactment aspects of photography, wrote:

> With a more creative, fluid attitude, one can see the camera's invitation to pose as an opportunity to create a new look, a new posture, a new element in the construction of the self whose identity is not a fixed essence but an ongoing project whose continuous construction can either reinforce habitual modes of being or creatively seek new ones. In some forms of art photography, the subject can be creatively spurred to creative self-fashioning, to experiment with different poses, costumes, expressions, attitudes; and the special situation of an art photography session provides a circumscribed, protected stage to try out such experiments and then resume one's habitual modes of being and self-presentation if one prefers them (or requires them) for dealing with the needs of everyday life.

There is also a sense of threat in photographic portraiture that Shusterman (2012, p. 72) notes, because of the reproducibility and potential fixity of the image:

> The camera thus creates a particular pressure of posing not only because it typically requires the subject to arrest her movement (or at least control it) to ensure that her image is captured clearly but also because it raises the stakes of one's self-presentation by harboring the threat of permanently representing the self as an object in ways that the self as subject may not want to be represented or defined. Though experience itself is elusively evanescent and significantly subjective, the photograph has the powers of durability, fixity, and objectivity that belong to real physical things.

Self-portraiture is different again. Bond, Woodall, Jordanova, Clark, and Koerner (2005) have described three elements here in being author, subject and spectator simultaneously. The author is the creator, the subject *is* (and experiences being), and the spectator is looking at herself. Cristina Nuñez (2010), who is particularly interested in the transformative aspects of self-portraiture (p. 7) wrote:

> Besides looking inside, every self-portrait is a sort of performance. What we do in front of the camera is certainly mediated by what we want others to see of us The artist performs to communicate Nevertheless, there is a space, a relationship between me and me which is, I believe, independent from the other's gaze, and which implies an intense inner dialogue of perception, thought, judgement and acceptance.

Portraits can also speak beyond the individual in evincing small acts of defiance. Iranian photographer, Shadafarin Ghadirian (b. 1974), for example, produces images shot in the style of nineteenth century *Qajar*-era photography, but with forbidden signs of 'modern' life enigmatically displayed, such as a tin of Pepsi, held by a protagonist. Following the Iranian revolution, women have been cast-back in time in some senses; the photographs are evocative

of how women's lives in Iran have been constricted; indeed, the constrained rebellion hints at how dangerous ostentatious revolt could be. Issa (2010) suggested that the work should be seen as paradoxical:

> Women born during the revolution, live with lots of things that are forbidden. Forbidden to dance, to listen to music, to drink alcohol, or even drink Coca Cola or Pepsi Cola— American and foreign products. But, of course everything exists through the black market, so Shadi's photos talk about all the music and dancing that happens inside the house — the difference between life inside the house and outside. (Issa, 2010 in interview cited Nelson & Silva, 2010, p. 1)

Fig. 19. Shadafarin Ghadirian. Untitled 2000. © Shadafarin Ghadirian.

PHOTOGRAPHY IN HEALTH PROMOTION AND SOCIAL CARE

The 1948 World Health Organisation definition of health moves the definition beyond a medical model: 'a state of complete physical, mental and social wellbeing, and not merely the absence of

disease or infirmity'. Photography can be used in didactic ways to show rather than to tell. The most obvious use of photography in health promotion is to show signs to look out for (shown on posters and leaflets in doctor's surgeries).

In terms of health and wellbeing, photography can help steer communities into making better food choices; extol the virtues of fresh fruit and vegetables; tempt people into green spaces through seductive photography, or combine with simple messages about health benefits of being in nature; promote physical activity through making it look attractive, or even challenge us to think in more positive ways. Photography can depict people *like us* doing healthy things (rather than using idealised models of super fit persons which may be alienating). Diversity of images can enable a wide audience to be addressed and recognise themselves within the images. It must be recognised that much of what makes us healthy lies outside of formal healthcare provision and involves lifestyle and available resources (such as the availability and access to green spaces, leisure and cultural facilities), which can be subject to unequal distribution, creating health inequalities (Marmot Report). Photography can, potentially, stimulate debate about health in these more broad terms too, in order to create greater health and wellbeing. 'What Works Wellbeing' identifies a number of broad dimensions: 'the natural environment, personal well-wellbeing, our relationships, [physical] health, what we do, where we live, personal finance, the economy, education and skills, and governance'. Thus, health promotion invites changes in behaviour in a wide range of domains, all of which can be consolidated by the use of photographs. Bruce et al. (1995) noted that:

> Art is seen as an important and effective means of involving people in activities that promote health, and in mediating between everyday life experience and scientifically based knowledge of what affects health – so that people are 'touched rather than indoctrinated' by health messages. (Bruce, 2000, p. 846)

Small attempts at behaviour change have also been called 'nudges' and photography can help provide these nudges.

Amnesty International is an organisation that has used photography to particularly good effect in campaigns that often address questions of inequality and social justice. Often complex ideas are communicated instantaneously by their sophisticated images.

DOCUMENTARY PHOTOGRAPHY FOR HEALTH AND WELLBEING

Campaigns addressing health inequalities also use documentary images. Documentary photography is a varied phenomenon and can be used as part of research processes and towards social change (see Chapter 5). 'Documentary has been described as a form, a tradition, a style, a movement and a practice; it is not useful to try and offer a single definition of the word' (Wells, 2004, p. 69). Ohrn (1980, p. 36) suggested that documentary photography, though varied in its forms, is always interested in bringing the viewer to a particular subject and usually with the idea of social change in mind. Chapter 2 discussed documentary photography in positive terms, as providing helpful evidence towards social reform, as well as pointing out that it could be misused for ideological purposes by governments to counter public criticism (as in the case of the Crimean War, above). Ethically, photographs 'alter and enlarge our notions of what is worth looking at and what we have the right to observe' and furthermore taking a photograph 'means putting oneself into a certain relation to the world that feels like knowledge – and, therefore, feels like power' (Sontag, pp. 3–4). Furthermore, Sontag suggests that photographs, or rather the photographers who take them, can be tacitly complicit with violence, as the photographer witnessing an act of violence cannot intervene, and conversely the person who intervenes cannot also record the event. It is possible to argue that the documentary evidence made can later become a form of intervention, but in the moment of the event she is correct. However, she goes further in her proposition, suggesting that it can even become an incitement to violence:

> Like sexual voyeurism, it is a way of at least tacitly, often explicitly, encouraging whatever is going on to keep on happening. To take a picture is to have an interest in

things as they are, in the status quo remaining unchanged (at least for as long as it takes to take a 'good' picture), to be in complicity with whatever makes a subject interesting, worth photographing – including another person's pain or misfortune. (p. 12)

Interestingly, a very early criticism of documentary photography was made during the Paris Commune. In 1871, the *Illustrated London News* ran an image called *The Ruins of Paris* showing a man photographing the aftermath of the fighting, apparently with callous insensitivity towards all around him. English (1981) says of the image:

[...] before the firemen pictured have even extinguished the flames, the photographer with his young assistant is taking views of the buildings. With his camera precariously perched upon the rubble, he not only takes a photograph but also obstructs the path of the efforts [of the fire fighters] to put out the fires. In the lower right hand corner a homeless mother and child sit in isolation and despair. The photographer's brazen disregard for the firemen and the homeless mother symbolise his insensitivity to the immediate physical and human needs of the time. He is interested only in capturing a marketable image of the ruins. (pp. 20–21)

This censure of the photographer is a contrast to the current position. As Gómez Cruz and Lehmuskallio (2016, p. 7) put it:

It is difficult to imagine a world in which demonstrations, political conflicts or violent acts are not mediated through camera technology or the broader media logics imposed by using cameras. Because digital photo files carry metadata and can be combined with a variety of databases, their use for the purposes of modelling events which have taken place, or for predicting what might happen, is increasing.

Sontag (1971) also expresses concern over our desensitisation to images which we have seen over and over again in an 'unbearable replay of a now familiar atrocity exhibition' (p. 19). Barthes (1980)

worried too that the photograph 'de-realizes the human world of conflicts and desires, under cover of illustrating it' (p. 118). Sontag (1971) suggests that we become inured to brutality: 'photography has done at least as much to deaden conscience as to arouse it' (p. 21). It is a provocation, but how true is it? Personally, I feel I am more moved by images than by textual information and more immediately.

PHOTOGRAPHY AS ART PRACTICE

A definite and absolute distinction between photography for pleasure and photography as an arts practice need not be made, as the two realms run into each other and overlap. Artists also report encountering and entering into a state of 'flow', so some of the potential physiological benefits can be the same.

It is perfectly possible for amateur photographers, those not trained formally in any way, to make pleasing, aesthetically interesting photographs, which compare favourably with those made by people trained in fine art and photography. There are distinctive characteristics to photography, which add weight to the endeavour. That the photograph is usually of *something* (a subject) lends the photograph particular power, import or credibility. Especially important is that the photograph is a moment of the real (Lacan's *tuché*) – *we encounter this photograph in its particularity*. This photograph might embody a person or thing in a way which breathes life into it – which animates it to such a degree that it becomes for us *alive* for us in the moment. The anthropologist Elizabeth Edwards, discusses how sensitive photography was for early ethnography, where people unused to photographs, might see the spirit of the depicted person as inhabiting the photograph. Photographs have a very similar effect today, developing talismanic qualities, meaning that they exhibit and provoke particular sensitivities which are fundamentally irrational. For example, if I gave you a photograph of a human baby and asked you to cut it up with scissors, you might find this a very distasteful or even distressing thing to do. A photograph is a piece of paper treated with chemicals. Nevertheless, *we see the baby*. Photographs have a potentially visceral energy. This is one of the reasons why it is a powerful medium per se.

Probably the main distinction to be made between photography for pleasure and as an arts practice is that the latter is more knowing and more theorised. Artists often work on projects requiring conceptualisations and planning. There can be pointless theorising, or pretentious posturing – indeed, as ceramicist Grayson Perry recently put it in a Reith Lecture, much modern art is characterised by an aura of weary cynicism! However, developing a theorised approach can also add value and an extra degree of interest and complexity to photographic practice. Certainly, this book has spent a lot of time preparing the ground for a discussion of practice and theory into practice. Liz Wells (2004, p. 35) helps to justify a discussion of theory, which also informs, therapeutic photography:

> What has all this got to do with making photographs? Visual methods of communication are, of course, embedded in particular cultural circumstances and therefore reflect specific assumptions and expectations For instance, criteria based upon established visual aesthetics inform the assessment of what makes a 'good' photograph, photojournalistic or otherwise. Similarly, questions of representation pertaining to, for example, gender or race, which have contributed to the challenge to the canon within literary studies and art history, are relevant to photography The key point is that theoretical assumptions founded in varying academic fields, from the scientific to the philosophic and the aesthetic, intersect to inform both the making and the interpretation of visual imagery.

Wells (2004, p. 37) spells out different ways a photograph might be viewed in relation to different concerns and priorities:

1. The photograph can be seen primarily as social or historical evidence.
2. The photograph may be viewed about or in relation to the intentions of the photographer and the particular context of it's making.
3. It can be thought about in relation to ideology and politics.
4. It can be analysed and appreciated mainly with regard to technique and process.

5. It can be contemplated with respect to traditions of representation and aesthetics in art.
6. It can be considered in particular ways around gender or ethnicity politics or other intersections.
7. The photograph might be subject to a particular interpretative system such as psychoanalysis.
8. Or it could be de-coded as a semiotic text.

The photographer can connote or conjure references to these (above) ways of reading images, or indeed may be subject to them regardless of intentions. So photographers can make works which 'speak' to particular discourses or debates, though interaction with other images and contexts might change their interpretation and reception. Images are ideological. To draw on Liz Wells (2004, pp. 35–36) again:

> In order to think about photographic communication, we need to take account of communication theory in broad terms as well as focussing on photographs as a particular type of visual sign, produced and used in specific, but differing, contexts. The photograph, therefore, might be conceptualised as a site of intersection of various orders of theoretical understanding relating to its production, publication and consumption or reading. Central to the project of theorising photography is the issue of the relation between that which particularly characterises photography (which, as we have seen, is its referential qualities), and theoretical discourses which pertain to the making and reading of the image but whose purchase is broader, for instance, aesthetic theory or sexual politics. What is crucially at stake is how we think about the tension between the referential characteristics of the photograph and the contexts of usage and interpretation.

Examples of artistic practice related to portraiture are now explored here. This section will discuss representations of the black male body, especially the work of Robert Mapplethorpe (1946–1989) and then move on to consider the work of Jo Spence (1934–1992) as examples, whose work is also interested in the body and

body politics (though Spence was ambivalent about the word 'artist'). Stuart Hall (2001) suggested that portraiture, especially the black-and-white nude work of Mapplethorpe and that of Rotimi Fani-Kayode (1955–1986) who was influenced by Mapplethorpe, was important with respect to a growing appreciation of the black male body in the latter part of the twentieth century. Fani-Kayode's work 'explored the tensions created by sexuality, race and culture through stylised portraits and compositions' (Tate webpage). Mapplethorpe stated of his own approach, 'I zero in on the body part that I consider the most perfect part in that particular model'. Despite the fact that some of the photographs are of fragments of bodies, such as a focus on the buttocks and thighs, or a torso, Hall stated 'identification and desire in relation to the black body was an incredible release and I think Mapplethorpe did that'. He suggests that a 'gay sensibility' was important. Hall argued that, 'This was a frontier. Many things blocked our capacity to feel directly our desire in relation to this image' and 'fear of acknowledgement of homo-erotic desire' was one of them; whilst he also acknowledges an 'appropriation' of the black male body as exotic and the 'fetishisation' of black skin, Hall is fundamentally positive about this complex work. Hall feels this photography helped to create a climate that allowed an acknowledgement of black homoerotic desire as 'a form of desire, a perfectly legitimate open conduit or current of feeling'. Photography was instrumental, because the politics of the gendered, sexual and racial body is inscribed on the surface of the body as insignia, so the challenge needed to be a visual one, argued Hall. Now 'diversity is the language we are obliged to speak these days', but photography led, in his view, to real cultural and personal change in relation to the politics of racial representation – indeed to 'an incredible epistemic shift' (Hall, 2001). Art critic and writer Kobena Mercer suggests that the emerging voices of Asian and Black queer photographers in the 1980s disrupted and dislocated consensual truths and commonplace certainties, interrogating 'ethnic ugliness and eroticised beauty' in a diverse body of work that had little patience for the anti-democratic tendencies of identity politics. Rather it is work characterised by dialogue between questions of ethnic and racial identity, sexuality and gender. He summarises that 'their work interrupts common-sense essentialism

in favour of a relational and dialogic view of the constructed character of any social identity' (Mercer, 1994, p. 220).

Fig. 20. A Nursery Is My Right. Hackney Flashers. n.d. c. 1978.
© Archive Bishopsgate Institute.

At around the same time, in the 1970s and 1980s, photography collectives appeared that endorsed using photography as a tool for advancing social change. The Birmingham Centre for Cultural

Studies helped to promote a wide range of European continental theory translated into English, so some of these cooperatives were both theorised and practical. Feminism had already been influenced by the work of Simone de Beauvoir from France. There was concern in this period with issues of equal pay and funded nursery provision. Jo Spence was a member of the Hackney Flashers, a women's co-operative (1974–1980) which photographed women's work – both paid work and childcare and campaigned for better nursery provision using slogans such as 'Don't take drugs, take action'. 'Flashers' is a reference to flash photography, but flashers are people who flash or expose their bodies (especially their genitals), so it's a humorous analogy for uncovering and exposing social injustice caused by capitalism and patriarchy. The equal pay act had been enacted in 1970, but was not being implemented. This was photography in support of social change, but can it also be called art? Although there were many artist cooperatives emerging in this period, Klorman-Eraqi (2017) argues that the Flashers were distinctive because:

> The Hackney Flashers in many ways challenged the marginalization of women and professionalism in the field of photography Although organised similarly to other photography collectives, the Hackney Flashers were distinguished by their political focus on socialist feminist concerns, their sharing of skills, and their view of photography as an educational political tool. (pp. 55–56)

Feminist photographers, such as Jo Spence, articulated their understanding that photographs communicate ideological messages that construct social roles and are important in shaping our awareness of sexual and ethnic stereotypes. She was active in depicting the lives of ordinary women, using photography for social critique. The drudgery and lack of glamour of many women's paid and unpaid work was often depicted. An important message was that women, particularly mothers, have continual responsibilities from dawn until dusk, whereas the fathers often manage to get some leisure time, being less involved with cooking, cleaning, childcare and shopping. This was part of a 'grass roots' feminism that also highlighted the use of antidepressants amongst housewives and

working mothers. The Woman & Work photography exhibition (1975) focussed on the underrepresented reality of women's work, offering a 'window' to women's lack of equal pay and harsh conditions in Hackney; it was consciously political work. The images were displayed with labels offering commentary that pointed out disparities in pay between women and men. The work also deconstructed media portraits of depressed or dysfunctional housewives by juxtaposing these images with photographs of social action, replete with empowering captions, bringing the message home that women should not allow themselves to be chemically lobotomised by the State. Indeed, this was a period in which electro-convulsive-therapy was a popular treatment in psychiatric hospitals for depressed housewives.[1] Advertisements were also toyed with and subversive text added to glamorous images, creating clever multi-layered work.

Another cooperative of relevance to feminism was Format, a photography agency founded in 1983 to promote the work of women photographers. As well as photographing many prominent women in the period, Format captured important events such as the Greenham Common Women's Peace Camp (1981–2000) (an anti-nuclear weapons protest) and the 1984–1985 Miners' Strike (in which miners' wives were prominent). Further work was completed for the Greater London Council Women's Committee.

As well as working as part of the Hackney Flashers, Jo Spence also explored her own socialisation as a woman through an ongoing self-interrogatory practice. Process-based work was undertaken with Rosy Martin looking at 'body politics', exploring conflicts between the erotic and the domestic in the family home. Spence posed and Martin photographed in a joint endeavour. The collaborative work highlighted differences between Spence's mother's post-war British modesty and sexless domesticity and her own sexual liberalism (increasingly mainstream in British culture). A celebration of female sexuality and the confined space of domestic self-realisation sit in an uneasy juxtaposition. In one image (Madonna and Hoover) the mother figure is depicted cradling a vacuum cleaner like a baby. Indeed, this evocation of the Madonna connotes the history of feminine submission within marriage and also provides a humorous dig at the adoration of

the domestic role. Why should women aspire beyond it? Yet, the work also asks about the place of desire and pleasure alongside the constraints of domesticity. This work was shown as a large-scale installation *Libido Uprising* (1989). The installation comprising 14 photographs, shot by Martin, is amongst Spence and Martin's most powerful collaborative work. She wrote:

> Most of my work remains totally private, but occasionally I feel safe enough to share it with others. Thus the work moves from being part of an ongoing process (the taking of pictures), through into a series of interior dialogues and transformations after my viewing the pictures, into finally becoming potential raw material for public work. In Libido Uprising (which is part of my on-going work on the mother and daughter relationship) I have endeavoured to enact interior metaphors for my conflict between the domestic and the erotic, between my image of my non-sexual mother and that part of myself which is still coming into being (Spence, 1991, p. 358)

The work does not foreclose meanings, nor is it didactic, rather it explores a particular relationship and a set of societal relations generated by time and place, and the ideals of gender inhabited by both.

Fig. 21. Jo Spence in Collaboration with Rosy Martin Libido Uprising 1989. Installation.

Fig. 22. Jo Spence in Collaboration with Rosy Martin Libido Uprising 1989. Detail. Colour Photograph.

PHOTOGRAPHY TO EMPOWER COMMUNITIES AND COMMUNITIES OF INTEREST

Photography is used in social science research (elaborated further in Chapter 5) and part of that work may include working with communities. For example, a particular geographical community might be encouraged to give input into planning processes using photography to illustrate the physicality of an area, or use photographs to point out local problems or concerns. Evidence can be provided photographically in an attempt to improve social conditions or raise issues of concern to a community (Hogan, 2011).

Projects using photographs have been very varied, including the use of self-generated photographs with new migrant workers

to provide insight into the ways in which these workers perceived their lives and learning in a new culture, for example (Gallo, 2002).

Communities can use photography to represent themselves, or to explore areas for improvement in programmes of community development. The arts have been used as part of a 'place-making' approach in which granular, nuanced local understandings of how a place is formed, shaped and re-shaped can be explored through artistic and social practices. Cara Courage (2017) has described 'place-making' as putting the community at the front and centre of changes to where they live with 'a golden thread of art' running through activities. The thrust of the approach is on doing and making, with a varied set of projects with a focus on the 'hyper local'; there is a strong emphasis on bringing people together (in what she calls 'social horticulture') to engage in political and civic activities. Projects foster 'place attachment'. It's a form of urban regeneration harnessing the power of people through arts-based projects, and with 'place attachment' comes care for community on lots of different levels and a willingness to 'fight for places where communities can thrive'. Fundamentally place-making is,

> grassroots arts-led interventions in the urban realm, participated in by citizens and with an aim to improve the urban lived experience and to form and cultivate connections between people, place and community... as a means of urban revitalization. (Courage. Arts & Place, n.d., BLOG)

Place-making can happen spontaneously; it doesn't necessarily have to be instigated.

A number of authors have employed photography to explore identity both at the level of the group and the individual (Barbee, 2002; Booth & Booth, 2003; Glover-Graf & Miller, 2006) to combat social exclusion, or to create communities of shared interest, or concern, that can come together through visual practices. Photovoice combines images with spoken or subtitled textual accompaniment to explain or amplify the images. Saita and Tramontano (2018) suggest that Photovoice is particularly useful to community social action:

Photovoice is a method aimed at identifying the needs of a community or social group and motivating social change. Individuals are active participants, supported – through discussion – to identify their point of view, then represented by their photo shoots. Finally the subjects, under the guidance of a professional, make a photography exhibit to show their work.

Photography was used in the Representing Self Representing Ageing project, which used creative arts to negotiate and challenge images of ageing and explore their contribution to participatory approaches to research in social gerontology. The initiative brought together researchers from gerontology and art therapy with a cultural development agency. Photo-diaries, re-enactment phototherapy, arts elicitation and photography were all used by different groups of women interrogating their experience of ageing (http://lookatme.group.shef.ac.uk).

Other communities of interest could include those interested in global ecological issues, such as global warming, and the disastrous environmental consequences that are stemming from this, such massive bio-diversity loss through habitat erasure and species annihilation; photographs communicate messages simply and easily. A photograph of a polar bear mother with her cub pictured on a tiny block of ice surrounded by water shows the loss of the native habitat, and immediately makes the viewer anxious about the survival of the species, and more motivated to take action to combat global warming. Text can accompany the image to help provide a steer towards planet-friendly behaviours such as activism, using public transport, plastic substitutes or moving towards a plant-based diet. Again, there is crossover here with documentary photography.

Issues of inequality have been explored photographically, for example, early photographs of Suffragettes being assaulted by police officers were promulgated to stimulate public sympathy for the cause. The work of contemporary Yemeni photographer Boushra Almutaeakel explores the 'over-covering' of women and girls prompted by an intolerant radicalism based on 'distorted interpretations of Islam and a strong fear of women – and a desire to eradicate them from any public life or arena' (2008, p. 1). In this

Fig. 23. Mother, Daughter, Doll 2010. © Boushra Almutawakel (Original in Colour).

image, mother and daughter start off brightly clad and visible and eventually utterly disappear. She says of her work *Mother, Daughter, Doll* 2010:

The idea was inspired by seeing so many women covered in layers of black and, most shockingly, seeing little girls no older than seven or eight wearing the black *abaya* or *niqab*, like mini versions of their mothers. I wanted to express and comment on the trend of extremism that has been increasing gradually in Yemen since the mid-90s, with the influence of Wahabi ideology, and how it affects women and girls.

In slightly more playful mood she challenges dress codes in *The Hijab Series: What If?*

Communities of interest have also included photographs explicitly exploring gay, lesbian or trans identities. A community harnessing the power of photography was the gay community on the issue of AIDS.[2] AIDS threatened gayness as a positive social identity, especially when members of the gay male community started dying. In the 1980s, AIDS was depicted in the mainstream press in profoundly negative ways, harnessing homophobic language around perversion and evil. As well as stimulating moral panic, homosexuals in general became ostracised or feared as sources of pollution and contagion. Indeed, at first there was some popular uncertainty about how the virus was transmitted, which caused understandable social anxiety; however, as it requires direct exchange of bodily fluids, it is not highly contagious (as compared with Covid-19).[3] Yet, for some, the mere presence of a known homosexual was seen as troubling.

Fig. 24. 'What If ...?' 2008. © Boushra Almutawakel (Original in Colour).

Fig. 25. Sunil Gupta. Gerry and Friend at 3425 Stanley, from the Series, Friends and Lovers: Coming Out in the 70's, Montreal 1972. © Sunil Gupta.

The writer Weeks argues that homosexual desire was no longer considered an affliction by the 1980s, but as something to be enjoyed and celebrated in an era which had become, for straight and gay people alike, more promiscuous (at least in major Western cities). Promiscuity for gay men, in particular, was an important part of their cultural experience:

> Homosexual desire was no longer an unfortunate contingency of nature or fate; it was the positive basis of a sexual and, increasingly, social identity. AIDS implicitly threatened that, firstly by offering fearful consequences for being actively gay, but secondly, more subtly, by undermining the assumption that homosexuality is in itself valid. AIDS, like nineteenth-century cancer, is seen as the disease of the sexually excessive just as 'the homosexual' is seen as the embodiment of a particular sexual constitution. The association of AIDS with homosexuality thus serves to critically undermine the basis of the gay identity. AIDS is the punishment for the forthright expression of certain sexual desires. (Weeks, 1985, p. 50)

Weeks provides a lively analysis of US media, comparing the coverage attacking the gay community and that of the gay community

itself. As *FACE Magazine* put it in 1985, 'The AIDS scare has rein-
vested a fashionable, almost mundane homosexuality with taboo,
rendering it marginal again' (cited Boffin & Gupta, 1990, p. 14).
Furthermore, some commentators suggested a 'reign of terror' and
'a return to the pre-modern idea that illness is 'a punishment and
a sign ...', indeed a form of divine retribution (Goldstein, 1983,
p. 83). Traditional ideas of art divorced from engagement in social
life and unsuitable to intervene in social matters were challenged
in the use of photography in response to the AIDS epidemic. As the
art historian Douglas Crimp (1987) put it,

> [...] AIDS does not exist apart from the practices that
> conceptualise it, represent it, and respond to it This
> assertion does not contest the existence of viruses, anti-
> bodies, infections, or transmission routes. Least of all does
> it contest the reality of illness, suffering, and death If
> we recognise that AIDS exists only in and through these
> constructions, then hopefully we can also recognise the
> imperative to know them, analyse them, and wrest control
> of them. (p. 3)

That is not to say that artistic endeavour cannot achieve what
many usually associate with it 'works of art that express human
suffering and loss, that are cathartic, raise consciousness, transcend
loss of individual lives' because art can be 'timeless and universal'
(Boffin & Gupta, 1990, p. 2). However, photography did become
part of an explicit attempt by a community to exert control over its
own depiction in the light of this crisis. Furthermore, Crimp went
on to argue that art has the power to save lives through cultural
activism and raising awareness. Photography was used to critique
mainstream media responses to AIDS.

Using photography, Tessa Boffin became an advocate for sex
positive lesbian culture in the 1980s and 1990s. Soboleva (2019)
writes:

> Queer history is by no means free of its own demons. While
> there is a tendency to exclusively portray the noble aspects
> of queer collectivity, pride is more truthfully tinged with
> shame, exclusion, and erasure. Everybody didn't always

get along or do the right thing. Yet … much of the early work in queer studies purposefully focused on celebrating the happy and courageous moments, ignoring the darker aspects of the queer past.

Fig. 26. Tessa Boffin, from the Series *The Knight's Move* (1990),
Reproduced in Tessa Boffin and Jean Fraser's,
***Stolen Glances: Lesbians Take Photographs*, Pandora (1991).**
© the Estate of Tessa Boffin/Gupta+Singh Archive.

Del La Grace Volcano's work was ahead of the non-binary curve and has produced an important body of work exploring queer-gender, intersex and non-binary cultures. Del (2021) said of his/her/their work:

My working practice employs what I call a queer femi-nist methodology, a way of working which is invested in

making work with people who have a voice, who collaborate and connect with the images we create together, in collaboration. I no longer 'take' photographs from people who become objects of the 'gaze' (personal correspondence, 2021)

Fig. 27. Della Grace. The Ceremony, Peri & Robyn, London 1988 Credit: (aka Del LaGrace Volcano).

Powerful portraits continue to be produced today by artists interested in challenging marginalisation and discrimination, such as the stunning portraits of photographer Zanele Muholi who celebrates and captures the lives of South African gay and non-binary communities. Using the pronoun 'they' Muholi describes themselves as a political activist.

The work of Diane Arbus (1923–1971) captured outsiders, the less loved of society or the marginal, carnival artists, strippers and nudists. With almost the antithesis of the 'deadpan' approach, she asserted that the subject of the photograph was always more important than the photograph. As these examples illustrates, people often give expression to their experience by using images, which can better conceptualise and articulate their situation or which might challenge dominant representations, or those representations

connected with their particular socio-economic or gender status (Hogan, 1997, 2012). This is a dominant emphasis within social or feminist art therapy and to an extent also within re-enactment phototherapy, which is the subject of Chapter 6. Before moving on to examine re-enactment phototherapy in depth, the next chapter examines the uses of photography within social science and other research methods.

5

PHOTOGRAPHY IN RESEARCH (SUMMARY OF PHOTOGRAPHIC RESEARCH METHODS: PHOTO-DOCUMENTATION, PHOTO-ELICITATION, SEMIOTIC ANALYSIS AND CONTENT ANALYSIS)

WHO CAN BENEFIT?

Photography can aid our health and wellbeing by contributing to research. The next section will summarise some of the useful ways photographic images can be used for public good and explore their distinctive characteristics. In *Working Across Disciplines Using Visual Methods in Participatory Frameworks* (2019), I elaborated 10 reasons to use visual images in research, which I summarise here, though I am referring to visual images in general, including collage, as well as photography. After the summary, photo-documentation, photo-elicitation and semiotic analysis are explored and explained.

SUMMARY OF PHOTOGRAPHIC RESEARCH METHODS

1. *Pictures can be used to represent and explore the ineffable:* That which is hard to put into words, including mood tones

and feeling states, can often be expressed eloquently by images. Symbols, analogies and metaphors can be sophisticated, and metaphors used in conjunction with one another create complex reverberations within a pictorial frame Feelings that are indefinable can find expression in a moment of ontological revelation in the act of making. The image and process of production is potentially illuminating ... subsequent interactions with it may become of significance. The images created in photo-documentation have been argued to encapsulate 'the textures and tactilities, smells, atmospheres and sounds of ruined spaces, together with the signs and objects they accommodate, [which] can be emphatically conjured up by the visual material' (Edensor, 2005, p. 16).

2. *Images can convey an all-at-oneness (Eisner, 1995):* Images can produce a holistic depiction of ideas or feelings. They can also encapsulate eloquently. As images are not linear sequences as are utterances, different levels of meaning can be conveyed simultaneously and contradictory sentiments expressed instantaneously. Equally, images can be used to convey complicated concepts and complex data. The developing field of informatics uses diagrams and images to summarise chunks of information, which would be hard to digest if simply heard, but which are immediately evident when seen. Complicated concepts can be condensed in simple visual formulations, or extended ones such as animations or cartoons.

3. *Images can make us attentive to things in new ways:* When visual anthropologists or sociologists photograph mundane practices, we are able to see these in a new light. The image can draw attention to previously unnoticed details, but can also enable us to look at objects afresh (Pink, 2001, 2015). The images can help us to refresh our sensibilities and to highlight culturally distinctive, but often taken for granted, cultural practices In her photo-elicitation practice, Ruth Beilin has used images to *reveal* landscape conservation issues. In my discussion of this work (see below), I note that the images are absolutely revelatory to the viewer who is not

used to seeing the land in such a way, and the images and text combine to open out a new consciousness to the reader.

4. *Images can be memorable:* From billboards to news footage, it is often iconic images that stay with us. In *The Birth Project* particular images stayed in participants' minds and triggered particular memories and emotions relating to their experience of childbirth.

5. *Images can develop empathetic understanding and generalisability:* Whilst issues of mass migration or civil war in some far corner of the globe might feel abstract and remote, images can be used to make these issues feel much more immediate. Often this is done by the depiction of individual people to highlight the issues of many, so the story of one family's migration journey stands for many such journeys, for example. Charities such as Oxfam or Amnesty International often use this approach ... through the photograph of the individual, the humanitarian issue is given weight and meaning.

6. *Images can be used to look at changes over time:* Photo-elicitation techniques have been used to look at how neighbourhoods change over time, but also as an ethnographic tool to look at specific cultural phenomena. Clayden, Green, Hockey, and Powell (2015), for example, used time-lapse photography to examine the ways that people use space and build informal memorials in natural burial sites. As a sequence, complex changes, which would be laborious to describe, are easily illuminated. We can *see* how people are changing the space.

7. *Images may be more comprehensible than most other forms of academic discourse:* People who might not read a broadsheet newspaper or academic article can still engage with images; also as a 'stimulant' to research interviewing, asking a respondent to talk about a photo can provide useful results, replacing abstract or interrogatory questioning (Prosser, 2006, p. 3).

8. *Images provoke action for social justice:* Images are often used to provoke social change. Photographs of police

brutality in the United States and in Greece have been used
prominently in campaigns for reform and retribution, and
are useful to researchers in lending weight to justifications for
research activity.

9. *Image making can foster the exploration of embodied
knowledge:* Images can be affecting almost as though through
a process of 'emotional contagion' (Hogan & Coulter, 2014,
p. 95). We *feel* a mood. Nor should the kinaesthetic aspects of
art or image making be overlooked: Bourdieu, for example,
speaks of embodied knowledge as 'habitas'. Others refer to
'muscular knowledge'. See Martens, Halkier, and Pink (2014)
for a discussion of embodied research practices. The kinaes-
thetic qualities of both producing and viewing artwork are
of potential importance. One characteristic of an installation
exhibition format, for example, is that it uses the total space
and invites the viewer to move within it. This physical moving
into the discursive space is slightly different qualitatively to
simply looking at something on a wall or plinth; it is a more
bodily engagement with the artwork and offers a more immer-
sive experience. It is potentially more challenging in its theatri-
cal invitation to the viewer to engage with the subject matter
in an embodied way. How the narrative flow unveils itself
depends on the participant's movement through the space; one
perspective may necessarily cut off another, and new configu-
rations are generated by being at different vantage points in
the space. The format evokes uncertainty, anxiety perhaps,
and the entire work cannot be viewed from any particular
vantage point. In certain conceptual frameworks, such as one
that seeks to emphasise heterogeneity, this might be a very
appropriate format to prevent the foreclosure of meaning.

10. *Image making can be vitalising:* Artworks can be made
in a manner that can jolt our mundane sensibilities, using
materials in ways that can refresh our outlooks and capture
our enthusiasm …. There is the opportunity to be immersed
(in the flow) using intuition, serendipity, spontaneously
enjoying the tactile embodied nature of the experience – what
many call 'creativity' (though often without defining what

they mean). In this indeterminate space individuals or groups of people can become highly attuned to what is emerging – it is an emergent space. If working collectively, there are also potentially productive opportunities to explore interpersonal dynamics (for instance, within teams) or to reflect upon the nature of personal authorship. These are spaces of being and becoming, of ontological uncertainty, spaces in which ways of knowing are explored.

WHAT HELPS? PHOTO-DOCUMENTATION, PHOTO-ELICITATION AND SEMIOTIC ANALYSIS

Photography is important in relation to healthcare, health and well-being more widely in terms of how we see the world and regard social issues. The International Visual Sociology Association (IVSA) was formed in 1981, originally concerned with photography and documentary filmmaking within a sociological context, but now more broadly interested in the contribution of visual research methods to the 'study of society, culture, and social relationships' (IVSA website). In this section, photo-documentation, photo-elicitation and semiotic analysis will be discussed. In order to understand the pros and cons of using photographs in research processes, it is necessary to think yet more deeply about the nature of photography. A number of terms are now in use to encompass a wide range of visual research methods, including 'visual sociology'. Anthropologist Sarah Pink supports a broad description of 'visual anthropology':

I would not want to prescribe the kind of project to which applied visual anthropology is most suited. Existing work suggests that visual research is successfully applied to projects that seek to represent the ways people experience certain dimensions of their everyday worlds and that create platforms on which people can represent their experiences, views, or culture. It facilitates the representation of embodied aspects of self that can be expressed audiovisually. It encourages the use of metaphor and the empathetic communication of knowledge and experience that cannot be expressed using words alone. (Pink, 2004, p. 10)

PHOTO-DOCUMENTATION

Photo-documentation is a technique in which 'photos are made systematically by the researcher in order to provide data that the researcher then analyses' (Rose, 2007, p. 243). Rose gives Charles Suchar's work on gentrification as an example of this method. Suchar (1997, p. 34) uses 'shooting scripts' consisting of a number of research questions or sub-questions yielding visual information about the primary question that act as guide to what kinds of photographs are actually taken. The images are answers to the research questions: what variety of shops is found in the different neighbourhood areas? What do they sell, or what services do they provide? Who are their customers? Who own these shops? Photographs are used as evidence, which is then interpreted by the researcher, but with supplementary evidence in the form of notes. The photographs themselves might generate further research questions and therefore act to help refine the research process. The use of images in social science research is expanding. Furthermore, the images themselves can be used in the published work to illustrate the points made.

Prosser (2006, p. 2) is keen to challenge the notion of the photograph as authenticating. He points out resolutely that:

> A photograph does not show how things look. It is an image produced by a mechanical device at a very specific moment, in a particular context by a person working within a set of personal parameters.

On the other hand, in an analysis of how a population has been portrayed (e.g. Wright's, 2003 analysis of media images of refugees), it would seem imperative to be able to reproduce key images and frames of television coverage. Rose distinguishes between this sense of verification and the photographs that are used to supplement social science research; she argues the latter are 'methods which give more space to the photographs themselves to have their own, perhaps rather unpredictable, effects in the research process' (Rose, 2007, p. 247).

One of these sub-genres of photo-documentation, which Rose calls 'specified generalisation' (the use of images of particular

individuals to give a particular feeling to a book or other work, which is exploring a general theme) – she gives the example of pictures of individual migrants in a book about migration in general. Charities such as Oxfam and Amnesty International often use this approach. Rape in Darfur is hard to conceptualise, but the image of the individual makes it shockingly real.

Similarly, the video and still photography work of Rosy Martin which examine the ill-health, the multi-infarct dementia and finally the death of her mother, deal with universal aspects of being in a caring role, but make it feel very, very particular by concentrating on the specificities.

Martin (1999) said of this work:

> It does however have a lot to do with the psychic processes that photography necessarily inhabits – the 'absent presence' of which Barthes spoke. I photograph in order to hold onto the moment, the place, the trace which I cannot stop, cannot keep, cannot hold. (p. 74)

Another sub-genre of photo-documentation is that of what Rose calls 'texture' and I would rather describe as 'atmospheric' – these are images that transmit the 'feel' of a place, which can be uniquely conjured up in a visual image. She gives the example of Tim Edensor's (2005) work on industrial ruins, formally sanitised spaces, which according to him provoke sensory responses (no. 1 in the summary above). Here, I would suggest we are running into the realm of arts photography. The photographs can be 'utilised as an alternative source of information independent from the text'.

PHOTO-ELICITATION

Photo-elicitation, 'the use of photographs in conjunction with qualitative interviewing is a long-established method in visual sociology' (Newbury, 2005, p. 2). Harper (2002) says that photo-elicitation is 'the simple idea of inserting a photograph into a research interview' (p. 13). Prosser (2006, p. 3) states that photo-elicitation is 'using a photograph as a stimulant in an interview situation'. It is 'akin to object, drawing, painting etc. elicitation'. Namiko Kunimoto (2004), researching WWII internment, found

the tenor and tone of the interviews changed, becoming more emotional, after the introduction of the photograph of the camp into the interview. It is clear that such techniques could be useful in research. Whilst the photograph may be one taken by the researcher, or could be the use of a found image, photo-elicitation is often based on asking research participants to take their own photographs. Because photographs can be information dense they offer the advantage of potentially holding a great deal of data which can be drawn out in interview, allowing a range of topics to be covered. Photographs are useful in capturing everyday activities in participants' lives. Taken-for-granted aspects of day-to-day living can be pictured and explored drawing out implicit assumptions and meanings.

PHOTO DIARIES

Photo diaries have been noted as a useful way to enlist research participants because photography, especially with phones, can be easy and enjoyable. Also, photographs can act as an incentive and reward. In the Representing Self Representing Ageing project, for example, participants were given high quality large prints of their photographic work, some of which had been professionally framed (Hogan & Warren, 2012). Other researchers have asked participants to maintain a photo diary, which then became the focus of an interview (Latham, 2003, 2004). In this case, using the camera 'gave his interviewees some distance from their ordinary routines and enabled them to articulate some of the taken-for-granted practical' knowledge with which they 'negotiated public space' (Rose, 2007, p. 241). The use of the camera helps to make the well known and implicit evident; it enables a 'fresh look'. Hodgetts, Radley, Chamberlain, and Hodgetts (2007) emphasise that is it is not just what is depicted in the photograph that is significant; as even with a simple prompt, such as 'a typical day', the photograph can be productive of analysis and debate, hence they like the term 'photo-production'.

Keeping a photo diary can also be empowering, as participants are given a central and well-defined role in the research process, allowing them to draw on their expert knowledge of the subject

under scrutiny. This can be of particular value to those with lived experience of particular conditions or illness. Photo-elicitation has also been used to explore the experience of those experiencing homelessness. Feelings of safety have been explored in a number of projects, from the perspective of children in school, through to adults in public domains. For example, in one project children were asked to photograph places in the school where they felt safe and unsafe. Though its empowering aspects has limits (Hogan, 2015; Joanou, 2009; Packard, 2008).

Alan Radley and Diane Taylor (2001) asked hospital in-patients to take their own photographs of their ward. They gave patients the task of photographing 12 of the 'objects, spaces and places that they found most significant' to them – however, it was perhaps the narration of meaning associated with the images, which was most helpful in research terms, rather than the photographs per se (Radley & Taylor, 2001 in Pink, 2007, p. 89).

Ruth Beilin also refers to her work as 'photo-elicitation' and is interested in 'seeing' the landscape and 'telling' about the landscape. Her work explores 'landscape practice' with respect to 'conservation', and involved her giving cameras to farmers in Australia. In this work, the images are absolutely *revelatory* to a viewer not used to *seeing* the land in such a way, and the images and text combine to open out a new consciousness to the reader; thus an aesthetically pleasing gash in the ground becomes 'land problems at the creek' and a pleasing rolling hill becomes a 'landslip' which is seen by the photographer as like a 'flesh wound' or a 'running sore'. Her narrative emphasises the challenges of managing the landscape and also evokes 'the intense physical relationship between landscape management and identity' (Beilin, 2005, p. 61). The photographs serve to change the consciousness of viewer and create empathy.

Blinn and Harrist's (1991) work asked women to take photographs and write something about them, prior to a detailed discussion of the photos in interviews. The researchers felt that the 'legibility' of the photos was very dependent on the verbal accounts and therefore none of the photos were reproduced in the publication of the final study. Rather, in this case, the photos served as an adjunct to the research process. Requesting that participants

Fig. 28. Landslip and Land Problems at the Creek. © Beilin.

write a caption for each photograph to prompt an initial reflective process on the photographs is a way that is helpful in enriching the subsequent interview (Blinn & Harrist, 1991).

The therapeutic possibility of such techniques is being employed by photo-therapists, such as Rosy Martin, who are interested in interrogating social phenomena but within a therapeutic frame.

Martin used photo diaries in helping to enable older women interrogate their own experiences of ageing, elaborated in further detail in Chapters 6 and 7. The diary work was shared within the therapeutic group (Hogan & Warren, 2012; Martin, 2000). Photo diaries can include written text and diagrams that can be looked at in conjunction with the images. Obviously, such techniques have to be used with informed consent. It has been noted that processes of selection can be helpful as it is easy to take many digital photographs. Martin elaborates below, on how she limits her participants to a specific number of prints to force them to choose the images that feel most significant.

A SEMIOTIC ANALYSIS

The importance and centrality of signs is emphasised by art historians Bal and Bryson (1991) who point out that 'human culture is made up of signs, each of which stands for something other than itself, and the people inhabiting culture busy themselves making sense of those signs' (p. 174). Signs are integral to human society. Hodge and Kress (1988, p. 1) note that 'Everything in a culture can be seen as a form of communication, organised in ways akin to verbal language' and Saussure (1974) described semiotics as 'the science of the life of signs in society'. Saussure wrote, 'I shall call it *semiology* (from Greek sémeîon: 'sign'). Semiology 'would show what constitutes signs, what laws govern them' (Saussure, 1974, p. 16). The focus in this approach is on photographs as readable and interpretable texts. C. S. Pierce developed a tripartite scheme of icon, index and symbol. Eagleton (1983, p. 101) summarises it:

> There was the 'iconic', where the sign somehow resembled what it stood for (a photograph of a person, for example); the 'indexical', in which the sign is somehow associated with what it is a sign of (smoke with fire, spots with measles), and the 'symbolic' [in which the link is arbitrary, a wedding ring denoting marriage], whereas with Saussure the sign is only arbitrarily or conventionally linked to its referent.

Liz Wells (2004, p. 30) suggests that photographs that have not been digitally manipulated incorporate all of the constituents described by Pierce:

> images resemble the person or place or object re-presented; they are indexical in that the subject had to be present for the photograph to be made, which means that the image is essentially a 'trace'; and images circulate in specific cultural contexts within which differing symbolic meanings and values may adhere. (Wells, 2004, p. 45)

Wells points out that it is currently common to use the term semiology to refer 'to the earlier, relatively inflexible approach based upon structural linguistics' and 'semiotics' to refer to a later more fluid approach which draws upon a wider range of theory to look at meaning-making processes more broadly, rather than a close analysis of textual systems. Social semiotics takes account of issues of interpretation, social behaviour and context (Wells, 2004, p. 30). Semiotics has contributed to a critique of representation. A *semiotic analysis* of images as part of discourse analysis can take place in the above models, but is also a research focus in itself. Linda Nochlin's (1989) 'Women, *Art and Power*' is a particularly strong example of this method, in which she looks at the different way men and women are represented in fine art, soft porn and advertising.

The images may be supplemented by analytical text, but are sufficiently iconoclastic to provoke questions in their own right, independent of the textual inquiry.

Drawing on the work of Foucault, she highlights binary oppositions in many works between female passivity (flaccid poses) contrasted with taught masculinity. She looks at the division of pictorial space in paintings such as *The Oath of the Horatii* by Jacques-Louis David (1784) and discusses what she calls a 'binary division' (1989, p. 4) between female relaxation and male energy, which she argues 'is as clear as any Lévi-Straussian diagram of a native village'. This binary division is

> carried out in every detail of pictorial structure and treatment, is inscribed on the bodies of the protagonists in

Fig. 29. *Achetez des Pommes* **(Anonymous Nineteenth Century) Juxtaposed with** *Achetez des Bananes* **by Linda Nochlin.** **© Estate of Linda Nochlin.**

their poses and anatomy, and is even evident in the way that that the male figures are allotted the lions' share of the architectural setting, expanding to fill it

An important challenge to semiotics comes from the critique which suggests 'that social dimensions of semiotic systems are so intrinsic to their nature and function that the systems cannot be studied in isolation' from a productive social context (Hodge & Kress, 1988, p. 1). Hodge and Kress complain that 'mainstream semiotics':

emphasises structures and codes, at the expense of functions and social uses of semiotic systems, the complex interrelations of semiotic systems in social practice, all of the factors which provide their motivation, their origins and destinations, their form and substance. It stresses system and product, rather than speakers and writers or other participants in semiotic activity as connected and *interacting in a variety of ways in concrete social contexts.*

Burgin (1982, p. 145) too suggests that semiotics

> assumed a coded message and authors/readers who knew
> how to encode and decode such messages while remain-
> ing, so to speak, 'outside' the codes – using them, or not,
> much as they might pick up or put down a convenient
> tool. This account was seen to fall seriously short

Language is slippery, even Wells (2004) falls into the trap of sug-
gesting that the photograph can be understood with reference
to 'discourses which exist *outside* the photographic' (p. 46, my
emphasis), but what she means is that analysis of an image might
be in relation to historical ideas about aesthetics, or gender; the
image per se is not located outside of these ideas.

Burgin (1982) attests that semiotic theory is 'not sufficient to
account for the complex articulations of the movements of institu-
tions, text, distribution and consumption of photography' (p. 2).
He elaborates:

> Social practices are structured *like* a language, from infancy,
> 'growing up' is a growing *into* a complex of significant social
> practices including, and founded upon, language itself. This
> general symbolic order is the site of the determinations
> through which the tiny human animal becomes a social
> human being, a 'self' positioned in a network of relations to
> 'others'. The structure of the symbolic order channels and
> moulds the social and psychic formation of the individual
> subject, and it is in this sense that we may say that language,
> in the broadest sense of symbolic order, speaks *us*. (p. 145)

Burgin sees semiotics as having been useful in debunking the pri-
macy of the notion of the author's intent and as highlighting the role
of photography as productive of ideological subjectivity. Particularly
poignant is Iversen's (1986) description of semiology as 'laying bare
the prejudices beneath the smooth surface of the beautiful' (p. 84).
Harris (1996, p. 7) goes even further than Hodge and Kress in ques-
tioning to what extent signs should properly be thought to exist
'independently of their users'; he argues that signs are created in-use:

> Signs, in short, are not waiting to be 'used': they are
> created in and by the act of communication.

However, the idea that images contain meanings to be de-coded is entrenched. Here is Lister (2016, p. 267, my italics):

> The act of finding meaning in a photograph is, of course, to engage with photography as representation. This, in turn (if it is not to be an innocent reading) inevitably entails a measure of academic discipline and methodology: the semiological scrutiny of images treated as texts with the aim of *revealing or interpreting the meanings encoded within them.* With regard to photography this is a developed practice

Rather than having meanings 'encoded within them' photographs *both constitute and are constituted simultaneously* in terms of their sense; so just thinking about images holding encoded meanings is too simple. Certainly signs are a vital dimension of culture and we 'make sense' of them in our day-to-day cultural interactions, so analysis of processes of meaning making is of importance. All signs are vulnerable to re-interpretation. Gillian Dyer (1982) provides a useful checklist for analysis of ways in which people are used in advertising (pp. 96–104). She emphasises the importance of analysing 'the way human actors communicate feelings, social meaning and values like power, authority, subordination, sexuality as so on' (p. 97). Though her analysis is of a particular historical moment, the questions she asks are still quite valid.

This is an emerging area of enquiry, Van Leeuwen (2005) has suggested that social semiotics is now leaning more towards analysis of use:

> in social semiotics the focus changes from the 'sign' to the way people use semiotic 'resources' both to produce communicative artefacts and events and to interpret them – which is also a form of semiotic production – in the context of specific social situations and practices. (p. xi)

CONTENT ANALYSIS

Content analysis is a social science research method which uses quantification to produce statistical results. Images can be analysed

in many ways, depending on the research question. For example, the focus of the photographic analysis might be types of technology depicted; geographic location; age of those depicted and so forth, with the research question itself determining the coding categories to be used. The coding process should be replicable. Systematic sampling techniques are used. Such analysis can enable trends to be located in new electronic media, broadcast and print domains. For example, the Global Media Monitoring Project garners large-scale statistics on gender representation, illustrating issues of global inequality in gender portrayal and representation.[2] Content analysis can also shed light on the type of portrayals of women that predominate in different contexts. Relations between different coding categories can also be explored to uncover interesting correlations. Whilst it may be tricky to fully acknowledge the mood tone or affect of images through codes, there is clearly an important place for content analysis in telling us about trends within particular media domains.

DISCUSSION

Kolodny (1978) suggested that three predominant models of Western thought provide strong stereotypical conventions that help to structure our response to images. These are not necessarily mutually exclusive (Mead, 1975, p. 5). These are: (1) a romantic mode linked to aesthetic responses and notions of exoticism; (2) a documentary mode which is interested in political or social comment and the world in action; (3) thirdly, a 'realist' mode which is linked to ideas of empiricism and that feeds into a positivistic scientific framework (e.g. knowledge derived from experience of natural phenomena and their relations and properties). Like Mead, Edwards (1992) sees these models of seeing which structure representation as intersecting, '… documenting traditional culture in the face of irreversible change, is not necessarily purely "documentary". It evokes feelings of nostalgia at the passing of cultures and an aestheticized "nobility" that transcends the "realist" or "documentary" mode' (p. 10), and that, one may argue, is part of the power of photographs in research contexts.

Ontology is the examination of concepts such as existence, becoming, being and reality. There are tensions at play in the very 'being-ness' of photographs, so it is worth thinking about photographs ontologically to help us understand their pros and cons for research in more depth. Liz Wells (2004, p. 31) sums up Barthes' position here:

> For Barthes, photography is never about the present, although the act of looking occurs in the present. In addition, the photograph is indescribable: words cannot substitute for the weight or impact of the resemblance of the image Furthermore, the photograph itself – that is, the chemically treated and processed paper – is invisible. It is not *it* that we see. Rather, through it we see that which is represented. (This, he suggests, is one source of the difficulty in analysing photography ontologically).

The ontological tension, noted by Barthes, is also explored by Edwards (1992, p. 8) that the photograph itself becomes more than just a representation, but a signifier – 'the photograph is perceived as "real" or "true" because that is what the viewer *expects* to see: "this is how it should be" becomes "this is how it is/was"'.

Kraus (1985) puts it like this: that a photograph

> is a photochemically processed trace causally connected to that thing in the world to which it refers in a way parallel to that of fingerprints or footprints or the rings of water that cold glasses leave on tables ... photographs are indexes. (p. 31)

But a photograph is never merely a trace.

On the subject of veracity, Berger (1979) proposed that in terms of a flow of events, and with respect to memory, that the photograph as *a moment pulled out of time* necessarily has a false quality per se,

> [...] if the photograph isn't 'tricked' in some way or another, it is authentic like a trace of an event: the problem is that an event, when it isolated from all the other events that come before it and which go after it, is in another sense not very authentic because it has been *seized*

from the ongoing experience which is the true authentic-
ity. Photographs are authentic and not authentic; whether
the authentic side of the photographs can be used authen-
tically depends upon how you use them. (Berger & Mohr,
1979/1980, p. 166)

So Berger sees the photograph's dislocation from the flow of
time as problematic. This pulled-out-of-time quality of the photo-
graph permits a different way of scrutinising a moment, which may
be useful, in terms of assimilating detail, but it is also potentially
reductive. Edwards (1992, p. 7) again,

it allows the viewer to linger, imagine or analyse in a way
which would not be possible in the natural flow of time
The photograph contains and restrains within its own
boundaries, excluding all else, a microcosmic analogue of
the framing of space which is knowledge.

This singularity of the image can lead to potential distortion;
Elizabeth Edwards therefore sees the photograph as a 'metaphor
of power' having the ability to appropriate and de-contextualise
time and space. The photograph isolates a single incident in history.
Edwards (1992, p. 7) explains:

The inevitable detail created by the photograph becomes a
symbol for the whole and tempts the viewer to allow the spe-
cific to stand for generalities, becoming a symbol, for wider
truths, at the risk of stereotyping and misrepresentation.

Edwards (1992) is cautionary about what photographs can tell
us, since the structuring of the content of photographs 'operates to
produce a range of signifiers which position the subject in broader
ideologies' (p. 10). Indeed, the most fundamental problem of using
images in research is polysemy.[3] She elaborates:

The term 'still' photography both describes the nature of
photography exactly and at the same time implies a mis-
representation of its nature. While the content is indeed
'still', chemically fixed on paper, its interpretation is not.
As with other forms of graphic image, viewers attribute
new meanings through their own cultural experience and

as such a photograph is in some ways submissive. Yet photographs are not totally passive. They suggest meaning through the way in which they are structured, for representational form makes an image accessible and comprehensible to the mind, informing and informed by a whole hidden corpus of knowledge that is called on through the signifiers in the image. (Edwards, 1992, p. 8)

Edwards (1992) here uses the archaeological metaphor of stratification:

But although 'meaning' may theoretically be open-ended, it is also historically and culturally determined. From the moment of its creation the photograph will 'mean' something, reflecting the photographer's intention. While this meaning may remain within it, or may be recoverable through historical research, it becomes stratified ... beneath other meanings attributed to the image. These may be in complete opposition to the photographer's intention since different bodies of knowledge are deemed significant as the photograph is used to express different preoccupations Ideas extraneous to the picture itself thus give meaning to it, both for its original audience and for subsequent generations of interpreters. (p. 12)

We can now fully appreciate some of the complexities of the use of images in research. Nevertheless, photographs as a documentary form and a purveyor of truth still prevails and our instinct is still to trust the veracity of the image, even though, as we have discussed, photographs are always of a moment, taken out of time, have the capacity to reify in productive or counter-productive ways and can be subject to varying interpretations. Cultural historian Mary Warner Marien (1997) suggests that in the 1970s and 1980s the concept, predominant in the nineteenth century, of the photograph as a facsimile (a true copy) was overturned, but here I would suggest she is incorrect – there was no fundamental reversal, more a gradual development of increasingly sophisticated understandings of the complexity of photographs, especially their ideological power as a means of representation (p. 41).

Photography was able to assume 'truth' to some extent because of the technology at play, that the camera, or a particular type of camera, was a standardised instrument helped to lend certain expectations; photography remains important to documentary processes, indeed, as Lehmuskallio posits, inescapably so. Kelly (2014) discusses the importance of photography as an important bearer of truth:

> Given recent developments in computer-assisted digitization of images, the photographic tradition of the past 150 years may have ended. During its history, photography was *the dominant bearer of visual truth, at least for those living in modern, industrialized societies*, who understood and tended to trust the medium's technology. This trust was never entirely naive. Few, if any, doubted that individual photographs might reflect the partisan views of their makers and interpreters, that they might be manipulated, and that their messages might intentionally be skewed; but it was also generally believed that the photograph could approach objectivity more readily than other images having similarly dense construction (paintings or drawings, as opposed to more schematic diagrams or maps). The photograph needed only to compete successfully with other accepted mediums in order to represent the 'truth'. In its favour, the practice of photography involved a standardized technology, with lens, exposure, development, and other such factors being specifiable; this meant that its image would be consistently related to its model throughout. The causes of its results would be traceable, so long as one knew the specifications. Photography also entailed a good measure of mechanical automatism, lending a hands-off or tamperproof quality to the process. These features ensured that something approaching a common standard of judgment could be applied when interpreting the photographic product. Computer-assisted digitization changes the situation because it introduces remarkably nuanced ways of fabricating photographic images, in effect reintroducing the play of the human hand (as

sequences of applied computer algorithms). The 'hand' may always have been present in more conventional forms of photography, but digitization makes it especially difficult to entertain the fiction that such an intervening 'hand' is lacking or that a fixed mechanism guides the medium's operation.

Photography and photographs can still contribute as evidence within the discipline of anthropology, argues Edwards (2015), but she queries *evidence of what?*

> I would argue that photographs and responses to them are woven into the very fabric of contemporary experience and the negotiated relations between past, present and future, and living and dead, spirits and ancestors, and places and spaces of connection. This is no linear trajectory, of either anthropological method or representational practice, but a folding together of anthropology's own pasts and presents, for better or worse, with the pasts and presents of other people. Consequently it can be argued that *ultimately photographs are evidence of affect, of how people feel, and think and negotiate their worlds, and as such photography and photographs are at the very heart of the anthropological endeavour.* (p. 248, my italics)

Contemporary ethnographer Allison Singer (2000) reminds us:

> As I understand anthropology, it is the meaning informants give to things they do and things they see that is important. Then, in a more contemporary context, the researcher also acknowledges where they are coming from and what might be influencing their analysis and what has influenced the decisions they have made in the field regarding data collection – in ethnographic research photography is a form of data collection *and says as much about the research as the informants.* (personal correspondence, 2021 my italics)

This attitude is a move away from what from early anthropological endeavour using the camera as a scientific recording

instrument, which Grimshaw and Ravetez (2009) have described as 'naively empiricist and lacking reflexive sophistication' (p. 538).

To re-capitulate, photography is a complex phenomenon, with tremendous power to help us think about the human condition, though in this age of digital manipulation we also need to look with caution upon photos as 'evidence'. The above chapters have discussed the distinctive quality of photographs and thought about the ideological nature of images and the complexities around documentation. This chapter has highlighted that in social science research and in ethnographic fieldwork, context is an important issue, as is the use of the image – the 'social acts' to which it is subject. Contextualising text can become very important to prevent misreading, or at least to offer some resistance. On the other hand, if misapplied, there can be a foreclosure of meaning. To give one example, a research assistant added captions to a set of legacy research project photographs for a website in a way that didn't really relate to the particular case studies in question. I suggested that instead we use quotations from the subjects themselves as the captions, which allowed for a more expansive reading of the images. Indeed, not pinning down meanings, encouraging heterogeneity, might potentially be used strategically in the delivery of research findings and become important to stimulate questions and debate (see point 9. *Image making can foster the exploration of embodied knowledge*, above).

Another issue that has been highlighted is that of polysemy. The importance of the viewer has been explored in terms of meaning making and interpretation and this creates complication in the use of photography in research environments. Tensions are created by wider context – the intertextual space inhabited which can subvert intended meanings and create new connotations, which in turn create new resonances (an issue that content analysis can struggle with, as images are more mobile now, and how they are read is context driven). Digital technology has allowed moving images, such as before and after scenarios to instantly appear online – allowing for 'flashbacks' of groups of people or places. Certainly this can be both arresting and useful for showing cultural change, changed use of space, etc. 'Live' photographs can also be attention grabbing.

This chapter has emphasised that photography, whilst useful to research and research processes, needs to be used knowingly and carefully. Though reproducible, the photograph produces a singular event, and when we encounter a photograph, we encounter *this* photograph in its particularity 'what Lacan calls *Tuché*, the Occasion, the Encounter, the Real, in its indefatigable expression' giving photography a particular enduring potency (Barthes, 1980, p. 4). Issues of temporality have been underscored: the pulled-out-of-time quality of photographs has been noted as having distorting effects; the emphasis on a moment's detail has been discussed as potentially leading to misrepresentation, or even stereotyping. Notwithstanding, photography retains a legacy of verisimilitude despite the recent de-stabilising of the image via the digital and the blight of fake news incorporating generated photographs. Its ontological complexity has been highlighted. The particular relationship of the photograph to reality needs to be considered when photographs are being used as part of research evidence and research processes as method. Some important ideas about the particularity of photographs have been highlighted, especially the important influence of Barthes and ideas about the photograph carrying a 'trace' of the past, and the implications of this for their use in research. Barthes pointed out that the 'reference' is of fundamental importance to photography; *what is actually depicted uniquely sticks to the image*. The referent as trace endures: perhaps de-contextualised, weakened, re-interpreted, contested *but nevertheless held* and this is arguably a unique and important aspect of photography.

Photography provides a valuable resource for research, but images must be used knowingly, rather than naively, and we should be analytic in our reception of them. Furthermore, photography, as a social custom, also tells us about social relationships, so anthropology is thinking further about this in its analytic practices.

Finally, semiology really didn't develop into a science as Saussure might have predicted, but as semiotics it has provided a critical means of looking at visual culture and the politics of representation; it is a useful tool in cultural analysis as Nochlin's work demonstrates. Semiology gives us a way to think about how we construct our own photographs.[4]

6

AN INTRODUCTION TO RE-ENACTMENT PHOTOTHERAPY

ANTECEDENTS AND EVOLUTION OF RE-ENACTMENT PHOTOTHERAPY

The images that surround us play a crucial part in the formation of our subjectivity. Representation (in images and language) is crucial to identity formation and the construction of our sense of selfhood. Language, in its broadest sense, can be used to both explore and resist oppressive discourses. Phototherapy and therapeutic photography, in a British context, has its antecedents in the collaborative work of Jo Spence (1934–1992) and Rosy Martin and is interested in social critique as a form of empowerment and therapeutic endeavour. Martin is clear, following Burgin, that there is no essential 'self' that precedes the social construction of the identity through processes of representation; she argues that we are sites of discursive struggle:

> 'Identity is not inborn, pregiven or "natural". Subjectivity is fractured, contradictory, ambiguous and disrupted. It is striven for, contested, negotiated; it is not achieved by an act of will, nor discovered in the inner recesses of the soul, but rather put together in historical circumstances, in collective and individual experiences, and subject to challenge and change' Representations cannot be simply tested

against the real, since everyday commonsense 'reality' is
based upon and formed through a pre-existing overlay of
existing representations. (Martin, 1991, pp. 95–96)

This is why representational practices, such as photography, have
a power and significance when applied and explored therapeutical-
ly; phototherapy as it developed between Martin and Spence was
not just orientated towards traditional therapeutic explorations of
selfhood, rather it is a practice which had this idea of the self as a
discursive formulation in relation to representational forms at its
centre. Martin (1991, p. 96) acknowledges a dearth of images of
certain subjects and also a naïve attempt to fill gaps with 'positive
images' of those underrepresented, as if it were possible to overturn
negative stereotypes with such 'positive' replacements. Something
more interrogative is required. She writes:

> Much of the original work on identity sought to find 'posi-
> tive images' for those who are outside dominant culture
> …. This work was founded on the premise that by creating
> a fixed positive image it was possible to overturn negative
> stereotypes. This premise assumes that a photographer can
> create and fix a particular reading and meaning within an
> image – that somehow intent is all. But this ignores the
> context for viewing the image: where it is seen, what words
> accompany it, what other pictures frame it. It ignores the
> role of the audience: what particular viewers may bring
> with them in order to interpret an image in terms of ideas,
> other pictures seen before, their visual vocabulary and other
> points of view. It also ignores any unconscious responses to
> images. There are ways in which identity work always does
> link back into stereotypes for the audience, since these are
> the short-hand versions of the world that people use to
> categorise diverse and complex ranges of meaning in order
> to make 'common sense' of them. Stereotypes are linked to
> underlying power relations, and call up an intuitive belief
> in their generalised prejudicial assumptions.

Martin's work on lesbian identity took on major theorists, such
as Havelock Ellis, and explores cultural clichés surrounding

lesbianism and lesbian identity to challenge some of the oppressive implications of such theory; of the lesbian, Havelock Ellis (1897) asserts 'She shows, therefore, nothing of that sexual shyness and engaging air of weakness and dependence which are an invitation to men' (cited Martin, 1991, p. 100). In a modern context, hearing that 'weakness and dependence' are alluring to men is somewhat disturbing. Martin toys with notions of 'unobtainable masculinity' whilst at the same time underlining that many of the 'traits' associated explicitly with the lesbian could now be applied to many modern women, so hence the relativity of the 'scientific' generalisations are exposed. The exploration is multi-dimensional, playful and also personal and painful in her exploration of homophobia. The work 'What Does a Lesbian Look Like?' intentionally explored a range of possibilities, from 'unobtainable masculinity', to the 'politically correct' feminist, another who is a weary lesbian mum and 'mother of three', to the 'femme'. So there is no one image, lesbianism is diverse.

Fig. 30. Rosy Martin in Collaboration with Jo Spence. What does a Lesbian Look Like? 1986. © Rosy Martin.

Spence described her photography practice as a form of cultural 'sniping'. She had already embarked on an ambitious trajectory, of critique and deconstruction prior to meeting Rosy Martin. Mark Durden (2013, p. 218) summarises Spence's theoretical contribution achieved through her distinctive photographic practice and her writings:

> Jo Spence's writing presents photography as a powerful tool with which to address questions of cultural and political struggle. It has contributed to the 'visual literacy'

in educational contexts, changing attitudes with regard to ethical photographic documentary, the establishment of the political and the autobiographical as valid subject matter, and the development of staged or fictional photography, and, above all, the use of photographs for the purpose of debate. Her writing ... always reflected her concern to use photography to address issues of class and power Spence's critique of representation contributed to the extensive 1970s debate about documentary photography In her concern to reconfigure what photography can do, Spence drew attention to social contexts, to the political content of personal photography and to the fictional aspects of documentary determined by the photographer's agency. Early essays expose the myth that photographers can be neutral or *un*political and argue that photographs always carry ideological messages that help to shape attitudes, values, and what we consider to be 'real and normal' (Spence, 1995, p. 31).

Jo Spence's work can also be seen as part of a yet wider movement in the 1970s and 1980s of feminist and critical cultural studies exploring these ideas, especially the ideological power of images – indeed, the ability and role of images to buttress oppressive discourses. What was particularly powerful about her work is that the interrogation was carried out through photographic practice. As Stuart Hall notes earlier, images have an unparalleled capacity to cut through what he calls ideological 'frames'. Spence describes this attempt to explore and highlight the ideological (or cultural 'conditioning' embedded in the image) as a process of 'making strange'. Roberts (1998, p. 200) described her contribution as intervening 'ideologically into areas of daily social practice with which a non-specialist public could openly identify'.

Early work included an interrogation of the family album and its ideological force in containing and suppressing narratives. 'Making strange' is an attempt to interrupt of our habitual ways of seeing. Roberts (1998, p. 202) expands further on the album's power, 'one of the consequences of the conventional family album is to lock the past and its subjectivities into certain typifying narratives'.

Roberts (1989, p. 202) notes that for Spence deconstructing the family album involved:

> The dismantling of prevailing cultural hierarchies about what has aesthetic significance, and the insertion of a conscious, critical agency into the representation of family life.... Working with what is disavowed or forgotten, Spence's aim was to produce a *counter*-memory of the everyday.

Roberts (1989, p. 202) expands on the importance of this work:

> The ideological force of the family photograph is always determined at a powerful level by the suppression of those memories that resist the consecration of family life, those memories that dissent from the mute, symbolic resolutions of the family album genres. In these terms, to reinvent the dominant genres of the family album is to reinvent the family subject's relationship to their own history and therefore to the conditions under which knowledge of the self is produced. To intervene consciously into the process of family documentation means judging why certain actions and their outcomes should or should not be seen

Spence (1986) wrote:

> For those of us who are photographic workers it is obvious that a vast amount of work still needs to be done on the so-called history of photography, and on the practices, institutions and apparatuses of photography itself, and the function they have had in constructing and encouraging particular ways of viewing and telling about the world. The photo work ... is an exploration of our attempts to work through some of this problem by 'making strange' the everyday, normalised, institutional practices and codes of 'the trade', re-ordered, re-modelled, re-invented, so that their common sense, unquestioned notions become disrupted. We are not trying to show familiar objects in unfamiliar ways, but rather to denaturalize the genres of

photography Above all, we wanted to get away from the dry didacticism which pervades so much worthy work on photographic theory and to provide instead a kind of 'revolt' from within the ranks. In a funny sort of way this is a return to our class roots, where adversity and oppression are dealt with not only through comradely struggles or learned exposition, but lived out through individual or group rituals like sarcasm or irony (which is commonly termed 'taking the piss'). We aimed to produce something which was perhaps not quite in such 'good taste' as it usually expected; something which tried to break down some of the sacred cows of photography and bourgeois aesthetics (pp. 118–119)

The work of Spence was perhaps most notable from a health humanities perspective for its interrogation of her experience of being a cancer patient in the early 1980s. However, this work built on her earlier examination with alternative family albums. Roberts (1989, p. 205) explains, that

to deal with her own cancer was to *become* the documentary object, and as such to feel the full weight of how such an illness has been invisible to everyday consciousness. Suddenly the issue of 'making visible', and extending the categories of the family album, became a highly emotive issue of self-description; theory was now grounded *in* the autobiographical.

Spence took her camera into hospital. She said of the experience:

I used the camera as a third eye, almost as a separate part of me which was ever watchful: analytical and critical, yet remaining attached to the emotional and frightening experience I was undergoing. (Spence, 1995, p. 130)

Spence was able to depict what might be described as iatrogenic practices of the hospital (illness-inducing aspects of hospital culture, as well as the overall dynamics of institutional power). It is a cultural critique and therapeutic practice both as one, exploring the myriad ways that patients are dehumanised, disempowered and

infantilised through 'routine' institutional regimes and discourses – from how she became the object of the ward round, to the norm of the male doctor standing over, rather than seating himself. Roberts (1998, p. 205) discusses the importance of this intervention:

> This seemingly innocuous event – the taking of pictures inside a hospital – had profound implications for her future practice, and has had profound implications for contemporary debates on photography and the everyday. For it showed in stark ideological outline how powerful institutional boundaries are denoting what is seen to be permissible *as* the 'everyday' and what is not. The voice of the expert, professionalised medical ethics, the view of the patient as observed supplicant, all made it possible for Spence to openly confront the power relations involved in the treatment of cancer.

It should be recalled that cancer was very hidden per se in the 1980s, and that there was a strong social taboo prevalent in the United Kingdom at the time about even admitting publically to having cancer. Indeed, those with cancer were ostracised, as though it were contagious, so people often did not disclose their illness. This, and an abundance of theories suggesting that individual maladaptive behaviours were responsible for its development, led cancer patients to feel isolated and ashamed. Her work began to interrogate the 'medical gaze'.

Here she describes the encounter that started the project (Spence, 1996, p. 150), having been called into hospital:

> Dutifully, so as not to waste time, I took with me several books on theories of representation, a thin volume on health and a historical novel. One morning, whilst reading, I was confronted by the awesome reality of a young white-coated doctor, with student retinue, standing by my bedside. As he referred to his notes, without introduction, he bent over me and began to ink a cross onto the area of flesh above my left breast. As he did so a whole chaotic series of images flashed through my head. Rather like drowning. I heard this doctor, whom I had never met

before, this potential daylight mugger, tell me that my left breast would have to be removed.

Spence re-enacted her encounter with the doctor, which was not photographed at that time, in a re-enactment phototherapy session with Rosy Martin, which explored her experiences that day of infantilisation. Thus, she attempted to reclaim her experience and sense of self, she explored her version of events and took her own power. She used these images publically to challenge existing treatments of cancer patients in her multi-layered exhibition *A Picture of Health*.

Roberts (p. 206) summarises the importance of this body of work:

> Essentially, this process of self-inclusion involved a radical transformation of her self-identity as a woman and a cultural producer. Her own experience of her damaged body became an 'asset'. She discovered that by using her body without constraints, she could tell the stories she wanted to tell about her own history and communicate these to other people who had been through similar kinds of experiences. In these terms this kind of self-representation leaps over the separation of subject and object in conventional documentary, to assert the possibility of the subject taking some control over their self image.

Sherlock (2012) describes Spence's overarching legacy thus:

> Taking aim at certain personal and political myths – the family snapshot, the domestic goddess, the cancer victim – her work asks unflinching questions about the power structures of visibility, of who can be seen under whose terms and in what light. (p. 1)

This is the tone, which informs her collaborative phototherapy work.

RE-ENACTMENT PHOTOTHERAPY IN PRACTICE

Spence (1995) explicitly suggested that photography should be used as 'one of the healing arts' and went on to co-develop a practice of

re-enactment phototherapy with Rosy Martin (p. 165). Re-enactment phototherapy developed out of an amalgam of co-counselling and feminism. Re-enactment phototherapy is interested in challenging dominant stereotypes and in creating new, more empowering narratives which are told in a pictorial sequence and are frequently publically exhibited as part of the process – indeed, the work is displayed openly as a proclamation (Martin, 2012). Text narratives may or may not accompany the work. Re-enactment phototherapy is an interesting and powerful practice because of the way it straddles the line between social science research, political activism and art, with a strong therapeutic dimension.

> Drawing on techniques learned from co-counselling, psychodrama and a reframing technique borrowed from neuro-linguistic programming therapy, Spence and collaborator Rosy Martin began developing their own form of phototherapy. In a challenge to the orthodox idea of fixity within portraiture, Phototherapy presented new forms of representation which allowed for multiple, fragmented selves. Martin and Spence created a personal therapy tool, producing work that allowed the subject to control their image and represent their own difficult and often previously unexpressed feelings and ideas In a number of different sessions, Spence worked through a number of personal histories and traumas such as going into hospital and her feelings of being infantilised; her relationship with her mother and feelings of abandonment while she was evacuated during the war and her emotional roots to patterns of eating. [Further photographic work] ... extended Spence's interrogation and decoding of sexuality, family and class. (Pieroni, Scotland, Shelley, & Vasey, 2012, p. 24)

Pieroni et al. (2012) said of the technique that by 'Working collaboratively and taking it in turns, the person in front of the camera was both subject and author of the image' (p. 24). However, Martin suggests that this is a fundamental misrepresentation of a technique that was and is fundamentally collaborative, hence the duel credit always given to the work.

Spence and Martin met during co-counselling training and during an exchange in pair work they came up with the idea of playing with aspects of their identities, which they felt had been hidden or denied.

> Our innovation was the creation of new photographic representations through performative re-enactments, within a therapeutic relationship ... we photographed one another, as we inhabited these roles. In some of our earliest work we used an old family album image as a starting point Crucially, we used what had been unearthed in the counselling beforehand to structure a session and explore a range of feelings in the process We soon realised that we had discovered a very powerful technique. (Martin, 2009, p. 41)

Martin (2009, p. 41) notes that some of their initial engagement was prompted by a lack of imagery, as film had been scarce during WWII and in the immediate post-war period and there were too few photographs:

> The work grew from an autobiographical engagement with the complexity of the multifaceted aspects of an individual's identity. We had started by deconstructing the existing visual representations of our lives and became acutely aware of the structured absences, and the paucity of representations within the dominant media that were available to us as middle-aged working class women We began to tell and explore ways of making visible the complexity and contradictions of our own stories, from our points of view, by re-enacting memories and imagining possible futures We showed the effects of institutional gazes and attitudes upon the individual, rather than seeing these as privatised distress. We highlighted the psychological and social construction of identities within the drama of the everyday.

Rosy Martin works in an intense way when running workshops and asks her participants to keep a photo diary to create images

on the subject chosen for reflection. This is how she describes the photo diary technique:

> The workshop participants were encouraged to experiment and use the digital SLR cameras to tell the story of their lives now, in complex and challenging ways that go beyond the traditional family album style. They were encouraged to find their own ways of using images as a means of expressing their experiences, feelings, thoughts and insights about themselves as ageing women. The ideas of using objects, places, the everyday or the extraordinary were suggested to open up a sense of possibilities and to inspire the use of metaphoric representations. Having each created their own extensive photographic diary, they were asked to edit, to choose twelve images and have these printed out to work with in the following session. They worked in pairs to articulate these stories of their lives through exploring their chosen images, in an open-ended way, whilst their partner listened, asked key questions and offered support. These personal narratives were then shared in the group When these feelings, thoughts and insights were voiced in the group work, there was a sense of recognition and acknowledgement, so that each could feel 'heard' and understood. This approach concentrates upon the individual, and from that moves out into the social, to make more 'general' observations. (Martin, 2012, p. 1)

Before Martin moves on to the re-enactment phase of her work, she uses found photographs as a way into telling the stories that lie within images. She suggests their benefits:

> They have the advantage of being anonymous and decontextualized. This allows for a much freer reading, since there are no potential conflicts regarding personal loyalties, nor self-silencing evoked. In my workshops, I use a selection of old family album photographs, alongside some contemporary images, which share the anecdotal captured

moment aesthetic of domestic photograph. I lay these out, and invite the client to choose one that they are drawn to, quickly, without intellectualising their choice. Clients are invited to tell a story using their chosen photograph as a starting point, by entering the space of the image, identifying with one of the individuals in the photograph, speaking from the first person, thereby inhabiting the imaginary space offered up. (Martin, 2009, pp. 38–39)

Martin's approach is always to see the individual within her social and cultural contexts, rather than to focus in purely on psychological processes. Martin's work, like that of Spence, spans many topics. In the workshops on ageing, the women also worked with found images, and a selection made from their own family albums; these were used to enable participants to consider and re-assess how each felt about her own life and respond to narratives of ageing. As Martin (2011) put it, 'Through a series of carefully structured sessions, each woman found the aspects about herself and her relationship to ageing that she wanted to make visible' (p. 1). Martin notes that:

Re-enactment phototherapy makes visible the performative body. The photography sessions are not about 'capturing' the image, they are about seeking to make it happen, to 'take place.' It is about a staging of the selves and knowingly using visual languages, referring to and challenging other pre-existing visual representations. Thus it makes visible the constructions of identities rather than revealing any 'essential' identity.

Martin (2009, pp. 43–44) emphasises that this is an embodied way of working and highlights the transformative elements of the work:

This is a very physical way of working, in which the body expresses the emotions. The chosen role is entered into and the scenario is re-played in the here and now. The body speaks its knowledge through gesture and movement as the emotional stories unfold. Its eloquence is recorded. Clients embody the issues and personal narratives they wish to

work on. By re-experiencing a range of frozen and previously repressed emotions in the here and now, and moving from there into a transformation there is a shift and a cathartic release. The transformative aspect is needed to create images of the potential for change, for example finding an inner nurturing part of the self to challenge a punishing super ego. This is crucial to the process, not merely to represent old pains, which could re-enforce distress, but rather to offer a possibility for another way of being.

THE RE-ENACTMENT PHOTOTHERAPY TECHNIQUE

In terms of process, it is important to emphasise that Martin does a lot of work to build up to the intense re-enactment sessions (such as facilitating group members talking about photo diary images; imaginatively creating stories from found images; practising role playing different power positions: parent/child, student/teacher, etc.).

The re-enactment phototherapy technique involves participants working together in pairs and determining specific scenarios to investigate, enact and re-interpret. The participants take turns being the performer/client and then the photographer. Each person has the chance to explore a narrative, which is photographed at various points by her partner, using props if required, to help the presentation of her story. The control of the general process rests principally with the person telling their story, with the photographer operating very much under her direction, in a supportive and accepting role. The sessions may start off with an exploration of an individual story, or issue that has arisen in the therapeutic work. In the pair therapeutic work, the photographer's role is more than that of simply being directed. Drawing on the knowledge gained in the therapeutic sessions the photographer enables the 'sitter' to tell her story and may offer prompts. Thus, both the sitter/director and the therapist/photographer have an active role on the image creation. Martin (2011) explains the method:

> Working in pairs, each woman performed her stories, using her chosen clothes and props and determined how she wanted to be represented. The woman being

photographed asked for what she wanted, and photogra-
pher was supportive, encouraging and was 'there for' her
partner as witness, advocate, and nurturer, whilst photo-
graphing the process as it unfolded …. It is a collaborative
process both sitter/protagonist and photographer work
together to make the images. (p. 2)

There is a strongly egalitarian aspect to the work:

Our work is collaboration between equals, in which we
take turns to be the client and the psychotherapist. In
this exchange of power relationships, the sitter/director
explores her story, determines the subject, the props and
the image, facilitated by the phototherapist who gives per-
mission, support and reflection, and uses role play, gentle
encouragement, provocation and contradiction to enable
the sitter/director to get deeply in touch with feelings she
has learnt to hide. Our therapeutic style is playful and
offers release from stored tensions, traumas and grief.
(Martin, 1991, p. 97)

Martin stresses the therapeutic dimension of her work, and
highlights that the woman in the role of photographer offers sup-
port and a 'gaze of nurturance and permission' to the sitter. Martin
(2013) expands on the therapeutic gaze:

Within the photo-session, the client is offered a therapeu-
tic gaze, which is akin to that of the 'good enough mother',
mirroring back the reflection of what is there to be seen to
the client. This gaze is offered within a context of safety,
trust and acceptance. The therapist acts as witness, advo-
cate and nurturer. There is also a sense of encouragement
and permission giving, if the client starts to become self-
censoring. This then provides a containing environment,
within which clients can explore the full range of their
emotions. (p. 73)

In Representing Self, Representing Ageing, each photographic
narrative sequence ended with images of transformation: the pro-
cess as a whole enabling each woman to find ways to transform or

re-frame aspects of her lived experience. Reflecting on her work, Martin (2011) added:

> The re-enactment phototherapy sessions produce an atmosphere of playful creativity. The roles are exchanged, so both have the opportunity to be in the picture, and to be the photographer. The resulting images challenge stereotypes of ageing. The whole process enabled each participant to find ways to transform her views of herself. It is therefore important not just to look at the phototherapy image in isolation, but as part of a developing narrative.

With respect to her creative ageing work (Representing Self, Representing Ageing), some of the photographs constructed a pictorial story and text was also used to supplement the photographs, when exhibited, to help to narrate the stories. The importance of the re-enactment phototherapy technique with respect to portraiture is summarised by Roberts (1998, p. 206) who notes that the idea of being able to depict interiority is part of the theoretical framework of portraiture, with good portrait photography being about capturing the 'subjective essence' of the sitter. Re-enactment psychotherapy is important because it debunks this idea.

> The development of the technique of phototherapy, then, is an open recognition of the obvious cognitive limits of portraiture, yet at the same time an attempt to use portraiture as a means to work through the relationship between images and personal identity. Instead of the highly codified and idealised moment of self-presentation in conventional portraiture, phototherapy involves the subject and photographer (or photographer as subject) in an extended process of self-questioning. To adopt such an approach is to 'get inside' the self-image of the subject, and its powerfully embedded histories Spence and Martin refer to this process as 'reframing'.

Martin's work on the lesbian and Clause 28 in a re-enactment phototherapy session with Jo Spence concluded with her being bound with bandages on which homophobic remarks extracted from the Parliamentary debates on Clause 28 and the rejecting

words of her mother, when Martin 'came out' to her were inscribed.[1]
This was a visceral fight to re-frame:

> I struggled, pulled and stretched myself free for a moment.
> No, phototherapy is not a magic cure, but it does help to
> say the unsayable, to make visible to others what they are
> doing, and to make visible to myself how my internalisa-
> tion of hatred, disgust and fear silences and contains me.
> And how it could feel to break out of these projections.
> So this work was both a highly personal and political
> response to Clause 28, and it enabled me to make a force-
> ful statement, publicly. (Martin, 1991, p. 104)

The therapeutic process needs to have been concluded before
any photographs can be shared or put on display; otherwise the
protagonist could be placed in a vulnerable a position that could
be potentially exploitative or emotionally counter-productive. As
with all psychotherapeutic work, the 'boundaries' of the sessions
are carefully negotiated. The photographs are only shown with
the express permission of the sitter/director; in practice it is nearly
always at their instigation. Consequently, almost all of the pho-
tographs produced in re-enactment phototherapy remain private.
In terms of the development of the technique, Martin and Spence
(1987) shared their work in an art context because they were keen
to share and promulgate their ideas. This transition from explora-
tory 'process' work to exhibition involves a stepping back and con-
sideration of the communicative power of the images. Photographs
chosen for display were those considered to speak about the social
and cultural formations of subjectivities.

Re-enactment phototherapy offers a methodology for explor-
ing selfhood and making aspects of the self visible and open to
scrutiny. It is a bodily and body-focussed exploration, relying on
'embodied eloquence': 'The languages of the body; gesture, facial
expression and movement' which is photographically recorded, but
not analysed in the moment (Martin, 2013, p. 80). There is a defer-
ral, so that the flow of action in the pair work, described above,
is not interrupted. The images produced are then used in counsel-
ling/psychotherapy sessions to explore, interrogate and integrate
the feelings visible in the images. This emotional processing of the

images is a vital part of the practice, and enables the protagonist to interrogate, internalise and learn from their, different, multiple representations arising from the photographic session. The final part of the process can, if wanted, be the exhibiting of key works, often with accompanying texts, the images themselves creating pictorial stories.

As illustrated, the practice has a strong therapeutic dimension. It is a distinctive therapeutic approach interested in thinking about representational systems in relation to identity formation and the construction of our sense of selfhood. It keeps in mind that the personal is political. To conclude, re-enactment phototherapy is a fascinating and impactful hybrid practice straddling the line between political activism, therapy, photography and art.

7

THERAPEUTIC PHOTOGRAPHY

THERAPEUTIC PHOTOGRAPHY OR PHOTOTHERAPY?

Therapeutic photography is a generic 'umbrella' term within the arts in health and incorporates a great range of practices from community-based participatory arts (techniques such as photo diaries) to intense confidential therapeutic group work.

Historically some psychotherapists have shown an interest in incorporating photographs as part of their clinical practice and have used the term 'phototherapy' for this process. An early definition of phototherapy (Steward, 1979, p. 42) is 'the use of photography or photographic materials, under the guidance of a trained therapist, to reduce or relieve painful psychological symptoms and to facilitate psychological growth and therapeutic change'. This is an explicit use of photography within psychotherapy practice for unambiguously therapeutic purposes. Another early definition described phototherapy as 'the use of photographs or photographic materials by a trained therapist as an aid in the alleviation of psychological symptoms or to aid in the personal growth of clients' (Krauss & Fryrear, 1983, p. ix). In contrast, Roberto Calosi (2020) uses phototherapy as part of a biographical therapy practice to create personal balance through inner activity, to counter the world's pressure on our senses. It is also seen as an activity enabling us to become more conscious of our own position in the world and in the community that we inhabit, thus here we have a slightly more outward-facing understanding at play less focussed on symptom

reduction and explicit therapeutic change. Arts practice, including photography, is revitalising, Calosi argues.

Gibson (2018, pp. 22–23), a social worker by discipline, suggests that the term 'therapeutic photography' encompasses a broad range of activity:

> An extensive description of therapeutic photography includes the application of photography to increase self-knowledge, awareness, well-being, relationships, and to challenge societal issues such as exclusion, isolation, intercultural relations, conflict, social injustice

Halkora (2013) also notes a broad range of endeavour, 'The targets of therapeutic photography might be health promotion, healing, rehabilitation, empowering work, or learning to express yourself' (p. 21). Gibson's (2018) final definition of therapeutic photography is:

> Therapeutic photography is the structured, guided, engagement with the creative intervention of photography in order to produce images for exploration with clearly defined outcomes for the participants. (p. 33)

This is rather an open definition of therapeutic photography. Gibson (2018) attempts to formulate a distinction between photography as part of therapy, which he calls phototherapy and a broader range of activity of therapeutic photography:

> 'Therapeutic photography is the term used for photographic practices in situations where the skills of therapists or counsellors *are not needed* ...' and is aimed at 'deepening understanding of the self with an aim to reduce inner conflict and enhance coping strategies' (p. 23, my italics)

The above emphasis on deepening personal understanding, the reduction of inner conflict and developing coping strategies are broadly speaking therapeutic endeavours, but not conducted within the confines of an ostensibly therapeutic relationship.

Gibson suggests that therapeutic photography can be used in practice to enable an exploration of social identity and roles and

can help to stimulate critical thinking. In particular, it can assist individuals in comprehending their social environment so they can map their roles within situations. Furthermore, the making and discussion of photographs can assist the ability to define other people, and help predict how they might behave, in turn improving an understanding of how the world functions. Moreover, an exploration of shared social identities affords a sense of 'unity and security' (p. 40). Therapeutic photography can be used to explore self-image, and consequently issues such as self-esteem. The creation of pictorial narratives can be important to this process. Photography can be used to investigate relationships through the life-course, including the expression of emotions and attachments; photography can be used to explore change, including loss. Furthermore, therapeutic photography can be used to attempt to make changes in society and photography can be used to uncover collective experience.

Gibson's distinction between 'therapeutic photography' as a broad range of practices and phototherapy as the use of photography within a therapeutic alliance rather falls down when we consider the example of re-enactment phototherapy discussed above. Re-enactment phototherapy evolved out of co-counselling, is not necessarily delivered by trained therapists, yet it has a strong psychotherapeutic dimension. Rather than a clear-cut division, Lowenthal (2013) suggests that therapeutic photography and phototherapy are not completely separate entities; both, he suggests, are 'photo-based healing practices' and are better understood as being on a continuum (2018, p. 82): 'In practice, the distinctions between phototherapy and therapeutic photography are not always clear ...' (p. 83).

Broadly speaking, therapeutic photography can be understood to traverse much of the same terrain as phototherapy, but therapeutic photography may be offered by social workers, or by other professionals. Phototherapy is more likely to be an explicitly therapeutic intervention carried out by qualified therapists; however, a clear-cut distinction of terminology is hard to apply. Furthermore, re-enactment phototherapy may also be referred to as phototherapy. As one practitioner put it:

> Whilst distinct from more formal photo or art therapy, therapeutic photography can involve sensitive, ethically

complex and emotionally challenging work and should always be undertaken within a clear and supported framework.[1]

The terminology is not straightforward as there is not a clear-cut use of terminology within the field. Therapeutic photography is perhaps a more apt term in order to distinguish this field of work from 'phototherapy' as a term, which is also used to denote the use of light (especially ultraviolet light) for its healing effects in medicine. Photography conducted within the confines of a therapeutic alliance may be described either as therapeutic photography or phototherapy and that these terms may be used interchangeably.

Finally, re-enactment phototherapy is a range of techniques and practices arising out of the collaboration between Spence and Martin; it has a very particular social critical lens and is a genuinely distinctive intervention, though much of this socially alert and critical analytic practice is now permeating art therapy in general (Hogan, 2016; Huss, 2015; Talwar, 2019). I shall use the term therapeutic photography as the generic term for the entire field and phototherapy and re-enactment phototherapy as specialisms within this, when the authors themselves use these terms.

PHOTOGRAPHY WITHIN ART THERAPY

Art therapy is a well-established discipline (and recognised profession) that specialises in using images.[2] Today photography is used in several models of art therapy, especially the use of photographic collage (Hogan, 2016). The use of photography within art therapy corresponds largely to points five, six and eight of Krauss and Fryrear's list below (using photography to facilitate socialisation; using photography as a form of creative expression; using photography as a form of non-verbal communication between client and therapist). Some art therapists also use photographs to document change in therapy by photographing the art work, or use photo voice (described in Chapter 5) to survey a series of images over time and to reflect on them (point nine).

Art therapists have considerable understanding of art techniques and have undertaken post-graduate specialist training.

In the United Kingdom, art therapist is a protected term and can only be used by those who have completed a post-graduate level training course approved by the Health and Care Professions Council (HCPC). They are proficient in using materials to facilitate non-verbal communication. Metaphors, symbols and the expressive use of art and photographic materials combine to create a rich language for self-expression. Art therapy affords the possibility for the transformation of strong emotions into images that can have a visceral intensity. Different aspects of art making, collage and photography can combine to enable a sophisticated articulation of thoughts and feelings. The symbolic and metaphoric potentialities of images allow for complexity to be expressed. Moods and immaterial ideas and qualities can be depicted and explored, in ways, which it would be very had to articulate in spoken language. These are common aspects of all forms of art as self-expression.

There are several types of art therapy evident in the published literature underpinned with different theories (Hogan, 2016), or drawing together several theoretical perspectives into one model, which can have different degrees of emphasis within it (Waller, 2015). These different philosophical underpinnings do have a bearing on practice and are not inconsequential as they posit different ideas about what humans are, what ails us and how art can be used to relieve distress. Therefore, there are different opinions as to the precise role of the art therapist. How the use of art materials is advocated can vary and the language used to describe this can vary depending on the theoretical model at play. Not all art therapists clearly define their position and some may be 'eclectic', drawing ideas from different, even seemingly antithetical theoretical positions. *Art Therapy Theories* (2016) explores the nuances of practice in detail and articulates the primary features of a number of approaches including cognitive behavioural art therapy; solution-focussed brief therapy; psychoanalytically orientated art therapy (Freudian); Analytic art therapy (Jungian); Gestalt art therapy; person centred (Rogerian); a mindfulness approach; integrative (the group-interactive model); feminist art therapy; and art therapy as social action. All of these approaches have the making of images at their core, but have different philosophical emphases that lead to practice differences. It is not within the scope of this chapter

to elucidate the use of imagery within each of these distinctive approaches in detail (I refer you to *Art Therapy Theories* for that). Art therapy practice with photography will be elaborated further in general terms as part of the general discussion.

THERAPEUTIC PHOTOGRAPHY

Therapeutic photography is employed as part of art therapy practice (Hogan, 2001) and is also used by psychotherapists or others, such as counsellors, or social workers, frequently as an adjunct to a verbally focussed practice (Krauss & Fryrear, 1983). Berman (1993), a phototherapist, suggests that 'Photographs can act as a bridge, a link between two separate people and their worlds' (p. 64). This section will discuss the ways in which professionals such as counsellors, psychotherapists and art therapists are using photography in broadly therapeutic ways.

Photographs are being used to explore self-image, relationships, environments, society and culture. Because photography is increasingly part of day-to-day meaning making and a reflection of how life is experienced for many people, the digital native generation are at home using this technology. Therefore, therapeutic photography using familiar mobile-phone cameras is arguably very accessible.

Psychologists Krauss and Fryrear identified a number of specific ways that photography has been used in relation to the domain of therapy, and categorised these into the following broad areas: They are (1) using photographs to evoke certain emotional states; (2) using photography to elicit verbal behaviour; (3) using photographs of others as models; (4) teaching photography as a skill; (5) using photography to facilitate socialisation; (6) using photography as a form of creative expression; (7) using photography as a diagnostic adjunct to verbal therapy; (8) using photography as a form of non-verbal communication between client and therapist; (9) using photographs of or by the client to document change; (10) using photographs to prolong certain experiences; (11) using photographs of the client as self-confrontation; and (12) training therapists to use photography as therapy (Krauss & Fryrear, 1983,

p. 226). Certainly, we can see these areas reflected in the following discussion of contemporary practice.

THERAPEUTIC PHOTOGRAPHY IN PRACTICE

As Martin (2009) points out, photographs can be used to enable clients to reflect on their ways of viewing the world and their value systems, the photograph acts as both 'a channel and a catalyst for communication' (p. 38). This section will elaborate how photography is being used in practice by a range of practitioners. Drawing on the work of Weiser, Del Loewenthal (2013, p. 6), a psychotherapist, sets out five overarching ways that photographs can contribute to therapy:

1. As part of a 'projective process' that can involve looking at ways of seeing, insights, outlooks and expectancies.
2. Work with self-portraits to enable exploration of the images participants make of themselves.
3. Analysis of images made by others of oneself, to enable exploration of different perspectives.
4. Using photographs in metaphoric ways to think about selfhood or self-construction.
5. Thinking about 'photo systems' – that is analysis and reflections on biographical photographic collections or family albums.

It is important to acknowledge that these categories can be overlapping and interconnected, but this schema will now be used to give some approximate structure to the following discussion. These five main domains will be now explored in further detail.

Photography as Part of Projective Processes

Photography has strong communicative and therapeutic potential, as Sontag (1971) pointed out, 'photographed images do not seem to be statements about the world *so much as pieces of it*, miniatures of reality that anyone can make or acquire' (p. 4, my italics). Photographs can feel very real and immediate. Photographs or paintings

can have an embodied (or talismanic) presence infused with feeling. Joy Schaverien in her potent book *The Revealing Image, Analytical Art Psychotherapy in Theory and Practice*, explored this concept of projective processes in further detail. Drawing on psychotherapeutic theory and biblical metaphor, she suggests that images can become imbued with feeling – they become alive in a magical and *contagious* way. The emotion experienced on viewing the work is palpable, at least to the maker of the image. If the feeling invested in the image is unwanted, an act of disposal can take place (like the sacrifice of the biblical goat onto which the sins of the community were symbolically transferred). She calls this scapegoat transference. 'These are attempts to alleviate human suffering by diverting them to objects which are then thrown away or otherwise disposed of without harming others' (Schaverien, 1991, p. 48). She expands on this idea further within the context of an art therapeutic relationship:

> A client may make a picture of her pain or depression and this brings a certain relief through placing it outside of the body. This may be further established by disposing of the picture; maybe putting it out of sight, temporarily banished to the art room shelf. The relief is accomplished by the externalisation, followed by the disposal. Temporarily, the pain has been dealt with, with the acknowledgement of the therapist, especially if she or he physically puts the picture away. The magical belief is that the picture is felt to hold the pain in the marks [or image] ... the picture has been subject to simple scapegoat transference. (p. 48)

Schaverien is talking about images in general, but it may be the case that photographs are particularly prone to having talismanic properties, particularly when they include images of people. Berger (1991, p. 54) similarly agrees:

> Unlike any other visual image, a photograph is not a rendering, an imitation or an interpretation of its subject, but actually a trace of it. No painting or drawing, however naturalistic, *belongs* to its subject in the way that a photograph does.

This particular quality of photographs gives them a particular potency and therapeutic potential. Whilst Benjamin (1969, p. 225) thought that mechanical reproduction 'emancipates the work of art from its parasitical dependence on ritual', I would suggest quite the opposite, that ritual has tremendous therapeutic force with respect to photography, especially with regard to it's potential for externalisation and containment of feelings and their 'disposal'. This idea of the scapegoat transference, which Schaverien (1991) expounds so eloquently, can be important to therapeutic practice,

> [...] the picture ... mediates and becomes an object of scapegoat transference. Through the mobilisation of the natural propensity for splitting and projection, the picture becomes an object onto which a transference of attributes is made. The picture comes to be experienced as holding, in substantial form, attributes, which are usually considered to be intangible. (p. 60)

In therapeutic terms, Schaverien argues that the projection of attributes to the images allows for the re-integration and resolution of feelings (the transference) without the feelings necessarily being enacted in relation to the therapist. This is the traditional Jungian approach to art therapy (Hogan, 2001, 2016).

Lowenthal, working with children using a verbal psychotherapy method, takes a slightly different approach; he noted that in 'talking picture therapy' participants were invited to express and explore in photography aspects of their lives they'd like to talk about (p. 82). He reports that therapeutic photography can involve personal exploration that may be initiated, but may be more self-directed than explicitly guided group work. It is useful to work through 'an emotional constriction' (p. 83). Following a psychoanalytic (Freudian) emphasis, Lowenthal sees photographs as a route to the unconscious with the meanings ascribed to the photographs as 'projections' of repressed material. In psychoanalytic theory, projection is 'viewing a mental image as objective reality' and also 'a process in which wishes or impulses or other aspects of the self are imagined to be located somewhere in an object external to oneself' (Rycroft, 1968, p. 125). Projection is a complicated concept, because it is often associated with disavowal, in which there is an

attribution of states to another, or simply a denial of the emotion or wish (Rycroft, 1968, p. 139). Lowenthal describes repression as 'an unconscious exclusion of memories, impulses, desires, and thoughts that are too difficult or unacceptable to deal with in consciousness' (p. 83). Following Freud (1914), he notes that 'the theory of repression is the cornerstone on which the whole structure of psychoanalysis rests' (p. 16). Photographs are conceptualised, as a devise through which clients' repressed projections can be comprehended, and are therefore the crux of therapy. This approach he recommends as appropriate for those who wish to explore an issue. He suggests that a therapist who has some 'interpersonal training' facilitate the intervention and he warns off teachers from attempting brief therapy (p. 93).

The polysemic nature of the image has been discussed. Nuñez (2010, p. 17) emphasises the importance of 'multiplicity', and invites members of her group to tell what they see in the photograph. She is interested in demonstrating to the maker of the image the power it can hold, but she also uses it as part of a group process, allowing free association to the images by group participants, allowing imagination and metaphor to play a part.

> All works of art must be open to interpretation, can contain contrasting meanings or be read in completely opposite ways by two different people. When we choose the work of art, the first condition is that we can attribute a multiplicity of meanings or messages to it, since this is what we humans are: extremely complex beings. First of all, every member of the group will say what the image 'says' to them, so that we discover how wide is the range of different interpretations the picture can suggest Another technique is to try to imagine other elements, beings or objects which the subject's expression suggests, even if they are not really present in the picture.

Joy Schaverien's important discussion of transference and its potential therapeutic role has been noted above: that photographs can have an embodied (or talismanic) presence imbued with feeling. Therapists of different theoretical persuasions can work with this idea of the *aliveness of the image* in important ways as part

of their clinical practice; furthermore, aware of the potency of the embodied image, they are mindful of the importance of how the work is kept or destroyed. As Schaverien (1987) reminds us, the artwork may

> come to be experienced as the embodiment of the image it carries …. It may temporarily be experienced as 'live' and so, if consciously handled, its disposal may have the effect of a cleansing ritual. (p. 167)

Material produced during art therapy is therefore safely stored throughout the therapeutic relationship and remains the property of the person who produced it (BAAT code of ethics point 14.1). The art may be worked upon again and again (a photograph being digitally edited, or a mixed-media piece, or a photographic collage), therefore the object is stored so that it is ongoingly accessible to the participant.

Alternatively, in therapy, something distressing might be produced and the person who makes it might not want to see it again. What happens to the art produced is always of significance. Indeed, Patrick and Winship (1994) suggest that 'The disposal of a created piece, when art has been used as a medium for therapy, is a most important stage in the therapeutic process' (p. 1). At the end of therapy or at a mid-way point the images can also be spread out for review, or looked at sequentially in ways that can give an overview or narrate a story. But disposal of art works is not just an issue that pertains to the end of therapy, what happens to the image is always important. As Edwards (2018. pp. 91–92) iterates:

> The question of what happens to artworks after art therapy has ended is a complex one. It is, moreover, self-evidently one that is not restricted to the end of therapy. Clients dispose of their images and artworks during or after sessions by all manner of means and for all manner of reasons: including hostility, the need for containment, or through a desire to have the artwork – and, by inference, the person who made it valued. The fate of an image after a session has ended, may, therefore, involve its being displayed, offered as a gift, or possibly even destroyed.

In each case, the fate of the image or object has meaning and significance.

To give an example from my own experience regarding 'disposal', I participated fairly recently in an art therapy-summer school; during a clay workshop in which we were instructed to make a vessel, I found myself making a tomb out of clay and suddenly recalled my daughter's recently deceased dog with sadness. I made and put a clay dog into the tomb and sealed it up, though it was more like an organic shape, a seashell ... then I embellished the tomb and was flooded with feelings about an older unresolved grief. The tomb became the larger grief and I reflected upon how this grief had, in many ways, blighted my life and continued to act upon the present. I decorated the tomb with flowers and greenery from the gardens and it began to look like a ritualistic object. I felt the need to bury it. After I'd shared my feelings about the object with the group, I took my grief object into the garden where a 'grave' had been dug for it at a point in the grounds I had requested for the burial (the group facilitator had very helpfully explained to a porter who had actually begun a small hole in the earth and had left the spade next to it for me to use). I enlarged the pit and then buried the object and stood in silence for a few minutes with my feelings, acknowledging the full depth of the pain. Then I filled in the grave and as with a real grave, left some flowers upon its top. Though the grief did not disappear entirely from my consciousness after that event, it did somehow shift and resurfaced less often after this act of ritualistic disposal. The skill of the facilitator was to the fore in handling this. She understood disposal and was able to seamlessly facilitate what needed to happen – the procurement of a spade, permission to go ahead and group member to stand with me in case I needed support during the burial act.

So the notion of the embodied image is an important element of the therapy process. What happens to images at the close of ongoing art therapy is also of crucial importance to the welfare of art therapy participants (and this applies to photography in psychotherapy). According to Joy Schaverien (1991, p. 115):

A picture may be kept by the client, left with the therapist, or a conscious decision made to destroy the pictures. The point is that, when these decisions are consciously

arrived at, in negotiation with the therapist, they may be important markers for acknowledging the importance of the ending of therapy.

It is regarded as fundamentally good professional practice to keep clinical notes and images for at least three years after the close of therapy in professional art therapy practice. Sometimes art-therapy clients will return to therapy after a break; or months after the close of therapy, they might make contact and request particular art pieces which were of significance. It is ethically important that the works are kept safe so that if these requests arise, the clients can get what they need; this is regarded as part of the supportive professional service that art therapists provide, which is exceptionally containing and cognisant of the power of images in holding distress. However, the act of disposal may be the act of leaving the art with the art therapist. As Edwards (2018, p. 92) puts it:

> More often than not, clients dispose of their artwork by leaving it with the art therapist. Sometimes these artworks are left with the explicit intention of being collected or returned to at a later date. At other times they may be forgotten or abandoned, the process of making images in art therapy having served its purpose.

It is important that the end of therapy is handled competently. Judy Rubin (p. 128) notes at the close of therapy that 'products taken home are mementoes of your shared journey' (p. 130). Edwards (2018, p. 92) suggests that these images can serve as a useful bridge between the close of therapy and moving on:

> Painful though ending art therapy may sometimes be, it is essential that clients are able to consciously accept the reality of this. The images clients make in therapy may help them successfully negotiate the transitional period between the end of therapy and their acceptance of the reality of this ending. These images may, in time, be forgotten, destroyed or disposed of in some other way. But during this period of transition they can provide considerable comfort and reassurance to the client. Though it is difficult to define precisely what a good or satisfactory

ending might entail, it is, perhaps, one in which feelings of sadness and anger, along with those of gratitude, may be expressed and acknowledged as fully as possible.

In group therapy acknowledging the forthcoming end of a group will often evoke feelings of bereavement, abandonment, fear or anxiety and these are often the dominant themes of group work in moving towards the closing weeks, as well as visions of the future and how things might be different and better in going forward. A skilful facilitator will ensure that there is full acknowledgement of the ending of a group well in advance of the final session, so that there is time and space for painful feelings around endings to be fully explored. Art therapists undergo personal therapy and experiential group work throughout their intensive post-graduate training, so that they are experienced in this type of work. Gift giving can provide a good exercise to end a group. Here, I discuss the ending of a training group which had been illustrating a series of structured directive exercises (Hogan, 2014, p. 50).

> I ask participants to make a gift for everyone in the group (but not flowers or boxes of chocolate) – I ask them to think about each person and to make something apt; this can be a resource like inner strength or a quality that they feel the person needs, or would enjoy more of. Everyone in the group has disclosed something about their personal situation at some point. It is an opportunity to make a really personal statement and because the gifts are so personal they are often deeply appreciated

The gifts might be 3D works, drawings, photographs, mixed media or cards. I ask each person to give out their gifts in turn, to physically give the gift to the person it's intended for and to say a few words about why they have made what they have made. It's an ending ceremony of sorts and a final opportunity for reparative sentiment, if needed.

Self-portrait Therapeutic Photography

The transformative aspects of portraiture have been introduced in Chapter 4. Self-portraiture can be used in a myriad of ways in

clinical settings, for instance, in cancer care (Frith & Harcourt, 2007), drug dependency centres (Glover-Graf & Miller, 2006) and in psychiatric and community settings (Hanieh & Walker, 2007), or to explore gender identity (De Oliveira, 2003; Wheeler, 2020).

As noted above, therapeutic photography with an emphasis on self-portraiture has its antecedents partly in the work of Jo Spence and Rosy Martin, which was interested in social critique as a form of empowerment *and* therapeutic endeavour; it is a peer-to-peer process. Spence described her practice as a form of cultural 'sniping' – the social critique was an essential part of the practice in combating negative discourses which are unhelpful for wellbeing and this emphasis continued into re-enactment phototherapy. In re-enactment phototherapy, another person takes the self-portraits, but acts under the direction of the person being photographed, this technique allowing hands-free performativity. It also works with a sense of 'flow', Martin (2009, p. 43) explains:

> This work was developed before the advent of digital photography. I still choose to work within the limitation of the analogue i.e. the deferral. The trust, even surrender that asking the other to make images of you, required on behalf of the client is important. Frequent checking back and reviewing during the process, as one now can with a digital camera, interrupts the flow, the happening in the moment.

Cristina Nuñez, who describes herself as an artist in lifelong recovery (a 'Recoverist'), is keen to promote the empowering aspects of self-portraiture as an opportunity for broadening one's self-perception. Crucial is that in self-portraiture there are three distinct roles at play, each with a different dialogue: that of author, subject and spectator. The author says *I am representing myself. I am building my self-image. I am creating my image.* The subject says *I exist. This is me!* The spectator says, *I see myself.* She has developed a practice in which she encourages participants to take self-portraits that express emotions, which she calls 'collaborative self-portraits'. She says on video, 'then we see ourselves and we don't delete the 'ugly' pictures. We don't delete those pictures in which we don't recognise ourselves' (Nuñez, 2020). Indeed, she thinks it is these images of the unrecognised parts of ourselves that

are of particular value. Soon they become perceived as less 'other' and through concentration on these more alienating or unrecognised images the photographer 'begins recognising emotions, life experiences, needs, values and therefore we take possession again of the 'other' in me and that, of course, is a way to enrich our identity' (Nuñez, 2020). Working with the 'selfie' generation, Nuñez is keen to shrug off the oppressive industry standards of beauty that are ubiquitous and to use photography to construct and re-construct identity in a fuller way, acknowledging our 'full potential', as the broadening of self-perception is a prerequisite for personal change. This broadening of self-perception, she argues, also enables a broadening of perceptions of others and results in a less immediately judgemental stance. This is a therapeutic process but not therapy, she suggests. Rather she sees her practice as political and as about liberating 'authentic human needs' in the hope of building a more respectful and united human society.

In her self-portrait experience (SPEx) workshops, Nuñez is interested in transformative work, and like Berman's phototherapy, discussed below, she notes the way that dialogues can be set up using photographs that would be impossible in 'real life' because one of the protagonists is deceased; so, for example, a son may be enabled to create an image of him receiving his mother's loving gaze, or he may wish to speak to his mother's photograph to tell her things he wished he had said, as in the practice of re-enactment phototherapy (Chapter 6). Though what we do in front of the camera may be mediated by what we want other people to see, Nuñez (2013) argues that,

> there is a space, a relationship between me and my self which is, I believe, independent from other's gaze, and which implies an intense inner dialogue of judgement, perception, thought and acceptance. (p. 102)

Nuñez (2013) advocates for the power of self-portraiture as a therapeutic tool:

> Standing alone in front of the camera is the easiest way to stimulate our deepest emotions and transform them into artworks. The work is produced in the moment and

therefore the subject is least conscious of the act of taking the picture, because he is immersed in his interior. (p. 97)

She elaborates on the performative and cathartic aspects of self-portraiture (Nuñez, 2013, p. 102):

> The expression of difficult emotions in the self-portrait is particularly therapeutic. Rage and despair often cannot be externalised, so we become accustomed to repressing them. But if we concentrate hard enough, tune in and listen and try to push them out, these extreme emotions can help us move our 'guts' and express ourselves fully. By objectifying our 'dark side' in a photograph, we separate ourselves from what is painful and open ourselves for catharsis or renewal.

The art therapist McNiff (2004) points to the potential for self-healing through the process, 'someone who is suffering might begin by expressing hurt in a picture, but then in subsequent pictures treat and transform the condition' (p. 115). Digital editing and filters now allow for non-static photos, adding a new range of expressive possibilities and opening up the potential to work retrospectively on preexisting portraits, or indeed to tell a story through modifications to just one image to create a narrative sequence. Thus, the inner dialogue of which Nuñez (2013, p. 105) speaks can happen both in the moment and retrospectively:

> In *The Self-Portrait Experience* we are the subject of our art: we are in front of the camera, at our most vulnerable, and the inner dialogue that occurs is similar to the inner process of therapy at length: self-perception, self-questioning, judgement, thought and acceptance. The multiple meanings of the self-portrait work contribute to the union of the different aspects of the self. In the method's first and most important exercise, the attempt to express extreme emotions requires full attention on our interiority, and full attention when looking at ourselves in the photographs.

Rowell (2017) also articulates this important moment of looking:

There is an important function of the pause to look at one's own image, like a snapshot or freeze-frame during a film, as if to stop time and to observe the artwork for greater objectivity about self, then developed through an ongoing dialogue with self – an act of self-realisation through practice. It is as if the artwork has this holding capacity to be able to refer back to. (p. 151)

In a slightly more investigative way, José Batista Loureiro De Oliveira (2003) uses photographs to enable participants to explore ideas around sex roles, arguing that gender is central in shaping our social lives. Machismo and homophobia within Latin culture are themes he enables others to explore, the photographs playing a pivotal role in the process.

Photographs Made by Others

Bringing of photographic images of oneself alone, or with others, may serve to highlight many of the themes that are operational in the participant's world; it is inevitable that dominant preoccupations will emerge in the interaction with images. Stephanie Conway and Julia Winckler (2006) describe phototherapy as a method that permits a potential to 'challenge and un-fix established practices of seeing and knowing' (p. 205). Phototherapist Berman (1993) suggests:

If we take time to 'read' photographs on more than one level, they can help us to explore the hitherto unknown opposites within ourselves. Photographs confront us with paradoxes in an immediate way, displaying them before our eyes, in stark monochrome or flagrant colour. Perhaps they can paradoxically, say more than words, because of this visual dimension. (p. 24)

Berman (1993, p. vii) emphasises that exploration of ambivalence can be helpful: 'These stilled images can function as powerful reflectors of the ambivalence, confusion and inconsistences that patients bring to therapy'. Berman argues that it is an exploration of the ambivalence, through discussion of images, which

can be therapeutically useful and can lead to enhanced accept-
ance and resolution of inner conflicts, and hence to increased
self-understanding.

The use of found images can be another way of introducing
photographs into therapy and some therapists may offer a selection
of images as a stimulus for therapy. Wyder (2020), for example, is
interested in using the house as a metaphor for the self, offers pho-
tographs of houses by artists and architects showing a wide array
of designs as stimulus materials.

Hogan (2014) describes an exercise in which she asks partici-
pants to bring in two images (taken from any sources, including
magazines or newspapers) of their own sex: female, male or more
non-binary and androgynous, as however they identify at that
moment in time. The exercise is to choose one image that makes
them feel uncomfortable and another, which they like and/or feel
comfortable with. The prompt is that it is not necessary to know
why one is discomforting and another comforting or confirming,
but simply to bring in the images with which they have had a gut-
reaction. Invariably photographs are brought in. This workshop
presents an excellent opportunity to analyse media images and to
think about stereotypes and how they make us feel and to com-
mence a discussion about gender norms and their pictorial aspects
(Hogan, 1997, 2019, 2020).

Found images made my others are also used as means of inspir-
ing imaginative dialogue responses in therapy. Before Martin moves
on to the re-enactment phase of her work, she employs found imag-
es. She suggests their benefits in Chapter 6, as a catalyst for stimu-
lating imaginative free association. Hers is an example of the use
of found photographs to precipitate the movement of participants
into an imaginary space, though Martin notes that clients often
draw on their own histories in their story telling. She explains:

> Found images can be used to demonstrate the narrative
> potential of photographs, and how all photographs are
> fictions. As chosen moments, edited out from the contin-
> uum of everyday life, or highly constructed presentations
> to the camera, framed extracts from the visual field, all
> photographs are constructions. (Martin, 2013, p. 70)

Using Photographs in Metaphoric Ways to Think About Selfhood

Symbols and metaphors are important parts of therapy, allowing for the expression of half-realised thoughts and feelings. It is too simple to say that symbols simply 'stand for' something else, as the relationship between them is often indeterminate and complex (Hogan, 2016). Symbolic and metaphoric representation enables the eloquent expression in imagery of feelings and ideas that would be impossible or very difficult to articulate in words. Mixed-media pieces encompassing photographs give scope for this, as does the editing of digital images. In photographic collage, which is widely used in art therapy, the photographs may continue to connote meanings linked to their original purpose or context, but they can also become the material with which to construct another image. In art therapy, the process of making the image can become an important element. For example, an image might be made but then obscured, so it is 'still there' in a sense, but covered up; it becomes a hidden aspect of a piece, perhaps analogous of something to later be revealed. Bodily movements in the construction of images can become important. Whether the photographic images in a collage are torn out of magazines, or meticulously cut out with scissors, or whether digital manipulation is used, can lend different qualities of experience. The various photographic images selected for a collage can create dialogues with each other within the pictorial frame and mixed-media pieces can complicate the picture – the photograph then has a relation with another material; the relative size of objects can be telling or perturbing, or combinations can be formulated which create fascinating mood tones, or begin to ask questions. Indeed, photographic collage can function in many ways just as painting can within an art therapy experience.

Fryrear and Corbit (1992) integrate photography into art therapy as part of active imagination using a technique they call 'graphic elaboration'. A photographic subject is cut out and then glued onto a large piece of drawing paper or canvas. The photographic image then becomes the starting point for a new piece of art, which may or may not completely subvert the original intention of the photograph.

The existential aspects of selfhood can also be explored in photography, and life-changing events such as bereavement and illness. Rosy Martin's *Too Close to Home?* series is an extended piece of autoethnographic[3] work conducted over a 16-year period. It includes photographic installation, video and sound following the death of her father and presaging the death of her mother and then finally documenting the contents that evoke the lost presence within her mother's house following her death. This and more recent work by Mike Simmons are examples of different projects that involved photographing the family home following the death of parents, capturing that 'absent presence' which is so often felt following bereavement. Martin (n.paradoxa reflection, 1999) wrote of *Too Close to Home?*:

> I also addressed my emotional responses to impending loss: it was a pre-bereavement project. I considered how photographs and video could represent affect, and the inevitable failure of any attempt to somehow hold onto life's passing. Working on the personal, the marginal, the ordinary, everyday touches both private and public memories. Photography offers this opportunity to confront in isolation elements of lived experience, made strange by their sudden removal from the continuum of day-to-day living, stilled.

Martin (1999) describes this work as 'an inquiry into texture of place and memory through the notions of absent presence' (p. 1). Martin's work situates her narratives within the discourses about post-war re-construction and optimism about the promise of suburbia; her work is about herself, but it also engages with social history. Thus, though the work is about her mother and the house, it is also about a generation and their aspirations and it invokes 'reflective nostalgia' for a set of values, hopes and dreams that are now largely moribund (Boym, 2001). Martin (1999) also explores her ambivalence about suburbia (p. 1):

> But, like many of my generation and working class background, I grew restless. I learnt to despise this space in between, with neither the bustle and excitement of the

city, nor the open space of the country Now, I return
to a place that is laden with loss. It is too familiar, I hold
on tight to my return ticket out My relationship to this
suburbia is indeed uneasy. I find myself feeling torn. Bleak,
repetitive and monotonous, how can I feel a loyalty to
vacuous boredom? The message lodged in my head is 'we
did it for you, we did it all for you'.

Consequently, this body of work has a monumental quality aris-
ing out of a focus upon the very specific details depicted. The work
has a similar potency to Marcel Proust's famous exploration of
involuntary memory in *À la recherche du temps perdu*: how an
object or smell or taste can suddenly conjure up memory, so that
the subject is instantaneously transported to a different time and
place, in Proust's case by the taste of a tiny cake called a Madeleine.
Martin (1999) says of *Too Close to Home?*:

> Like a palimpsest, layers of small changes subtly represent
> adaptations over time. By mapping the wear and tear on
> the fabric of the house, the objects within it and my moth-
> er's body, represented through traces, the camera stands
> in for the searching eye, which averts from the gaze of the
> other, yet seeks evidence of presence. By concentrating on
> the materiality of things, I offer the possibility of a second
> glance at that which might otherwise be overlooked. It
> is about the act of looking, in which the viewer's eyes
> wander around a room, seeking out clues, as associations
> arise. It is a gaze which is tender as an old wound or as
> a comforting embrace cut with impending loss This
> re-encounter with the image allows transient and ephem-
> eral elements to be reconsidered. A strangeness emerges, as
> that which lies below the surface of what is shown begins
> to surface, in a parallel way to that in which as a therapist
> I search for the meaning that lie behind the meanings of
> that which is spoken to be revealed. Photography allows
> the secrets that the moment contains to be revealed, in
> contemplation. As objects can stand in for recalled events,
> so can experience be recollected through a return to a

place, which becomes a point of entry into a labyrinth of reminiscences.

Martin (1999, p. 1) is self-conscious about pushing the boundaries of legibility of her project, but she is also aware that she is communicating beyond her own concerns and that the work has a larger social and temporal resonances. She reflects:

> It is a melancholic project, the view-finder misted with soft tears and an ache that no image can assuage. Yet filled too with contradictions, remorse tinged with a longing to escape …. I am using photography and video to explore and isolate tiny details and fragments, so the audience only builds up a sense of the space over time. By pushing at the edge of legibility I enable the audience to project their own meanings upon the images, which symbolise and stand in for the continuity and discontinuity of change over time. Through macro close-up and by taking a child's point of view I represent the common-place as strange.

Simmons is interested in using photography with bereavement. He argues that doing grief work can result in 'resilient rather than vulnerable survivors' (Riches, 2002, p. 8) and is therefore an important undertaking. He says of his own project, which encompassed the production of digital montage, that he was trying to explore some of the unease felt, arising from the task of having to dismantle the contents of the domestic space. He says that,

> the work seeks to re-create a common bereavement experience, that of expectation and anticipation of finding some reference to the deceased in the reflection of a mirror, through a crack in a door or the shadow on a wall, 'for a long time you expect them to still walk in' (Skevington, 2003, p. 3) …. This intense scrutiny is intended to slowly give way to the realisation that there is *No One Home*. (Simmons, 2013, p. 58)

Simmons work is another example of how digital technology is being used in therapy.

The digital capabilities of photography are still developing with new apps appearing that make doing extraordinarily complicated-looking things simple to accomplish, such as images dissolving and morphing in astonishing ways. Photo animators are becoming more commonplace, enabling new relationships with photographs to be made. Images need no longer to be static. Visual culture in its broader sense promotes dialogue and connection between groups of people. Photographs serve an important function in creating virtual realities as 'dwelling environments' for modern people (Kopytin, 2013, p. 144); the literature on the utilisation of such dwelling places is still in its infancy in therapeutic photography. The sharing and reception of digital photography made in therapy on social media platforms has potential effects. For example, images might be 'tested out' for reaction. For instance, a particularly revelatory image might be shared on Facebook and then the reactions to this brought into art or psychotherapy. Conversely, images made in therapy may speak to such dwelling places – certain dynamics happening within them, or responding to the likelihood of certain sets of feedback, creating an interchange and potential constraints.

Digital social media is already being employed in therapy. Firstly, for example, in the design and performance of avatars, which can be discussed and thought about in the same way as the production of a photograph, with modifications made in the light of conversation with the therapist or group and self-reflection. However, multiple versions of a personal avatar can allow different ways of being to be explored and rehearsed once it leaves the confines of the therapy room. For example, the use of avatars enables participants to change their sex, or to experiment with aspects of gender identity. In virtual reality, art therapy groups held in the *Second Life* virtual domain, many constraints can be lifted enabling exploration and play. Ottiger and Ehemann (2020) describe the virtual reality space as a therapeutic 'potential space' and 'an area of self-play between subjectivity and objectivity, of experiencing and connecting both internal and external realities In virtual reality we transform into fluid subjects' (pp. 256–257). This, they suggest, could have particular advantages for those testing

out new ways of being. Imagination is always at play within art therapy, but the use of avatars allows a novel way of exploration which, at one remove, may feel less threatening and more accessible for some people.

Therapeutic Photography in Relation to Photo Systems

Family albums have been noted as a useful stimulus for life review work, since they can facilitate reflection on a lifetime; the images help recall and provoke reminiscence. Photographs are powerful in terms of stimulating reflections and memories on the present and the past. Drawing an imaginary family portrait may yield fruitful release, where photographs are lacking.

Photographs can be used as part of genograms which are a pictographic presentation of a person's family relationships. A genogram includes information about relationships and interactions between members of a family over several generations. It's a family tree of sorts, but one that may reveal intergenerational patterns of behaviour. Photographs can be brought in which span numerous generations, so that 'family wounds' and intergenerational trauma can start to be considered. De Bernart (2013, p. 125) notes different factors used for reading the genogram. One is interactive, so the photographs are used to help the individual (or couple) think about how the people depicted interact and what impact that has; another interconnected aspect is relational – specific patterns or repetitions might be identified and whether these have been internalised and incorporated; a emblematic parameter is also at play with certain images holding particular beliefs or myths about the family. Berman (1993) also advocates the use of photographs in genograms, as enabling therapists 'to gain a view of the relationships, the hierarchies, the culture, myths, norms and customs that make up the family system' (p. 106). She expands:

> As the photographs are described, the patient's narrative will expand to include many peripheral details about the people in the pictures. The therapist will hear about the

traditions, stereotypes and attitudes within the family and she will be given a sense of the chronology of family events and experiences. Both patients and therapist will gain a clear picture of the changes over the years in individuals and in the family as a whole, exploring the meaning of these changes for the family and the people within it.

Rosy Martin (2009, p. 40) discusses the power and importance of the family album suggesting:

Family albums provide a rich resource for autobiographical storytelling and an exploration of family systems: how it was to be part of this family and how these early experiences continue to affect the individual.

Photo elicitation is used in therapeutic photography as part of therapy practice. Photographs from family albums can be brought in as a stimulus for therapeutic work. Another term 'photo presentation' has also been identified in the literature:

Photo Presentation involves the use of sets of images or pictures chosen by the same individual. After the presentation of the images, a clinical interview or a discussion takes place. (Saita & Tramontano, 2018, p. 293)

Placed in a clinical context, this is a facilitating practice used as part of art therapy or psychotherapy. The photographs are explored to help people better understand their lives. As well as genograms, family albums can per se capture relations across generations. Berman (1993, p. 121) eloquently describes this:

As we now move on through the family album in therapy, we will see further how these past messages have influenced the present, for similar responses repeat themselves through its pages. Multigenerational modes of relating fix the past in the present and often create trauma and distress for those who inherit them. The family album can reveal, to those who look, such recurring patterns of circular, futile behaviour that may have existed for decades. They show how, blinkered by fear, unconscious of inner

motivations, people retrace together the same patterns of behaviour over time.

Berman (1993) notes that the family album can be a useful starting point for telling family stories, and may serve as an opportunity 'to describe the feelings and the reality behind poses and smiles' (p. 106). In relation to couple or family work, there can be a collective revisiting of key events:

> People can revisit the past together, and face feelings that have been left without resolution. Questions are posed, memories triggered, both shared and individual; there is review, reflection, a looking back, a tracing of family patterns of behaviour. (pp. 106–107)

The chapter on photographs and research methods (Chapter 5) also touched on this power of images to stimulate recall of past events in relation to interviews. Interestingly, Berman (1993, p. 113) has the idea of the image becoming *live* once more:

> Now the therapist and patient have begun to 'read' photographs, the once lifeless images become activated, releasing floods of recollections and communications Messages from important figures in the patient's past are recalled and these help the therapist to build up a significant picture of the patient's early life experiences.

Halkola sees working with snapshots and family albums as important in attempting to understand another's life. She notes these dimensions, which can be explored: (1) 'the relation between photographs and reality; (2) the relation between photographs and memories; (3) the relation between photographs and biographical meanings' (Halkola, 2013, p. 24). Halkola acknowledges that images can veil and distort reality, but she also emphasises that photographs have appeal because they 'can preserve moments of life we have lived' (p. 25). She draws on Barthes to distinguish between two types of image – those that have unexceptional effect and those that have a strong emotional effect (*punctum*). She elaborates,

The *punctum,* according to Barthes, rises from the photo-
graph with such strength that it can shoot like an arrow.
As Barthes (1980, p. 47) states, 'the *punctum* is like a sting,
hole, speck or a cast of the dice A photograph's *punc-
tum* is the accident which pricks me'. (Halkola, 2013, p. 25)

Such images are useful to work with since they can provoke
emotions and memories and can bring to mind difficult past events
and feelings associated with these. She elaborates:

The basic idea of phototherapy is that from the abundance
of photos there are significant photographs that arouse
interest as if they were magnets and, subsequently, once
chosen, their contents will be discussed and studied from
multiple aspects. The essential point is that working with
photographs is not restricted to verbal descriptions; with
photographs, associative work is also possible, almost
promoting time travel led by emotions. Biographical time
travel involves remembering one's own life. Biographical
photographs are therefore a logical source of knowledge
of one's life events (Halkola, 2013, p. 26)

Berman points out the usefulness of looking at sets of photo-
graphs which can reveal patterns of being in interactions, repeated
gestures which may be clues to underlying family dynamics, though
she emphasises the importance of checking out 'readings' of the
photographs with the client. She suggests that the therapeutic anal-
ysis of a photograph differs from the way we may normally look at
a photograph; it is a different way of looking:

It differs in that the photographs are 'read', with an ana-
lytic attitude, a new way of seeing. The therapist will at
first feel into the photograph, sensing the overall atmos-
phere and the emotions in the family group. She will
notice and question the way in which the people have
grouped themselves and will also look at the setting, the
background and the objects in the picture. As she does
so, there will be a careful, sensitive checking out with the
patient, so that the focus of therapy is not deflected by the
therapist's own assumptions. (Berman, 1993, p. 107)

Berman goes on to suggest we notice actions, gestures, positions and postures depicted in photographs to help us think about the recurrent styles of relating. In particular, she highlights proximity – the space between people in the photographs. She suggests that the recurrent patterns seen in the photographic record may shed light on emotional distance, or over-closeness, or point to a claustrophobic atmosphere. An obvious example might be a family member often shown standing apart. Postures are important. Noticeable examples are learning in towards another, or out and away from particular family members, especially if this is an on-going feature. More subtle still is how children are paired with parents and how at ease with that intimacy, or lack of it, they appear. Expressions and poses used in mainstream advertising may be duplicated in family albums. Dryer (1982, p. 100) notes that poses can be seductive, snuggly, passive, leisurely, composed, relaxed. Other people in the picture might be acting as a shield. As 'pose is also related to social position and status', Dryer asserts that 'women [and I'd add children] are often seen in a lower position than the man, for instance sitting at their feet'.

Bodily movement and gestures can all be telling. Dryer notes that women are more often depicted shown touching themselves, a finger resting on their face, for example, which can indicate a sort of thoughtfulness, but of a dissociated quality. Objects may be included in photographs, lightly touched or firmly grasped. There is a lot conveyed by postures.

Berman (1993) advocates looking intently at embraces, how parents hold their children, or are held, 'evidence of how safe and secure children feel in the arms of an adult is to be gleaned from their demeanour and expressions' (p. 114). Berman emphasises that touch is a basic human need and that its absence in childhood may cause difficulties for those deprived of it in later life. She argues that if children are held emotionally and physically, with real affection, then they will be likely to carry these loving feelings with them into adulthood. Likewise in therapy, the participant should also feel held in a confirming safe relationship. 'Then he or she will feel secure enough to relax into the process of therapy without fear of being 'dropped' or roughly handled, in emotional

terms' (p. 116). Berman (1993, p. 109) gives an example of working with this in therapy:

> Marion felt that her mother had always favoured her brother. On all the family photographs, mother was holding Daniel close to her, whist Marion was trailing some distance behind, or sitting apart. In therapy, Marion decided to experiment with her pictures. She brought photocopies of them, so she would not have to destroy them, and also so that she could try various ways of playing with the same photographs. She cut out the figures and began to rearrange the pictures according to her wishes and longings. Eventually, she deftly managed to place herself in her mother's arms, and to put her brother on the ground beside her. She was only able to do this, however, after she had worked on her self-image in therapy. Up to then, she felt that she had 'no right' to be held by mother, for she did not deserve much nurturing.

Millum (1975, p. 96) distinguished between different types of relationship shown in photographs: a two-way relationship in which each person is the centre of the other person's attention in a 'reciprocal' manner; images in which each person's attention is focussed on a different thing in a 'divergent' manner; images in which there is a shared attention on a particular object – it is 'object' focussed; or a 'semi-reciprocal' gaze in which one person's focus is directed on the other, whose attention is elsewhere. Berman notes the therapeutic potential of thinking about different types of look or gaze captured in family albums. Berman also has the idea of 'this photograph says it all', which is that a particular family dynamic exists and one photo exemplifies it. Likewise a 'favourite' photograph may be particularly revealing. She also notes the importance of omissions in sets of photographs as potentially significant. There can be many reasons for omissions and their exploration is potentially therapeutically fruitful. There may be noteworthy gaps in albums, caused by periods of crisis or illness, worthy of exploration.

Photographs create, as much as record events, so they can be analysed as a narrative. How the photograph is framed may be

telling, giving clues to who is *really* the main object of the photographer's attention. Berman also gives some harrowing examples of dissonance between the image and the reality. Nevertheless, the perfect and idealised, constructed image can also act as a trigger to memories surrounding its creation. The memories can be very different from what is depicted. The sharing of family albums in therapy can help with thinking about multi-farious family dynamics. For example, a person shown as standing out from the rest 'might have taken on and expressed various behaviours and feelings for others in the family' (p. 136) or even could be serving a scapegoating function for the family group. She concludes that:

> As in individual and marital therapy, photographs enable families in therapy to recognise patterns of interaction and to gain insight into the family system and their role in it …. Photographs may be used to verify feelings and memories, so that these can be shared and discussed. They reveal changes in the family and the individuals within it over the years. There is also provided a stimulus to interact, to discuss the images, share memories, both within the session, and outside therapy …. The feelings and thoughts about the experience depicted in the photograph may be shared and discussed within the safe boundary of the therapy.
> (Berman, 1993, p. 144)

Krauss and Fryrear (1983, p. 4) found an early example of photographs being used in psychotherapy to evoke emotions. In this case, a young woman had completely repressed a traumatic childhood experience and had no recall of it at all. Discussion and review of photographs from her family album was incorporated into therapy sessions to help her remember the experience and to release her repressed emotions. Dissociation is the detachment from phenomena, sometimes triggered by trauma, in which memories may become split off and inaccessible, though still creating affect, or carried in an undefined somatic way; phototherapy, especially working with emotionally laden or embodied images, allows the recall and re-integration of such traumatic but disavowed material. Secondly, it is easier to reminisce with the aid of a photograph, despite the difficulty of the material, as they are tangible reminders.

Thirdly, having a material object to work with can be useful as an object of focus.

Art therapist Judy Rubin (2005) explains that photographs can have a particular function in helping to think about troubling relationships; she recommends bringing in images of oneself with the person in question. Berman (1993, p. 163) notes that photographs can play a role in working with trauma where images can work as a form of corroboration of sexual abuse:

> Within the internal world of the sexually abused child, and of the adult abused as a child, are many, many horrific images, frozen snapshots of incidents that haunt and continue to abuse the mind. These are the pictures *not* taken, leaving the survivors terrifyingly isolated with their memories, bereft of external conformation of their traumas. They are left to rely on the fragmented memories of childhood.

Sometimes a therapy client will make a series of staged photographs exploring events that have occurred, but were not recorded. Rubin describes the experience as both potentially painful and cathartic, but also as freeing in moving the individual out of trauma. Berman concurs this work can be painful, but that it can enable the past to be 're-worked' in the present in a way that can help with post-traumatic manifestations such as nightmares and flashbacks.

Additionally, photographs can be used in psychodrama.[4] For example, participants might be asked to bring in a childhood photograph and then turn it into a living scenario – acting it out, with other members of the group being asked to participate. If working in a group-interactive model, group members' reactions or memories in response to the exercise might then be shared and examined. Alternatively, photographs from other sources might be brought in as a stimulus for group work, with images being chosen to base dramatic work around.

To re-cap, these different elements of therapeutic photography have been divided up for discussion and presentation, but in reality are overlapping an interlinked. This chapter has discussed photography as part of projective processes and given examples of how

therapists work with these ideas in relation to emotionally embodied images and their disposal; it has emphasised the potency of photography in therapy in which sensitivity to the material object is crucial.

The chapter has touched upon self-portrait photography mentioning different models of working with portraits: the cathartic SPEx work of Nuñez; the re-enactment phototherapy model of Martin and Spence, which is more narrative in that a series of pictures are produced to tell a story; the analytic interrogative portraits of de Olivera which probe Mediterranean homophobia; the deeply psychotherapeutic photographic re-staging of lost events of Rubin and the self-identity explorations with digital avatars of Ottiger and Ehemann. These examples serve to show a range of work being undertaken with portraiture.

The use of photographs by others as stimulus materials has also been highlighted. The chapter described using photographs in metaphoric ways, to think about selfhood. Finally, photography in relationship to sets of photographs, particularly family albums, has received attention: their potential is noted as an impetus for life review work, since they can facilitate reflection over a long duration of time and help recall and stimulate reminiscence. Finally, it is important to emphasise that therapeutic photography with survivors of abuse should only be undertaken by fully-trained psychotherapists or art therapists, who themselves have supervisory support.

Lastly, I refer the reader to the suggestions for further reading for additional understanding of photography as therapy, and for additional readings on re-enactment phototherapy and the use of photography within the social sciences.

SUGGESTIONS FOR FURTHER READING

Photography

Freeman, M. (2013). *The photography Bible. All you need to know to take perfect photos.* Focal Press.

O'Carroll, B. (2016). 20 composition techniques that will improve your photos (Online illustrated resource). Retrieved from https://petapixel.com/2016/09/14/20-composition-techniques-will-improve-photos/

Wells, L. (2015). *Photography: A critical introduction* (5th ed.). Oxon: Routledge.

Re-enactment Phototherapy Technique and Practice

Martin, R. (2003). Challenging invisibility – Outrageous agers. In S. Hogan (Ed.), *Gender issues in art therapy.* London: Routledge.

Martin, R. (2020). Look at me! Representing self: Representing ageing. Older women represent their own narratives of ageing, using re-enactment phototherapeutic techniques. In S. Hogan (Ed.), *Gender issues in international arts therapies research.* Abingdon: Routledge.

Therapeutic Arts and Arts in Health

Clift, S., & Stickley, T. (Eds.). (2017). *Arts, health and wellbeing.* Cambridge: Cambridge Scholars.

Hogan, S. (2016). *Art therapy theories. A critical introduction.* Oxon: Routledge.

Waller, D. (2015). *Group interactive art therapy* (2nd ed.). Oxon: Routledge.

Therapeutic Arts and Arts in Health – History and Development

Gilman, S. L. (Ed.). (1976/2014). *The face of madness. Hugh W Diamond and the origin of psychiatric photography*. Brattleboro, VT: Echo Point Books.

Hogan, S. (2001). *Healing arts: The history of art therapy*. London: JKP.

Visual Research Methods

Banks, M., & Zietlyn, D. (2015). *Visual methods in social research* (2nd ed.). London: Sage.

Margolis, E., & Pauwels, L. (Eds.). (2012). *The SAGE handbook of visual research methods*. London: Sage.

Pink, S. (Ed.). (2011). *Advances in visual methodology*. London: Sage.

Pink, S., Fors, V., & O'Dell, T. (Eds.). (2019). *Theoretical scholarship and applied practice*. London: Berghahn.

Rose, G. (2016). *Visual methodologies. An introduction to researching with visual methods* (4th ed.). London: Sage.

NOTES

CHAPTER 2

1. Gilman (1988) suggests that physiognomy 'captured the popular fancy of all Europe from about 1770' (p. 26).

2. Quote from the cover and title page of Laveter (1866), William Tegg edition, Laveter (1741–1801).

3. *Physiognomic Fragments* was produced between 1774 and 1778, but this and other work was reprinted in many editions posthumously, so was very influential.

4. H. W. Diamond (1857), On the application of photography to the physiognomic and mental phenomena of insanity read to the Royal Society with a published abstract. Published: 01 January. *Proceedings of the Royal Society of London.* https://doi.org/10.1098/rspl.1856.0036.

5. H. W. Diamond (1857). This paper has been reproduced in full by Gilman (2014, p. 23).

6. Eugenics is concerned with improving the genetic health of the population. Galton, first cousin of Charles Darwin, is attributed with having coined the term 'eugenics' in 1883 – 'a brief word to express the science of improving stock' (Galton, 1883, pp. 24–25).

7. The technique was a succession of images exposed from exactly the same position – but with a brief exposure time, which resulted in making common traits evident, but with only a 'ghost of a trace of peculiarities' (Galton, 1883, p. 10).

8. To be fair to Galton (1883), he admitted his composite of convicts revealed only 'common humanity of a low type' (p. 15). However, his supposition that criminal character is inherited is fundamentally anachronistic.

9. 'The high and wide forehead [is] generally indicative of intelligence and imagination' wrote John Connolly (1858) and this would have been an ingrained way of seeing in educated British society (cited Gilman, 2014, p. 13).

10. Galton (1869) didn't suggest a woman couldn't be a genius, but did believe 'an inherent tendency to barrenness of men and women of genius' (p. 331) and saw women in general as 'blinder partisans and more servile followers of custom' (p. 196). He saw this as innate, rather as the result of dominant cultural conditioning of the period towards female obedience. Later, in 1883, he asserted that women lack sensitivity in relation to men – they lack the 'more delicate powers of discrimination' – hence the tuners of pianofortes, the tasters of wine or tea, the sorters of wool and the like are men (p. 29). Indeed, a 'delicate power of sense discrimination is an attribute of a high race' inferring a hierarchy of races and indeed that women are closer to the lower because of their alleged lack of sensitivity (p. 33).

11. The attractive, 'are also judged to be more outgoing, socially competent, powerful, sexually responsive, intelligent and healthy. They do better in all manner of ways, from how they are greeted by other people to how they are treated by the criminal justice system' (Wiseman, Highfield, & Jenkins, 2009, n.p.).

12. The genetic instruction to make the spike on a molecule called MRNA was actually the content of the vaccine, so our own bodies, having received the instruction, produced the distinctively shaped spikes, which then stimulated our immunity – clever!

13. In the early 1840s, Richard Beard acquired the patent rights from Daguerre, and he exercised these in England to restrict competition (Lamb, 2019, p. 18). In December 1854, the court ruled (against Fox Talbot) that photography should be available to all and Beard's patent had expired. Between 1854 and 1863 there was a proliferation of commercial photographic studios in London (Lamb, 2019, p. 19). This coincided with a large increase in the country's gross national income, resulting in a wealthy middle-class, who had money to spend.

14. Entry on work in the Brooklyn Museum online colleague: https://www.brooklynmuseum.org/opencollection/objects/112132.

15. The Presidential Medal of Freedom was awarded to Adams in 1980 and these were the words spoken by President Jimmy Carter: https://www.anseladams.com/gallery/welcome/about-ansel-adams/.

16. A term used to denote eunuchs, intersex and transgender people in India.

17. A photographic print made from paper coated with albumen (egg white). It is significant, as it was a cheaper process using a new type of camera that could produce multiple images from a single negative, thus allowing unparalleled mass production and large profits for commercial studios. The previous technology, the daguerreotype, was a delicate product produced on silver-coated copper and covered with glass which had to be handled with care and which were very expensive to produce.

18. 'the investigation, by means of photographs, of the national and local types of race prevailing in different parts of the United Kingdom' (BAAS, 1882, p. 270 cited Poignant, 1992, p. 58), so here we have photography becoming a research method to discern regional variations.

19. Quotations are from a pamphlet produced in 1884 which is reproduced in Poignant (1992, p. 45).

20. Especially tragic is that all nine contracted Tuberculosis during a tour of the United States in 1883 and that by 1885 all were dead save three.

21. 'Whether there was an explicit directive from the British government to refrain from photographing views that could be deemed detrimental to the government's management of the war effort, perhaps in exchange for permission to travel and photograph in the war zone, or whether there was merely an implicit understanding between the government, the publisher, and the photographer is not known'; however, Thomas Agnew's original, commercially driven impulse, was to provide photographs which could help mitigate the negative newspaper reporting. It is therefore reasonable to refer to this body of work as early propaganda (Library of Congress, entry on Fenton. https://www.loc.gov/pictures/collection/ftncnw/background.html).

22. Particularly the Bonapartists, the royalists, the Boulangists, the Ligue des Patriotes and the Ligue antisemitique.

23. It may be the case that images of the dead following the defeat of the Communards, made to celebrate the destruction of the Paris Commune, had a counter-productive effect in creating martyrs.

24. This event shows the power of fake news. President Trump and his supporters claimed the electoral process as rigged and that his win as 'stolen', thus casting doubt in the minds of some of his more gullible

supporters on the legitimate, carefully administrated, electoral pro-
cess. That a proportion of the population was tricked into doubting
the legitimacy of the electoral result through fake news is very trou-
bling and the photos of the rioters in the Capitol building are now a
symbol for that too.

This incident also provoked photographic joke responses on social
media. For example, a digitally constructed image of the Speaker of the
US House of Representatives (Nancy Pelosi) is shown sitting at her desk
and mounted on the wall behind her, in the style of a hunting trophy, is
the distinctive head of one of the more flamboyant rioters (Jake Angeli)
who had sported a hat with horns for the event. An educated US audi-
ence would immediately get the visual joke.

25. Select Committee Proceedings items 1840 item 1079 (see bibliography).
26. Select Committee Proceedings items 1084 and 1085.
27. Select Committee Proceedings item 1089.
28. Select Committee Proceedings item 1097.
29. Friedrich Engels is quoting J. C. Symons, an assistant commissioner
 of the West of Scotland Handloom Weavers Commission, who is giv-
 ing evidence to the select committee.
30. The author distinguished this group from gypsies proper, though
 noted them as allied in way of life and having kinship links.
31. Half-tone photographs were created using mechanical printing pro-
 cesses that could imitate the subtle details and tone of a photograph,
 via the use of small printed dots.
32. Eugenic ideas became very popular in the twentieth century, and even
 underpinned some of the early arguments used for the promotion of
 birth control in England (that the less fit should be enabled not to
 breed, for the good of the Nation as a whole). In the United States,
 eugenics followed a darker path and was implemented forcefully,
 with 33 states enforcing involuntary sterilisation on those deemed
 unfit to breed. In California State, for example, from 1909 around
 20,000 sterilisations took place in mental institutions, based on ideas
 about the hereditary transmission of mental illness. The Supreme
 Court in 1927 upheld the enforced sterilisation of handicapped
 persons (the 'mentally deficient' or 'feebleminded') as not violating
 the Constitution (*Buck v. Bell*), and this invidious position was not
 overturned until 1942. Therefore, it was not just Nazi Germany
 which enthusiastically embraced eugenics. The Nazi regime in

Germany erroneously postulated that Jewish peoples tainted the general populace. In 1935, the Reichstag passed citizenship a law for the protection of German Blood and German Honour, which rendered only certain persons German citizens. Further legislation prohibited the marriage of Germans to others, such as Roma or Jewish persons. They took this misguided view of eugenics beyond morally dubious and highly reprehensible sterilisation programmes, to the horrifying extreme of committing genocide. In a recent survey conducted by the Pew Research Centre in 2020, it was revealed that half of Americans didn't know that 6 million Jews were murdered during WWII. People with mental illness and visible handicaps were also murdered, as were the deaf and the blind, black and Roma Germans and Germans who helped or hid Jewish people.

33. An estimated 2 million civilians were killed in the war. More than 58,000 Americans lost their lives. Estimates are that that 1.1 million North Vietnamese and Viet Cong fighters were killed and up to 250,000 South Vietnamese soldiers. The history of the war is too complex to elucidate here. Some key elements are that Japanese troops invaded French Indochina and occupied Vietnam in the autumn of 1940. In 1945, communist Ho Chi Minh declared an independent North Vietnam, and following rejection of a French proposal granting Vietnam limited self-government, began a guerrilla war against the French colonial rulers. In 1947, the foreign policy of the United States was to assist any country whose stability is threatened by communism. The policy became known as the Truman Doctrine.

34. Cited I. Butler, Tony Ray-Jones photographers (BLOG), https://www.211pix.com/tony-ray-jones/.

35. '... research reveals that Homo sapiens is *one continuously variable, interbreeding species*. On-going investigation of human genetic variation has even led biologists and physical anthropologists to rethink traditional notions of human racial groups'. In the twenty-first century, 'race' is a problematic cultural construct used in identity politics; arguably, it may be more meaningful to talk of cultural affiliation when describing differences between groups of people (NIH, 2007, my italics).

36. The 'attractiveness halo' is discussed above under natural sciences in the discussion of physiognomy. This is the proven idea that attractive people experience many benefits, not least higher pay.

CHAPTER 3

1. 'Stadium' is a good photograph that interests the viewer and 'punc-
 tum' is that which pierces emotionally; this distinction is discussed in
 further detail later in the book.
2. The photographs were taken during an expedition to Lapland in
 1884 by G. Roche.

CHAPTER 4

1. An emphasis on collectivism characterised some aspects of femi-
 nism in this period in the twentieth century. Now, because of a shift
 within feminism itself, there is currently much more emphasis on an
 acknowledgement of difference between women and a cognizance
 of a plurality of intersecting influences upon the constitution of a
 woman. Indeed, it has always been a tension within feminism that
 we should overlook potential differences (class, educational attain-
 ment, ethnicity, marital status and age) to bond together to make
 social change *as women*. The collective's enquiry was not nuanced
 anthropology, but a group political engagement and important in
 photographing women's working lives, including a rare depiction of
 working-class women's lives. To retrospectively label the group as
 racist, as overlooking racial differences by universalising them in the
 broader context of working-class women's experience, seems to miss
 the point of the dominant thrust of an empowering egalitarian, and
 inclusive movement focussed on a *shared oppression* and *sameness*,
 rather than difference. Indeed, Judith Butler (2020) in recent work
 emphasised the importance of inter-dependence – what she calls a
 'coalition practice of vision and solidarity'.
2. AIDS stands for Acquired Immune Deficiency Syndrome caused by
 the HIV Virus. HIV stands for Human Immunodeficiency Virus.
 Immunodeficiency refers to the weakening of the immune system by
 the virus. It is a syndrome because it is a collection of illnesses caused
 by the virus that makes the immune system weak, hence 'immune de-
 ficiency'. HIV has been passed on between humans for decades, but
 was only identified in the early 1980s. It was particularly associated
 with the male homosexual community and the practice of anal
 sex.

3. HIV, compared to Covid-19, for example, is not highly contagious as requires direct transmission through semen, vaginal fluid, anal mucus, breast milk or blood. Though associated with sexual practices, needle sharing Heroin drug users are therefore also another community at particular risk. Transmission through blood transfusion also occurred.

CHAPTER 5

1. The inspiration for this was a list produced by Weber (2008). As I felt Weber's categorisations lacked sufficient distinction, I used her list as a starting point and wish to acknowledge her work as the initial stimulus.
2. http://whomakesthenews.org/gmmp-2020
3. This concept is explained and discussed in Chapter 3.
4. Warner Marien argues that Baudrillerd's notion of the simulacra was pivotal in debunking the veracity of photography, but because of the trace of the referent, I think she is incorrect. The idea of the hyperreal – that is a multiplicity of images or signs unanchored from their original referents while useful, cannot be properly applied to photography, except in its digital forms.

CHAPTER 6

1. Clause 28 of the Local Government Act 1988 (an amendment to the local government Act of 1986) prohibited 'promotion of homosexuality' by local authorities.

CHAPTER 7

1. http://tiffanyfairey.co.uk/therapeutic-photography. Visited 3.10.20.
2. In the United Kingdom, the HCPC regulated art therapy practitioners who are maintained on a professional register in the same way as doctors and nurses.
3. Autoethnography is a recognised research method employing self-reflection and analysis of personal experience and then extending this personal reflection to wider societal issues and concerns.

4. A form of therapy in which dramatic techniques (improvisation; role play) are used to foster self-exploration towards enhanced self-understanding.

BIBLIOGRAPHY

Agee, J. & Evans, W. (1941). *Let us now praise famous men*. Boston: Houghton Miffli.

Althusser, L. (1969). *For Marx*. London: Allen Lane.

Ashcroft, B., Griffiths, G., & Tiffin, H. (2007). *Post colonial studies. The key concepts* (2nd ed.). Oxon: Routledge.

Ball, M. S., & Smith, G. W. H. (1992). *Analyzing visual data*. London: Sage.

Banks, M., & Vokes, R. (2010). Introduction: Anthropology, photography and the archive. *History and Anthropology, 21*(4), 337–349.

Banks, M., & Zietlyn, D. (2015). *Visual methods in social research* (2nd ed.). London: Sage.

Barbee, M. (2002). A visual-narrative approach to understanding transsexual identity. Art therapy. *Journal of the American Art Therapy Association, 19*, 53–62.

Barkan, E. (1994). Post-anti-colonial histories: Representing the other in imperial Britain. *Journal of British Studies, 33*(2), 180–203.

Barthes, R. (1980). *Camera Lucida. Reflections on photography* (R. Howard, Trans.). New York, NY: Farrar, Straus & Giroux.

Baudelaire, C. (1859). Salon of 1859 published in *Révue Française*, Paris, June 10–July 20. Cited Warner Marien, M. (1997). *Photography and its critics, a cultural history, 1839–1900* (p. 65). Cambridge: Cambridge University Press.

Becker, K. (2016). Variance in everyday photography. In E. Gómez Cruz & A. Lehmuskallio (Eds.), *Digital photography in everyday life. Empirical studies on material visual practices* (pp. 98–105). Oxon: Routledge.

Beilin, R. (2005). Photo-elicitation and the agricultural landscape: "Seeing" and "telling" about farming, community and place. *Visual Studies*, *20*(1), 56–68.

Benjamin, W. (1969). The work of art in the age of mechanical reproduction. In *Illuminations* (H. Zohn, trans.). New York, NY: Schocken.

Berger, J. (1967). *Understanding a photograph*. London: Penguin Books.

Berger, J. (1972). *Ways of seeing*. London: Penguin Books.

Berger, J. (1980). *About looking*. New York, NY: Vintage.

Berger, J., & Mohr, J. (1979/1980). The authentic image. Interview with J. Berger and J. Mohr. *Screen Education*, *32/33*, 28.

Berman, L. (1993). *Beyond the smile. The therapeutic use of the photograph*. Hove: Routledge.

Blinn, L., & Harrist, A. W. (1991). Combining native instant photography and photo-elicitation. *Visual Anthropology*, *4*, 175–192.

Boffin, T., & Gupta, S. (Eds.). (1990). *Ecstatic antibodies: Resisting the AIDS mythology*. London: Rivers Oram.

Bond, A., Woodall, J., Jordanova, L., Clark, T. L., & Koerner, J. L. (2005). *Self portrait. Renaissance to contemporary*. London: National Portrait Gallery Publications (Catalogue 224 pages).

Booth, T., & Booth, W. (2003). In the frame: Photovoice and mothers with learning difficulties. *Disability & Society*, *18*, 431–442.

Bruce, N. (2000). Images and reflection: Photography in the pursuit of public health. *Journal of Epidemiology Community Health*, *54*, 846–850.

Burgin, V. (Ed.). (1982). *Thinking photography*. London: MacMillan.

Butler, J. (2020). Judith Butler on the culture wars, J. K. Rowling and living in "anti-intellectual times". [Interview]. *New Statesman*. September 22. Retrieved from https://www.newstatesman.com/international/2020/09/judith-butler-culture-wars-jk-rowling-and-living-anti-intellectual-times?fbclid=IwAR357C2K1-tPdJswr8ZVljvAFJ6F7WuEl5brihx7FnaeHSmSZNJSZOpz8_I

Calosi, R. (2020). *Photo therapy day online. The last frame*. Grigo [film]. Retrieved from https://www.youtube.com/watch?v=_UvxcURtzn8

Carmen, T. (2008). *Merleau Ponty*. London: Routledge.

Carroll, H. (2014). *Read this if you want to take great photographs*. London: Laurence King Publishing.

Castle, T. (1995). *The female thermometer. Eighteenth century culture and the invention of the uncanny*. Oxford: Oxford University Press.

Clarke, G. (1997). *The photograph*. Oxford: Oxford University Press.

Clayden, A., Green, T., Hockey, J., & Powell, M. (2015). *Natural burial*. London: Routledge.

Clifford, J. (1988). *The predicament of culture*. Cambridge, MA: Harvard University Press.

Collins, M. (2015). Hilla Becher obituary, Photography. *The Guardian Newspaper*, October 15.

Connolly, J. (1858). Case studies from the physiognomy of insanity. *The Medical Times and Gazette*. Reprinted in S. L. Gilman (Ed.). (1976/2014). *The face of madness. Hugh W. Diamond and the origin of psychiatric photography* (pp. 27–31). Brattleboro, VT: Echo Point Books.

Conway, S., & Winckler, W. (2006). Acts of embodiment: Explorations in collaborative phototherapy. In D. Barndt (Ed.), *Wild fire: Art as activism*. Toronto: Sumach Press.

Courage, C. (n.d.). Arts & place [Blog]. Retrieved from http://www.caracourage.net/research. Accessed on June 5, 2020.

Courage, C. (2017). *Placemaking and community*. Cara Courage. TEDx Indianapolis. Retrieved from https://www.youtube.com/watch?v=Sfk1ZW9NRDY

Cowie, E. (1977). Women, representation and the image. *Screen Education*, 23, 15–23.

Crimp, D. (1987). AIDS: *Cultural analysis/cultural activism* (October, No. 43, Winter, pp. 1–3). Cambridge, MA: MIT Press.

Crimp. D. (1995). *On the museum's ruins*. Cambridge MA: MIT Press.

Darwin, C. (1872). *The expression of emotions in man and animals.* London: John Murray.

De Bernart, R. (2013). The photographic genogram and family therapy. In D. Lowenthal (Ed.), *Phototherapy and therapeutic photography in a digital age* (pp. 120–128). New York, NY: Routledge.

De Oliveira, J. B. L. (2003). A Mediterranean perspective on the art therapist's sexual orientation. In S. Hogan (Ed.), *Gender issues in art therapy* (pp. 126–148). London: JKP.

Durden, M. (2013). *Fifty key writers on photography.* London: Routledge.

Dyer, G. (1982). *Advertising as communication.* London: Methuen.

Diamond, H. W. (1857). On the application of photography to the physiognomic and mental phenomena of insanity. In S. Gilman (Ed.), *The face of madness: Hugh W. Diamond and the origin of psychiatric photography* (pp. 22–23). New York, NY: Brunner/Mazel 1976.

Edensor, T. (2005). *Industrial ruins: Space, aesthetics and materiality.* Oxford: Berg.

Eastlake, E. (1857). Photography. *The London Quarterly Review, 101,* 442–468. Retrieved from https://www.nearbycafe.com/photocriticism/members/archivetexts/photohistory/eastlake/pf/eastlakephotography1pf.html

Edwards, D. (2018). *Art therapy* (Creative Therapies in Practice series). London: Sage.

Edwards, E. (1992). *Anthropology and photography 1860–1920.* London: Yale University Press.

Edwards, E. (2013). *Anthropology and photography.* Oxford Art Online. Oxford University Press. Retrieved from https://doi-org.ezproxy.derby.ac.uk/10.1093/gao/9781884446054.article.T2229130. Accessed on February 11, 2013.

Edwards, E. (2015). Anthropology and photography: A long history of knowledge and affect. *Photographies, 8*(3), 235–252.

Eisner, E. (1995). What artistically crafted research can help us to understand about schools. *Educational Theory, 45*(1), 1–13.

Engels, F. (1958). *The condition of the working class in England* (W. O. Henderson & W. H. Chaloner, trans.). Oxford: Basil Blackwell.

English, E. (1981). *Photos and captions: The political uses of photography in the Third Republic, 1871–1914*. Ph.D. thesis, University of Washington.

Evans, R. (2018). History in albumen, carbon, and photogravure: Thomas Annan's old Glasgow. In M. Nilsen (Ed.), *Nineteenth-century photographs and architecture documenting history, charting progress, and exploring the world* (pp. 59–75). Oxon: Routledge.

Fani-Kayode. (n.d.). Tate webpage. Retrieved from https://www.tate.org.uk/art/artists/rotimi-fani-kayode-20378

Fardon, R. (Ed.). (1990). *Localizing strategies: Regional traditions of ethnographic writing*. Edinburgh: Scottish Academic Press.

Foderaro, L. W. (1989). Pollution by Kodak brings sense of betrayal. *New York Times*, March 8, Section 3, p. 1.

Freud, S. (1914). *The history of the psychoanalytic movement* (A. A. Brill, trans., 1917). London: Prospect.

Frith, H., & Harcourt, D. (2007). Using photographs to capture women's experiences of chemotherapy: Reflecting on the method. *Qualitative Health Research, 17*, 1340–1350.

Gallo, M. L. (2002). Picture this: Immigrant workers use photography for communication and change. *Journal of Workplace Learning, 14*(2), 49–57.

Galton, F. (1869). *Hereditary genius. An enquiry into its laws and consequences*. London: Macmillan.

Galton, F. (1883). *Inquiries into human faculty and its development*. London: Macmillan.

Geismar, H. (2006). Malakula. *Comparative Studies in Society and History, 48*, 520–563.

Giddens, A. (1990). *The consequences of modernity*. Cambridge: Polity.

Gilman, S. L. (Ed.). (1976/2014). *The face of madness. Hugh W Diamond and the origin of psychiatric photography*. Brattleboro, VT: Echo Point Books.

Gilman, S. L. (1988). *Disease and representation: Images of illness from madness to aids*. London: Cornell University Press.

Goldstein, R. (1983). Heartsick: Fear and loving in this gay community. *The Village Voice*, 28 June.

Gómez Cruz, E., & Lehmuskallio, A. (Eds.). (2016). *Digital photography in everyday life. Empirical studies on material visual practices*. Oxon: Routledge.

Grogan, S. (1999). *Body image: Understanding body dissatisfaction in men, women and children*. London: Routledge.

Grogan, S., & Wainwright, N. (1996). Growing up in the culture of slenderness: Girls' experiences of body dissatisfaction. *Women's Studies International Forum*, *19*(6), 665–673.

Glover-Graf, N. M., & Miller, E. (2006). The use of phototherapy in group treatment for persons who are chemically dependent. *Rehabilitation Counseling Bulletin*, *49*, 166–181.

Hall, S. (2001). *Stuart Hall: On photography*. Interview by Sunil Gupta. Autograph. Retrieved from http://vimeo.com/51527926

Haloka, U. (2013). A photograph as a therapeutic experience. In D. Lowenthal (Ed.), *Phototherapy and therapeutic photography in a digital age* (pp. 21–31). Hove: Routledge.

Harper, D. (2002). Talking about pictures: A case for photo-elicitation. *Visual Studies*, *17*, 13–26.

Higgonet, A. (1998). *Pictures of innocence: The history and crisis of ideal childhood*. London: Thames & Hudson.

Hodgetts, D., Radley, A., Chamberlain, K., & Hodgetts, A. (2007). Considering photographs never taken during photo-elicitation projects. *Qualitative Research in Psychology*, *4*, 263–280.

Hoffman, J. (2006). Sousveillance. *New York Times Magazine* (Online). December 10, no page number.

Hogan, S. (2011). Images of Broomhall, Sheffield. Urban violence and using the arts as a research aid. *Visual Anthropology*, *24*(5), 266–280.

Hogan, S. (2012). Ways in which photographic and other images are used in research: An introductory overview. *Inscape: International Journal of Art Therapy*, *17*(2), 54–62.

Hogan, S. (2015). Interrogating women's experience of ageing – Reinforcing or challenging clichés?. *The International Journal of the Arts in Society: Annual Review*, *9*(1), 1–18.

Hogan, S. (2016). *Art therapy theories. A critical introduction*. Oxon: Routledge.

Hogan, S. (2017). Working across disciplines: Using visual methods in participatory frameworks. In S. Pink, V. Fors, & T. O'Dell (Eds.), *Theoretical scholarship and applied practice* (pp. 142–166). London: Berghahn.

Hogan, S. (2018). Gender representation, power and identity in mental health and art therapy. In B. Hadley & D. McDonald (Eds.), *The Routledge handbook of disability, arts, culture and media* (pp. 137–148). Abingdon: Routledge.

Hogan, S. (2020a). Arts in health: Pregnancy, birth and new parenthood. In S. Hogan (Ed.), *Therapeutic arts in pregnancy, birth and new parenthood* (pp. 1–8). Oxon: Routledge.

Hogan, S. (2020b). Photography. In P. Crawford, B. Brown, & A. Charise (Eds.), *The Routledge companion to health humanities*. Oxon: Routledge.

Hogan, S. (2020c). Unnatural women: Reflections on discourses on child murder and selective mortal neglect. In S. LaChance-Adams, T. Cassidy, & S. Hogan (Eds.), *The maternal tug: Ambivalence, identity, and agency* (pp. 247–261). Ontario: Demeter Press.

Hogan, S., & Coulter, A. (2014). *The introductory guide to art therapy*. London: Routledge.

Hogan, S., & Warren, L. (2012). Dealing with complexity in research findings: How do older women negotiate and challenge images of ageing?. *Journal of Women and Ageing*, *24*(4), 329–350.

Hurdley, R. (2006). Dismantling mantelpieces: Narrating identities and materializing culture in the home. *Sociology*, *40*(4), 717–733.

Ingold, T. (2000). *The perception of the environment*. London: Routledge.

Iversen, M. (1986). Sassure v. Pierce: Models for semiotics of visual art. In A. L. Resse, & F. Borzello, (Eds.), *The new art history* (pp. 82–94). London: Camden Press.

Joanou, J. (2009). The bad and the ugly. *Visual Studies, 24,* 214–223.

Kelly, M. (2014). *Encyclopedia of aesthetics* (2nd ed., no page numbers). Oxford: Oxford University Press. Online Version e.ISBN:9780199747115

Kinsay, K. (2016). How often are people sharing your sexts?. Retrieved from https://www.cosmopolitan.com/sex-love/news/a62330/how-often-are-people-sharing-your-sexts/. Accessed on August 4, 2016.

Klorman-Eraqi, N. (2017). The Hackney Flashers: Photography as a socialist feminist endeavour. *Photography and Culture, 10*(1), 53–71.

Kopytin, A. (2013). Photography and art therapy. In D. Lowenthal (Ed.), *Phototherapy and therapeutic photography in a digital age* (pp. 143–155). Hove: Routledge.

Kozloff, M. (1987). *The privileged eye.* Albuquerque: University of New Mexico Press. Retrieved from https://www.cosmopolitan.com/sex-love/news/a62330/how-often-are-people-sharing-your-sexts/

Kozloff, M. (1998). Aesthetics of intimacy. In D. Bright (Ed.), *The passionate camera: Photography and bodies of desire.* London: Routledge.

Krauss, D. A., & Fryrear, J. L. (Eds.). (1983). *Phototherapy in mental health.* Springfield, IL: Charles C. Thomas.

Krauss, R. (1985). *Photography at the service of surrealism.* In R. Krauss & J. Livingstone (Eds.), *L'Amour Fou.* New York, NY: Abberville Press.

Lamb, J. (2019). *The commodification of the celebrity portrait: An analysis of photographic business practice in relation to image mass production in London c.1857–1880.* Ph.D. thesis, The Open University.

Lange, D. (1960). The assignment I'll never forget. In N. Beaumont (Ed.), *Photography: Essays and images.* London: Secker & Warburg.

Laveter, J. C. (1866). *Physiognomy. The corresponding analogy between the conformation of the features and the ruling passions of the mind* (New ed.). London: William Tegg.

Lister, M. (2016). Is the camera an extension of the photographer?. In E. Gómez Cruz & A. Lehmuskallio (Eds.), *Digital photography in everyday life. Empirical studies on material visual practices* (pp. 267–274). Oxon: Routledge.

Lowenthal, D. (Ed.). (2013). *Phototherapy and therapeutic photography in a digital age*. Hove: Routledge.

Mapplethorpe, R. (n.d.). The photographs of Robert Mapplethorpe. The Tate gallery. Tate webpage. Retrieved from https://www.tate.org.uk/art/artists/robert-mapplethorpe-11413/photographs-robert-mapplethorpe

Martens, L., Halkier, B., & Pink, S. (2014). Researching habits: Advances in linguistic and embodied research practice. *International Journal of Social Research Methodology, 17*(1), 1–9.

Martin, R. (n.d.). Author responses to contributing to n.paradoxa. Retrieved from https://www.ktpress.co.uk/conference/Contributors_nparadoxa.pdf

Martin, R. (1991). Don't say cheese say lesbian. In T. Boffin & J. Frazer (Eds.), *Stolen glances. Lesbians take photographs* (pp. 94–105). London: Pandora.

Martin, R. (1999). Too close to home: Tracing place. *n.paradoxa, 3*(1), 73–80.

Martin, R. (2009). Inhabiting the image: Photography, therapy and re-enactment phototherapy. *European Journal of Psychotherapy and Counselling, 11*(1), 35–49.

Martin, R. (2011). Phototherapy workshop led and created by Rosy Martin. Unpublished Paper.

Martin, R. (2012). Looking and reflecting: Returning the gaze, re-enacting memories and imagining the future through phototherapy. In S. Hogan (Ed.), *Revisiting feminist approaches to art therapy* (pp. 112–139). London: Routledge.

Martin, R. (2013). Inhabiting the image: Photography, therapy and re-enactment phototherapy. In D. Loewenthal (Ed.), *Phototherapy and therapeutic photography in a digital age* (pp. 69–81). London: Routledge.

Martin, R. (2019). Look at me! Representing self: Representing ageing. Older women represent their own narratives of ageing, using re-enactment phototherapeutic techniques. In S. Hogan (Ed.) *Gender issues in international arts therapies research*. Oxon: Routledge.

Maude, R. J., Koh, G. C., & Silamut, K. (2008). Taking photographs with a microscope. *The American Journal of Tropical Medicine and Hygiene*, 79(3), 471–472. https://doi.org/10.4269/ajtmh.2009.08-0256

McNiff, S. (2004). *Art heals. How creativity heals the soul*. Boston, MA: Shambala.

McKinley, J. C. (1994). Kodak is fined $5 million for toxic chemicals leak. *New York Times*, October 8, Section 1, p. 29.

Mercer, K. (1994). *Welcome to the jungle. New positions in black cultural studies*. London: Routledge.

Millum, T. (1975). *Images of women: Advertising in women's magazines*. London: Chatto and Windus.

Mohanty, C. T., Russo, A., & Torres, L. (Eds.). (1991). *Third world women and the politics of feminism*. Bloomington, IN: Indiana University Press.

Morton, C., & Edwards, L. (2009). *Photography, anthropology and history. Expanding the frame*. Farnham: Ashgate.

Nagy, A. (2018). What's behind the veil? The Art of Boushra Almutawakel. Amira Nagy in Conversation with Boushra Almutawakel. *Women in Islam.com*, November 6. Retrieved from https://www.womeninislamjournal.com/articles/2018/11/6/whats-behind-the-veil-the-art-of-boushra-mutawakil

Nelson, D., & Silva, N. (2010). The hidden world of girls. National Endowment for the Arts. Retrieved from http://www.kitchensisters.org/girlstories/the-series/the-hidden-world-of-shadi-ghadirian/. Accessed on 20 December.

NIH. (2007). *National Institutes of Health (US); Biological sciences curriculum study* (NIH Curriculum Supplement series) [online]. Retrieved from https://www.ncbi.nlm.nih.gov/books/NBK20363/

Nochlin, L. (1989). *Women, art, and power and other essays.* London: Thames and Hudson.

Nuñez, C. (2010). Self-portrait as self-therapy (pp. 1–19). Reworking of a paper published in Italian in "Autofocus" by Prof. Stefano Ferrari of the University of Bologna.

Nuñez, C. (2013). The self-portrait as self-therapy. In D. Lowenthal (Ed.), *Phototherapy and therapeutic photography in a digital age* (pp. 95–106). Hove: Routledge.

Nuñez, C. (2019). The self-portrait, a powerful tool for self-therapy. *European Journal of Psychotherapy & Counselling, 11,* 51–61.

Nuñez, C. (2020, May 23). Phototherapy day. Long presentation. Retrieved from https://youtu.be/J-rxO1m-3iM

Ottiger, N., & Ehemann, R. (2020). Gender roles in virtual reality. In S. Hogan (Ed.), *Arts therapies and gender issues. International perspectives on research* (pp. 247–260). Oxon: Routledge.

Packard, J. (2008). I'm going to show you what its really like out here: The power and limitation of participatory visual methods. *Visual Studies, 23,* 63–77.

Patrick, J., & Winship, G. (1994). Creative therapy and the question of disposal: What happens to created pieces following the session?. *British Journal of Occupational Therapy, 57*(1), 20–22.

Pearl, S. (2009). Through a mediated mirror: The photographic physiognomy of Dr Hugh Welch Diamond. *History of Photography, 33*(3), 288–305. doi:10.1080/03087290902752978

Pieroni, P., Scotland, J., Shelley, L., & Vasey, G. (Eds.). (2012). *Jo Spence Part 1 and Jo Spence Part II.* Exhibition Catalogue. SPACE, London and Studio Voltaire, London. Jo Spence Memorial Archive, London, the authors, SPACE, London and Studio Voltaire, London. Retrieved from https://www.studiovoltaire.org/wp-content/uploads/2015/11/Jo-Spence-Exhibition-Guide-web.pdf

Pichel, B. (2019). Reading photography in French nineteenth century journals. *Media History, 25*(1), 51–69. doi:10.1080/13688804.2018.1530974

Pink, S. (2001). *Doing visual ethnography: Images, media and representation in research*. London: Sage.

Pink, S. (2015). *Doing sensory ethnography* (2nd ed.). London: Sage.

Pink, S. (2016). Photographic places and digital wayfaring. In E. Gómez Cruz & A. Lehmuskallio (Eds.), *Digital photography in everyday life. Empirical studies on material visual practices* (pp. 186–191). Oxon: Routledge.

Plunkett, J. (2010). Celebrity and community: The poetics of the Carte-de-Viste. *Journal of Victorian Culture, 8*(1), 55–79.

Poignant, R. (1992). Surveying the field view: The marking of the RAI photographic collection. In E. Edwards (Ed.), *Anthropology and photography 1860–1920* (pp. 42–73). London: Yale University Press.

Prosser, J. (2006). *Researching with visual images: Some guidance notes and a glossary for beginners. Real life methods*. NCMR Working Paper Series 6/06, University of Manchester and University of Leeds, ESRC National Centre for Research Methods. Retrieved from http://eprints. ncrm.ac.uk/481/1/0606_researching_visual_images.pdf

Proust, M. (1913). *À la recherche du temps perdu* (Vol. 1. Swan's Way). Paris: Grasset.

Ratcliffe, T. (2019). Foreword. In R. Sammon (Ed.), *Photo therapy motivation and wisdom. Discovering the power of pictures*. Independently Published Kindle Edition (no page numbers).

Riches, G. (2002). Out fathers. Loss and childhood memory. Exhibition Catalogue. Lincoln: Simmons & Hind. Cited by Simmons, M. (2013). A creative photographic approach. Interpretation and healing through creative practice. In D. Lowenthal (Ed.), *Phototherapy and therapeutic photography in a digital age* (p. 58). Hove: Routledge.

Riis, J. (1890). *How the other half lives: Studies among the tenements of New York*. New York, NY: Charles Scribner's Sons.

Rischon, O. (1885). Representation: The harem and the despot. *Block, 10*, 34–44.

Roberts, J. (1998). *The art of interruption: Realism, photography and the everyday*. Manchester: Manchester University Press.

Rogoff, I. (1998). Studying visual culture. In N. Mirzoeff (Ed.), *The visual culture reader*. London: Routledge.

Rose, G. (2011). Photography and its circulations. In S. Daniels, D. DeLyser, J. N., Entrikin, & D. Richardson (Eds.), *Envisioning landscapes, making worlds: Geography and the humanities* (pp. 287–292). London: Routledge.

Saita, E., & Tramontano, M. (2018). Navigating the complexity of the therapeutic and clinical use of photography in psychosocial settings: A review of the literature. *Research in Psychotherapy: Psychopathology, Process and Outcome, 21*(1), 293.

Schaverien, J. (1991). *The revealing image. Analytical art psychotherapy in theory and practice*. London: Routledge.

Sekula, A. (1982). On the invention of photographic meaning. In V. Burgin (Ed.), *Thinking photography* (pp. 84–110). London: MacMillan.

Sekula, A. (1999). Reading an archive: Photography between labour and capital. In J. Evans & S. Hall (Eds.), *Visual culture: A reader* (pp. 181–192). London: Sage.

Select Committee and Minutes of Evidence Taken Before the Select Committee on Health of Towns. (1840, March 30). *Committees of House of Commons*. Session 1840 (Vol. 28. Minutes of evidence).

Sharrona, P. (2009). Through a mediated mirror: The photographic physiognomy of Dr Hugh Welch Diamond. *History of Photography, 33*(3), 288–305. doi:10.1080/03087290902752978

Sherlock, A. (2012). Jo Spence. *Frieze Magazine*, Issue 149, September, no pages. Retrieved from http://www.frieze.com/issue/review/jo-spence/. Accessed on April 4, 2013.

Shusterman, R. (2012). Photography as performative process. *The Journal of Aesthetics and Art Criticism, 70*(1), 67–77 (Special Issue: The Media of Photography).

Simmons, M. (2013). A creative photographic approach. Interpretation and healing through creative practice. In D. Lowenthal (Ed.), *Phototherapy and therapeutic photography in a digital age* (pp. 53–66). Hove: Routledge.

Sloboleva, K. M. (2019). How Tessa Boffin, one of the leading lesbian artists of the AIDS crisis, vanished from history. *Hyperallergic*, June 17. Retrieved from https://hyperallergic.com/505433/how-tessa-boffin-one-of-the-leading-lesbian-artists-of-the-aids-crisis-vanished-from-history/

Smith, A. (1877). *Street life in London*. London: Sampson Low, Marston, Searle and Rivington.

Sontag, S. (1979). On photography. Harmondsworth: Penguin.

Spence, J. (1986). *Putting myself in the picture: A political, personal and photographic autobiography*. London: Camden Press.

Spence, J. (1991). *Exploring the unknown self: Self portraits of contemporary women* (p. 358). Tokyo Metropolitan Museum of Photography exhibition catalogue, (published in *Jo Spence. Beyond the Perfect Image. Photography, Subjectivity, Antagonism*, MACBA Exhibition catalogue).

Spence, J. (1995). *Cultural sniping*. London: Routledge.

Spence. J. (2005). *Beyond the perfect image. Photography, subjectivity, antagonism*. MACBA Exhibition catalogue (Barcelona: MACBA).

Steward, D. (1979). Photo therapy: Theory and practice. *Art Psychotherapy*, 6(1), 41–46.

Street, B. (1992). British popular anthropology: Exhibiting and photographing the other. In E. Edwards (Ed.), *Anthropology and photography 1860–1920* (pp. 122–132). London: Yale University Press.

Tagg, J. (1988). *The burden of representation. Essays on photographies and histories*. Basingstoke: Macmillan.

Tylor, E. B. (1876). Dammann's race-photographs. *Nature*, *13*, 184–185.

Theroux, L. (2017). *Talking to anorexia*. BBC Documentary. First shown 29 October 2017.

Uimonen, P. (2016). I'm a picture girl! Mobile photography in Tanzania. In E. Gómez Cruz & A. Lehmuskallio (Eds.), *Digital photography in everyday life. Empirical studies on material visual practices* (pp. 19–35). Oxon: Routledge.

Vallencourt, M. (Ed.). (2015). *The history of photography*. Chicago, IL: Britannica Educational Publishing.

Van Leeuwen, T. (2005). *Introducing social semiotics*. London: Routledge.

Victor, C., & Dammann, C. (1873–1876). *Anthropologisch-Ethnologisches Album in Photographien*. Berlin: Berliner Gesellschaft fur Anthropologie.

Warner Marien, M. (1997). *Photography and its critics, a cultural history, 1839–1900*. Cambridge: Cambridge University Press.

Weeks, J. (1985). *Sexuality and its discontents*. London: Routledge & Kegan Paul.

Wells, L. (Ed.). (2003). *The photography reader* (1st ed.). London: Routledge.

Wells, L. (Ed.). (2004). *Photography: A critical introduction* (3rd ed.). London Routledge.

Wenger, E. (1998). *Communities of practice: Learning, meaning, and identity*. Cambridge: Cambridge University Press.

Wheeler, M. (2020). Beyond masculine and feminine. In S. Hogan (Ed.). *Gender and difference in the arts therapies* (pp. 207–218). Oxon: Routledge.

Wiseman, R., Highfield, H., & Jenkins, R. (2009). How your looks betray your personality. *NewSceintist The Daily Newsletter*, February 11, no page numbers. Retrieved from https://www.newscientist.com/ article/mg20126957-300-how-your-looks-betray-your-personality/ #ixzz6OxadxCuG

World Health Organisation: Preamble to the Constitution of the World Health Organization as adopted by the International Health Conference, New York, 19–22 June 1946, signed 22 July 1946 by the representatives of 61 States (Official Records of the World Health Organization, No. 2, p. 100) and entered into force on 7 April 1948.

Wright, C. (2003). Supple bodies. In C. Pinney & N. Petersen (Eds.), *Photography's other histories* (pp. 146–172). London: Duke University Press.

ACKNOWLEDGEMENTS

I would like to thank series editor Professor Paul Crawford for inviting me to contribute this volume to the Arts for Health Series. It consolidates my interests in visual culture, hopefully in ways pleasing to the reader. Starting just before the Covid-19 lockdown in 2020, symbolically its writing was an act of optimism and hope.

As a teenager, I vividly remember weeping with frustration when upon reading and re-reading Claude Lévi-Strauss, I could not understand the book! It was impenetrable. Since this formative incident, I have striven to address complex subjects in a comprehensible way. I hope I have succeeded.

Thanks to photographers Professor Sarah Pink, Rosy Martin and Dr Cristina Nuñez for their help. Rosy Martin's detailed critical commentary on her techniques has ensured accuracy. Omissions have been pointed out; however, photography is a *big subject* and in a short-monograph format it is impossible to be definitive and fashion photography as a vitalising force has been the major casualty. Thanks to Dr Allison Singer (ethnographer and drama therapist), who looked over my anthropological sections. Further thanks to Professor Alan Rice and colleague Mark Hall for their reading suggestions. Last, but by no means least, thanks to Phil Douglas who offered a detailed critical appraisal of the entire manuscript.

The section entitled 'Summary of Photographic Research Methods' first appeared in its current abridged form in the *Routledge Companion to Health Humanities* (edited by Crawford et al.) in my chapter (31). It is reproduced here verbatim with kind permission from Routledge. A section of Chapter 5 is based on an essay, *Ways in Which Photographic and Other Images Are Used in Research:*

An Introductory Overview, extensively enhanced and re-written, so as to constitute a fresh piece of work. Deep thanks to image copyright holders for their fee waivers that made an illustrated book possible. Also, thanks to Charlotte for making a donation on behalf of Emerald to the Tessa Boffin/Gupta+Singh Archives.

INDEX